D0941260

Published by McNidder & Grace
4 Chapel Lane, Alnwick, NE66 1XT

First Published 2012

©Thierry Falise

All rights reserved. No part of this work may be reproduced or
transmitted in any form or by any means, electronic or mechanical,
including photocopy, recording, or any information storage or retrieval
system, without permission in writing from the publisher.

Thierry Falise has asserted his right to be identified as the author of this
work in accordance with the Copyright, Designs and Patents Act 1988.

A catalogue record for this work is available from the British Library.

ISBN: 978-0-85716-041-6

Designed by Obsidian Design

Printed in China on behalf of Latitude Press Ltd.

Acknowledgments

I have put in thousands upon thousands of hours of work over the twenty-five years I've been reporting on Burma. That work has finally culminated in the publication of *Burmese Shadows*, an event of which I am extremely proud. But all of that work would have been impossible without the help, support and (mostly friendly) cajoling from a host of family, friends and colleagues.

First and foremost I must say thanks to the people of Burma who have taken me into their homes and shared with me their lives, warts and all. You are an inspiration. This book is for all of you.

A sincere dedication is also due to Emm, my long-suffering wife, and Damien, our son. They have put up with my long absences when on assignment and tolerated my frantic moods when at home. Quite simply I would not have had the strength to complete this without your unremitting love and support. I am truly grateful. I wish my father Charles was alive today to see this book, but I know he would have been proud that his engraining in me of the values of independence and tenacity resulted in my becoming a freelance photojournalist which ultimately instilled the passion needed to produce this work. To my mother Françoise, I'm sorry for all of those times that you have patiently sat in your home in Belgium and endured the anxiety that comes with my long spells in the jungle. You are never far from my thoughts. Eternal thanks to the rest of my family in Belgium.

I owe a very special thanks to the few people who believed in the project from its infancy. Without them this book would never have seen the light of day: Léon de Riedmatten, you are a solid companion and a sincerely true friend of the people of Burma. Jean Michel Romon, we both know how much you have helped out, I hope you think it was worth it. Thanks to my agent and friend Greg Lowe who I first discussed the project with six years ago, and to Chris Steele-Perkins who, as picture editor, has brought considerable talent and experience to this book. Of course, no one would be reading this if it wasn't for all the hard work by Andy Peden Smith and his team of editors and designers at McNidder & Grace – thank you for believing in me.

A hat's tip must also be given to my motley crew of journalist colleagues and rebel friends: Bernard Genier, in remembrance of our numerous and sometimes awfully long and exhausting but always unforgettable trips inside Burma; David Eubank, his wife Karen and their three kids, as well as Amy, Hosie, Nate, Mitch, Micah, Jessie, Josh and the other Free Burma Rangers, you are the best travel companions in the world. I mustn't forget the "Animals" – Paw Htoo, Eliya, Ka Paw Say, Doh Say, Nick, Laurie Naw Nam, K'Chay, Ae Paw, Sai Nong, Saw Nu, Reh Ko and Toby Bee – I hope those whose names I have forgotten can forgive me – nor those who are no longer with us: Bill Young, Di Gay Htoo, Shining Moon, Sai Pao, Benjamin Kyar Oo, Remy Favret and U Ye Htoon. Olivier Nilsson, my old friend and schoolmate, who is a ruthless but fair picture editor. Those other friends who, in one way or another, have given me their experience and wise counsel – Vincent Reynaud, Ben Davies, Patrick de Noirmont, Roland Neveu and Dan White – whether I wanted it or not, it was always valuable. Marc Charuel, many thanks for opening that first door into the mysterious world of the Karen.

Shannon Allison, Jane Birkin, Clément de Riedmatten, Luc de Waegh, Allan Eubank, Boris Grange, Denis D Gray, Ko So Mo, Kyaw Swa, Philippine Leroy-Beaulieu, Chris Lewa, Chris Lom, Florent Massot and Tuja, you have my heartfelt thanks.

Finally, no acknowledgements would be complete without thanking all those who as guides, porters, translators, cooks, protectors and villagers have aided me over the years – your names may have faded in my memory, but I will remember your faces forever.

Contents

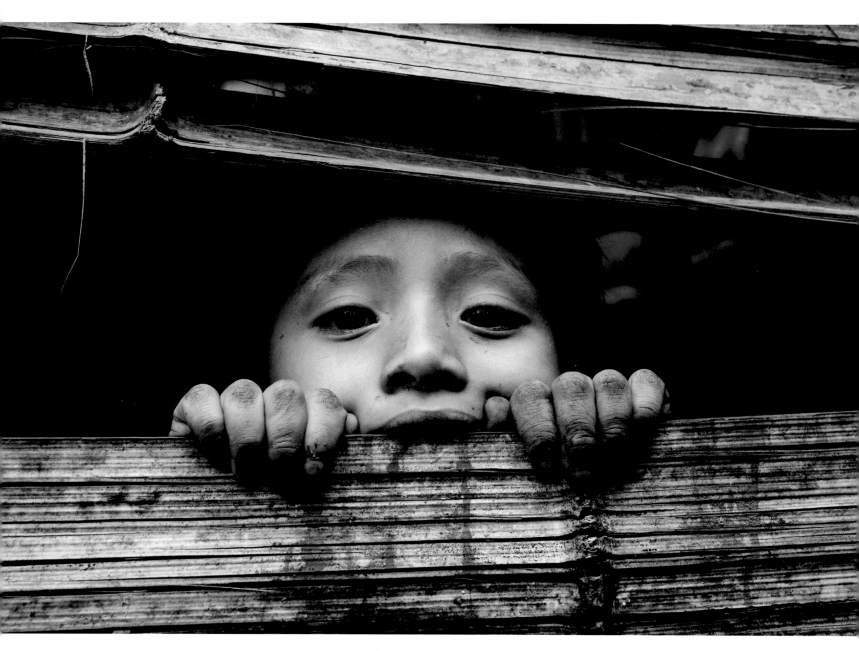

A young Karen boy looks through a hole in the bamboo hut in a jungle where he and his family are hiding from the Burmese army.
Karen State, 2008.

In August 2011, I had a dinner in Rangoon with a Burmese businessman friend of mine who I have known for a while. Over the years he had always been keen to talk about politics and other sensitive issues on condition that we met in discrete locations. Back then, he would always keep looking over my shoulder as we chatted to make sure our conversation wasn't being listened in on, or that we were not being observed or followed by a government informant. After all, people had been thrown in jail for lesser offences than discussing the cut-and-thrust of the country's politics or for criticising the generals who ran the show.

And so it was on this rainy night that we came to be sitting in a crowded Burmese restaurant talking openly about the latest political developments in Burma and the positive steps that had been taken by the new civilian president Thein Sein. My friend was speaking about the country's pro-democracy icon Aung San Suu Kyi by name, instead of referring to her in whispers as "The Lady" as he had done so in the past. This dinner took place just a few days after the president and the Nobel Laureate had met for the first time in the capital Naypyidaw, an event that would have been practically unthinkable just a few weeks earlier when Aung San Suu Kyi had reportedly confided that she expected nothing from the new government which had been born out of massively rigged elections which were held the previous November.

However, significant changes were already starting to take place within the government and the country in general and these changes were fast gaining momentum. Burma finally seemed to be on a path towards political liberalisation, though democracy would surely take some time to come. People all over the country, to coin the title of one of Aung San Suu Kyi's most famous essays, were aware that they had won some "freedom from fear", that the blanket of oppression under which they had been living for half a century was starting to unravel.

But, as is often the case with Burma, the situation was far more complex than first meets the eye. Away from the heady, if not cautious optimism surrounding political events in Naypyidaw and our discussion of them that night, a different story was playing out. This story had much greater affinity with the Burma of old and its well-worn path of army oppression and human tragedy. About a thousand kilometres north of Rangoon, in a vast mountain territory that straddles the border with China, a 17-year-old ceasefire agreement between the government and the local Kachin minority had recently broken down. I had travelled there the previous month to report on how young Kachin women and men were trading in their peasant's hoes for machine guns. They were digging in to fight the Tatmadaw, or Burmese army, for the long haul. While there, I had visited makeshift bamboo and tarpaulin camps which accommodated 16,000 villagers who had been forced to flee when the army descended on their settlements a few kilometres away and razed their houses to the ground. Within a year this number would rise to more than 50,000. These once-proud Kachin men and woman had been transformed into an acronym – they had become IDPs, internally displaced persons.

This trip sent my mind back to 1987, the first time I entered Burma and also the first time I heard the term "I-D-P". That year, I had followed in the footsteps of other young European journalists who had flown to Bangkok and then taken a number of increasingly ramshackle bus rides to Mae Sot in northwest Thailand and the border with Burma. The aim was to covertly cross over into Karen State where a rebel ethnic force, the Karen National Liberation Army, had been fighting the Burmese junta in its various guises since the country's very first day of independence in 1948. These were the first steps I would take on what would become an exciting adventure. Long-haired guerrillas were ambushing the then disciplined and ruthless Burmese army. I was invited to

accompany a platoon of insurgents on a mission into a so-called "black zone" in Karen State, an area where the army had been given shoot-on-site clearance, an order which extended their murderous impunity to the killing of rebels, men, women, children, livestock, pretty much anything that moved, including foreign journalists, which they considered to be fair game.

It was an intensely gruelling but worthwhile experience. Beyond the blisters I was rewarded with for making an exceptionally poor choice of footwear, and the adrenaline which flooded my body as I observed firefights between the rebels and the army, I was able to meet locals first-hand and record their flight from the military's counter-insurgency operations which were directly targeting civilians. These men, women and children, who were living in makeshift shelters with nothing but thin leaf roofs to protect them from intermittent rain or searing heat, had horrendous stories to tell. I was shocked beyond belief by their personal accounts of murder, torture, rape, forced labour, of having their farm animals slain and houses burnt to the ground by the marauding Tatmadaw.

They were the first IDPs that I met in Burma. They were certainly not to be the last.

After that first experience with the Karen I visited the country scores of times, sometimes for just a day, others for five weeks or so. My forays into Burma became more frequent after 1991 when I moved from Paris to Bangkok. There was just something about the situation in the country that I couldn't get out of my mind. Stories needed to be told. The suffering and human rights abuses that were being experienced by hundreds of thousands of people every day needed to be given a voice. Every time I went back it seemed that there was more to understand, more to report. While I spent considerable amounts of time travelling clandestinely in ethnic territories to cover guerrillas, humanitarian operations, the drugs trade, spiritual movements, and warlords and their armies, I always insisted on reporting in "legal Burma" or, to

keep in line with what was previously said, in the "white zone", the vast part of the country that was open to people with visas.

Covering the extraordinary stories which were unfolding in remote and uneasily accessible areas was no excuse for putting aside the lives and realities of the majority of the country's population. It also fast became apparent that living in the more open territories did not necessarily make life much easier, after all, millions of people were living in fear and poverty. During these trips I met and photographed normal people who were working hard to make ends meet, who paid respects to Buddha and the spirits, and who simply wanted to enjoy life.

There were also some exceptional episodes, such as an expedition by foot and mule from Thailand across the mountainous Shan State to the Chinese border with a Wa ethnic leader who was opposed to his group's opium and heroin business; my interview with Aung San Suu Kyi who, during a sort of "Rangoon Spring" in the mid-1990s, was giving rousing speeches from the gate of her home every weekend to crowds of thousands of her supporters; and in 2007 when I covered the full course of the monks' demonstrations in Rangoon and the army's swift and brutal crackdown. The following year I journeyed south to the Irrawaddy Delta a few months after Cyclone Nargis had devastated the region and killed more than 140,000 people.

But, as anyone who has been following news from the country understands, the story of Burma cannot be confined by its borders. Millions of people have left their homeland in search of a better life. The majority have settled in neighbouring Thailand and Bangladesh, many of them working illegally or living in refugee camps. I have made a point of following these people to see how they are affected by living outside of their country. Many want to return home, but cannot due to political or economic pressures. Some, such as the Rohingya, appear to have fallen through the gaps, with hardship following them from Burma to Bangladesh to Thailand and beyond.

Going back and forth between these black and white zones for twenty-five years has enabled me to build a personal and somewhat comprehensive portrait of a country and its people who I have nurtured a passion for. This portrait is certainly not exhaustive: it is a work in progress. As my latest visits to Kachin State, and other reports from the area, make clear is that whatever developments are currently taking place in Naypyidaw, no matter what positive steps are taken to build stronger relations with the international community, Burma is a country that has yet to escape its past. Above all, these recent developments raise the crucial issue of the army's future. How far will the reforms go and how ready are the generals to relinquish power and transform the army into a body which exists solely to defend its citizens rather than rule over them?

In 2012, at the time of this book's publication, people from Burma finally seemed to be entering an era of increasing freedom. There is, undoubtedly, a long way to go before the goals of a fully functioning, open democracy and the far-reaching human rights that that should bring can be achieved. But one has to hope that the potential for change will be realised and that old traits and prejudices do not derail the process. Furthermore, the economy has to be redesigned from scratch and proper education and health systems need to be constructed. A key priority is establishing mutual trust and confidence within the country. Confidence has to be built between citizens who for decades were manipulated to mistrust their neighbours, colleagues, even their own families. Trust not only needs to be established between the dominant Burmans and ethnic minorities, but also between the diverse ethnic groups themselves – clashes between Rakhine Buddhists and Rohingya Muslims, in which more than 80 people were killed and 30,000 displaced in June 2012 showed just how strained these tensions can be – and of course, between the citizens and the government and army.

Burmese Shadows strives to show the complexity of Burma's history, at least during the twenty-five years that I have been reporting on the country, to serve as a reminder of recent turbulence and human rights abuses, but also to bring to light the diversity, beauty and life that can be easily found there. My hope is that the bright points soon outshine Burma's dark past and that these painful events remain memories in the shadows – things neither to be forgotten nor repeated.

On a final note, throughout the book I refer to the country as "Burma". While the junta officially changed the name to the Republic of the Union of Myanmar in 1989, both Burma and Myanmar mean the same thing, the people are still referred to as "Burmese" and for the greater part of the past twenty-five years, most of the people I met inside and outside of the country referred to the country as Burma.

Thierry Falise
Bangkok, Thailand
June 2012

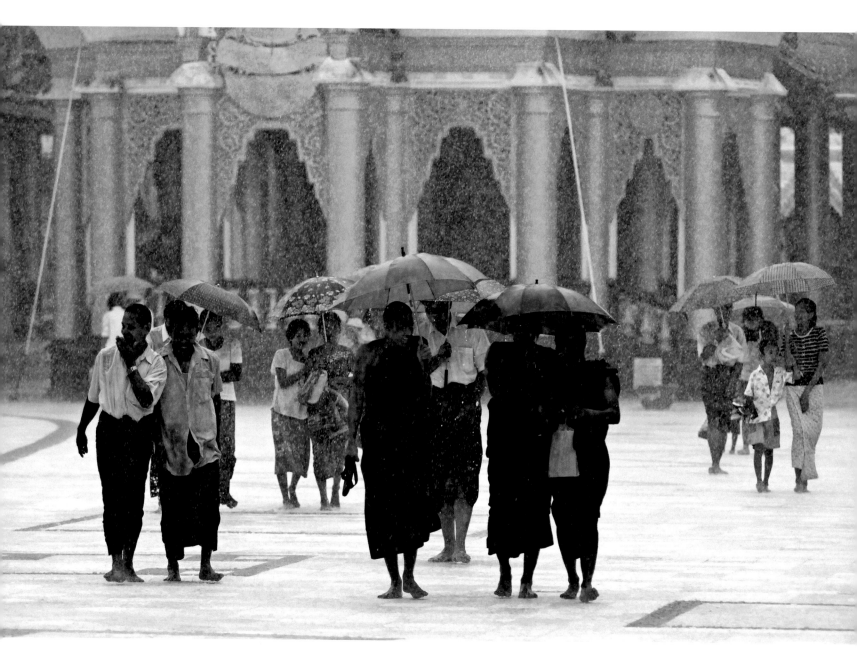

Monks and laypeople walk in the rain at the Shwedagon Pagoda, Rangoon.
Rangoon Division, 2006.

Chapter One

FROM BABELS TO BUDDHAS
Military, monks and making merit

Nestled on the sacred Mindama hilltop in Rangoon's outskirts stands a site which is well-known for its stables of white elephants, revered animals in both Buddhist and local animist traditions. By the time I first visited the place in 2006, however, it had become famous for its iconic Loke Chantha Abhaya Labhamuni Buddha, an eleven-metre-tall statue carved from a single 500-tonne block of white marble – which had been housed in a purpose-built pagoda.

The story behind this impressive image provides keen insight into the nature of religion in Burma and how Buddhism can provide fertile ground for both oppression and rebellion. The creation and instalment of this awesome monolith is as epic as the statue itself. In mid-2000, the Buddha image started a 700-kilometre journey down the Irrawaddy River from Mandalay to Rangoon which took 13 days. When the statue arrived in Rangoon, thousands of people took to the streets to help haul the Buddha with ropes and rollers from the jetty to the hilltop, hoping to "make merit" – something akin to the building up of karmic credit in preparation for the next life by doing good deeds.

Save for the trappings of modern day Rangoon, a lively city where popular music blares out from radios and TV's and the streets are busy with cars and trucks, the scene playing out was a ritual which had been conducted countless times over the centuries. In the past, Burmese kings would use the building of pagodas and the installation of Buddha images as a mechanism for exerting their influence on the religion and its followers. The generals who have run the country since 1962 continue the tradition, to make merit for themselves, but more importantly as another way of exercising power over the population, of which some 90 percent are Buddhist.

For those who were unable to witness the statue being hauled through the streets, the events have been recorded for posterity in murals that adorn the walls surrounding the pagoda. The story of how the Buddha image was carved, transported and installed is depicted in these ornate paintings. One can even see scenes where the junta's top brass paid respects to the Buddha image on its arrival at the site. Closer inspection of these murals provides another insight into how the Burmese political system operates. On that first visit I was surprised that Khin Nyunt, one of the most powerful generals and a former prime minister and head of military intelligence, was missing. I was told that while Khin Nyunt's figure was included in the original mural, he had been painted out of existence after October 2004 when he fell from grace and was confined to house arrest. As with other victims of dictatorial regimes in Burma and abroad, Khin Nyunt was expunged, his role purged from memory in an Orwellian manner.

While the military has managed to control large sections of the Buddhist Sangha, Burma's monastic community, that control has never been absolute. It is a tough call to rein in an estimated 300,000 to 500,000 monks and nuns. Despite the generals appointing their own abbots and building Buddha images and temples of megalomaniacal proportions, the clerics have time and again proven to be a thorn in the side of the authorities, often spearheading protests and popular uprisings (as shown in Chapter 10).

Many Burmese Buddhists are uncomfortable with the politicized and materialistic direction their religion has taken, a direction which must seem light-years away from the simple fundamentals of the Buddha's "middle path". Nevertheless they don't seem to let this get in the way of their worship and rituals. Buddhism forms the fundamental backbone of daily life for the majority of the country's population. It is a vibrant and beautiful tradition. All over the country, people make daily offerings to wandering monks, or at pagodas and monasteries, from the smallest village stupa to the iconic Shwedagon Pagoda in Rangoon. Their donations, besides serving to accumulate merit, help fund Buddhist monasteries, institutions which continue to play a pivotal role in society today, providing a place for education, counsel, spiritual guidance and other key support services in a nation where the government fails to provide essential social and health services for a large part of an impoverished population.

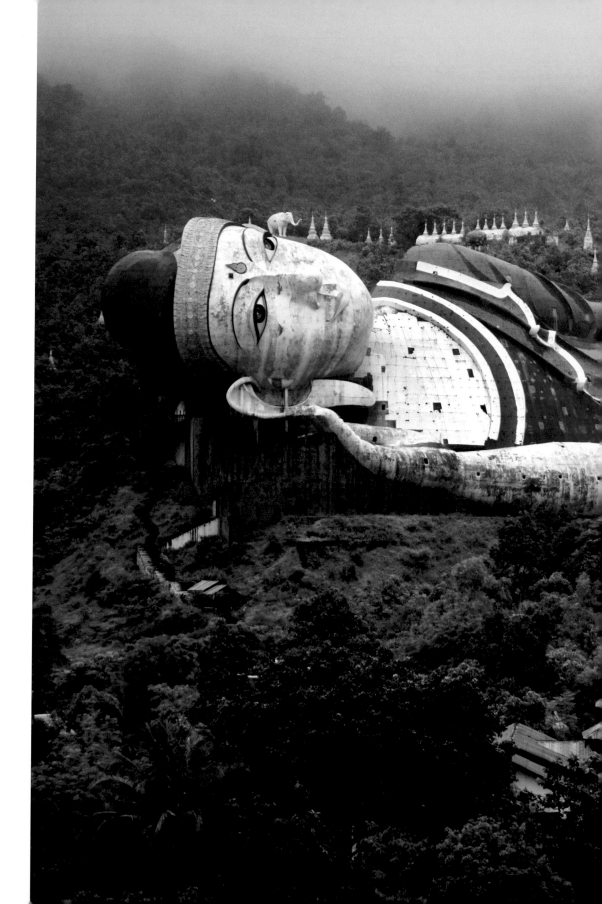

The reclining Buddha of Zinathukha Pagoda, a
200-metre long, 40-metre high concrete structure.
Mon State, 2006.

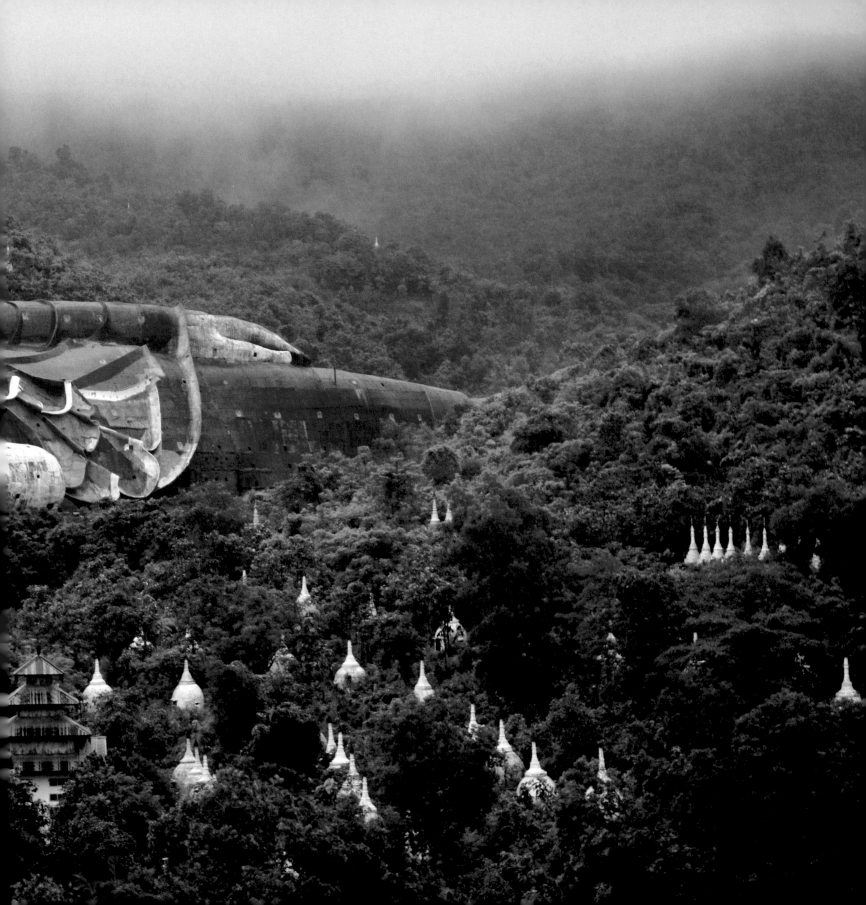

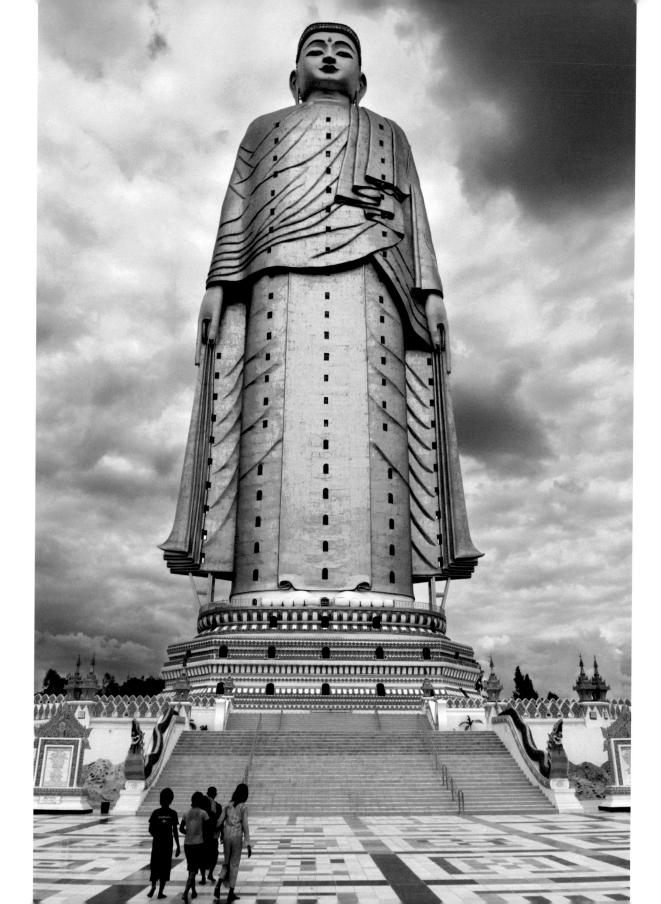

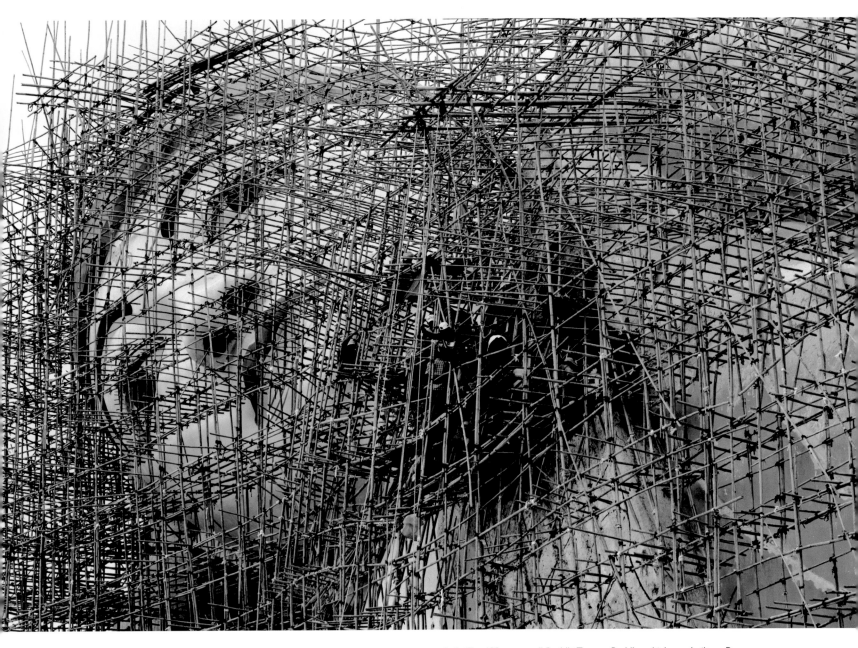

Left: The 132-metre tall Boddhi Tataung Buddha which was built on Po Kaung Hill is allegedly one of the tallest Buddha images in the world. Sagaing Division, 2009.

Above: Workers restore the 90-metre long Boddhi Tataung reclining Buddha which was built in the early 1990s on top of Po Kaung Hill. Sagaing Division, 2009.

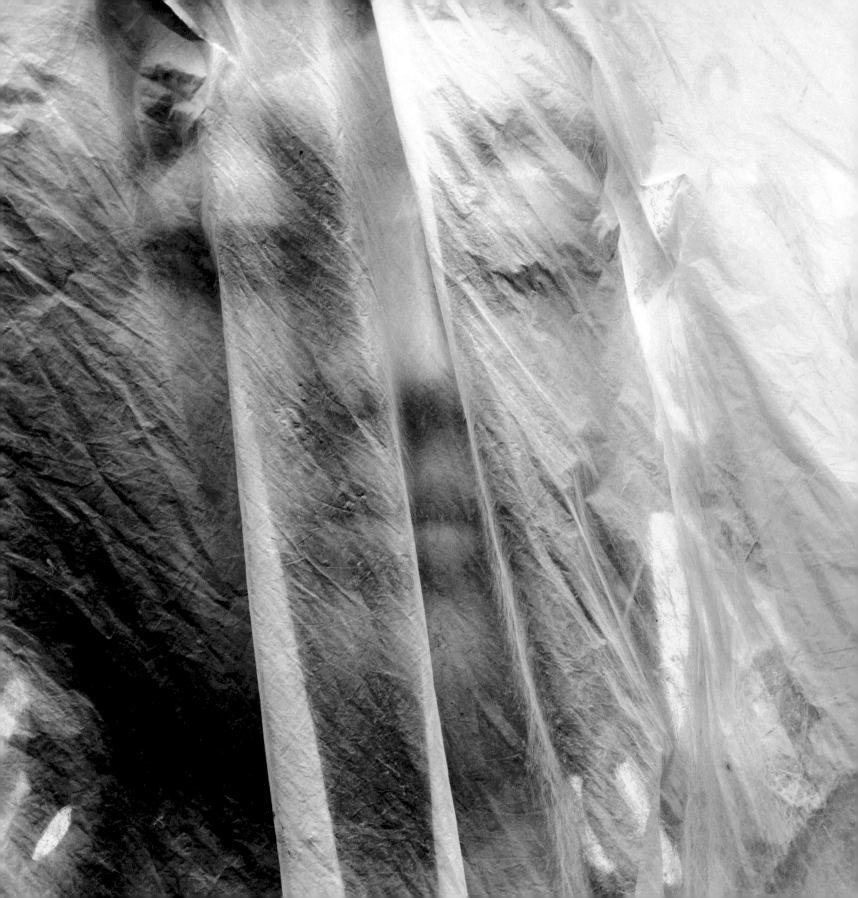

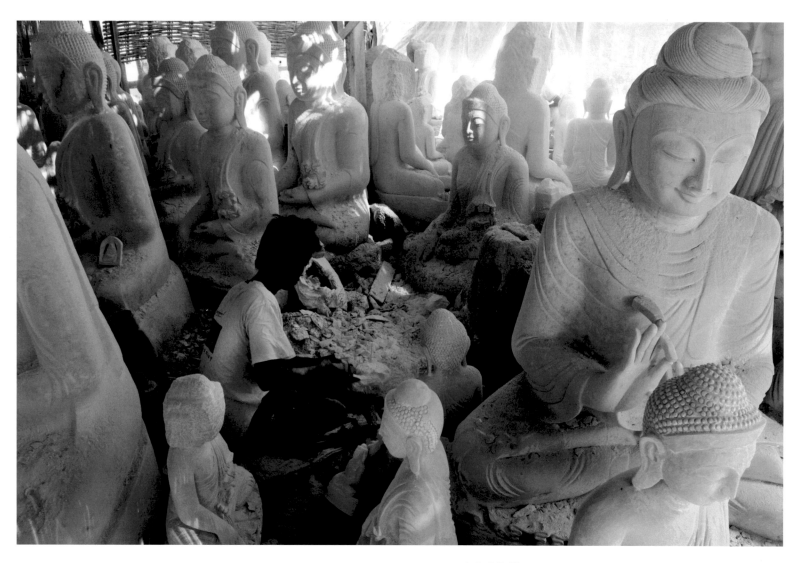

Left: A Buddha statue is wrapped in a plastic sheet in Sagyin, a village (whose name means "marble" in Burmese) located close to a white marble quarry. Buddha images and statues of Chinese deities are either carved on location or in nearby Mandalay before being exported to China. Mandalay Division, 2010.

Above: A sculptor works on a marble Buddha statue on the side of a Mandalay street. Mandalay Division, 2010.

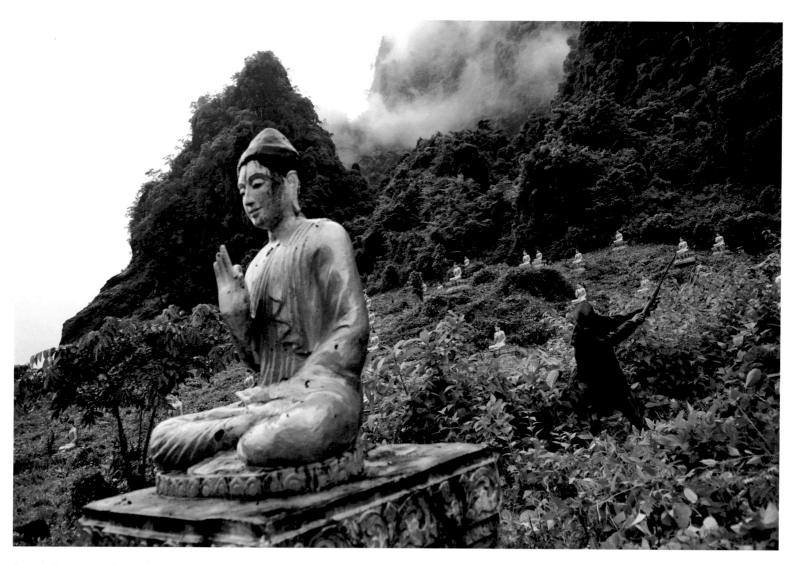

A monk clears away undergrowth in an area where 500 Buddha statues
have been erected at the foot of a hill near Thayet U Min Pagoda.
Karen State, 2006.

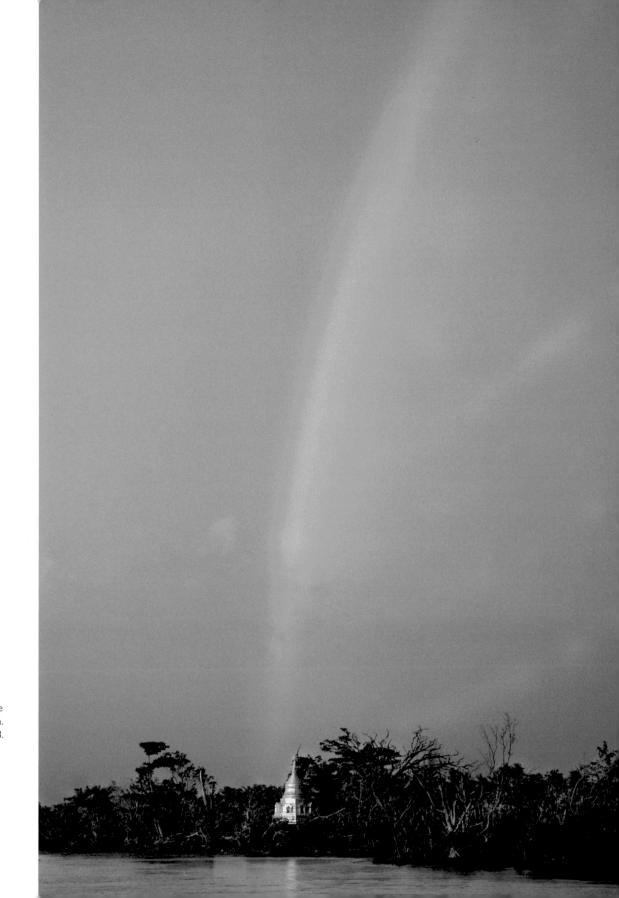

A rainbow appears to emerge
from the top of a stupa.
Irrawaddy Division, 2008.

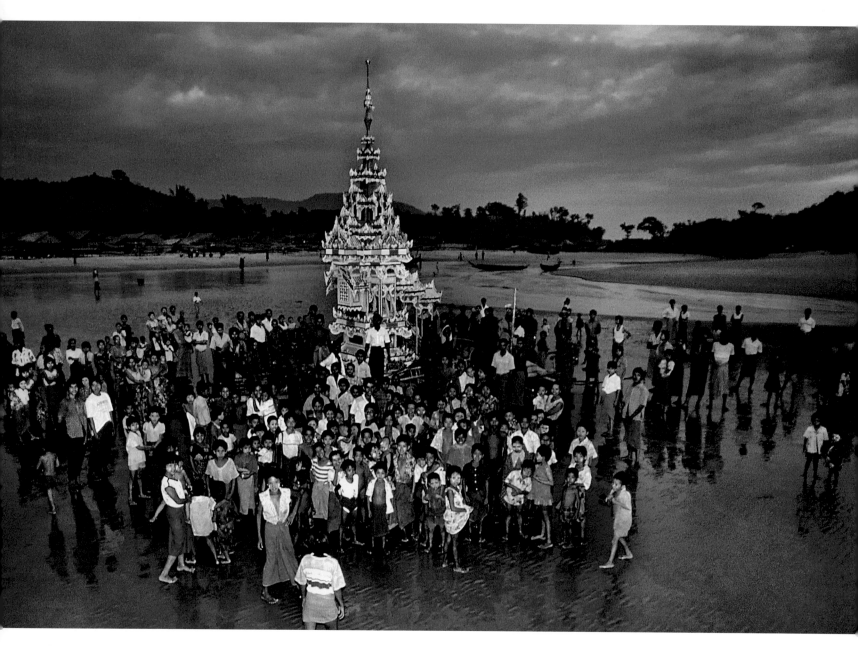

Ethnic Mon villagers participate in a Buddhist ceremony
where a miniature wooden pagoda is launched into the sea.
Mon State, 1988.

Top: A sculptor carves a bust of
the former abbot of Shwe Kyin
Monastery in Mandalay.
Mandalay Division, 2009.

Bottom: A Buddhist novice looks
through the window of a
watchtower at Boddhi Tataung site.
Sagaing Division, 2009.

Top: A wall painting at Kyauk Taw Gyi Pagoda depicts military rulers welcoming the arrival in Rangoon of a barge from Mandalay carrying a 500-tonne white marble Buddha image. Rangoon Division, 2006.

Lower left: Pilgrims converge on the Shwedagon Pagoda on Dhammacakka day, a celebration which marks the day when Buddha held his first sermon. Rangoon Division, 2006.

Lower right: A monk walks down the stairs of Kin Wun Mingyi Monastery which is built from teak wood and dubbed the "Scottish House". Mandalay Division, 2008.

Opposite page: A Buddhist novice in Homong, the headquarters of the drug lord Khun Sa. Shan State, 1994.

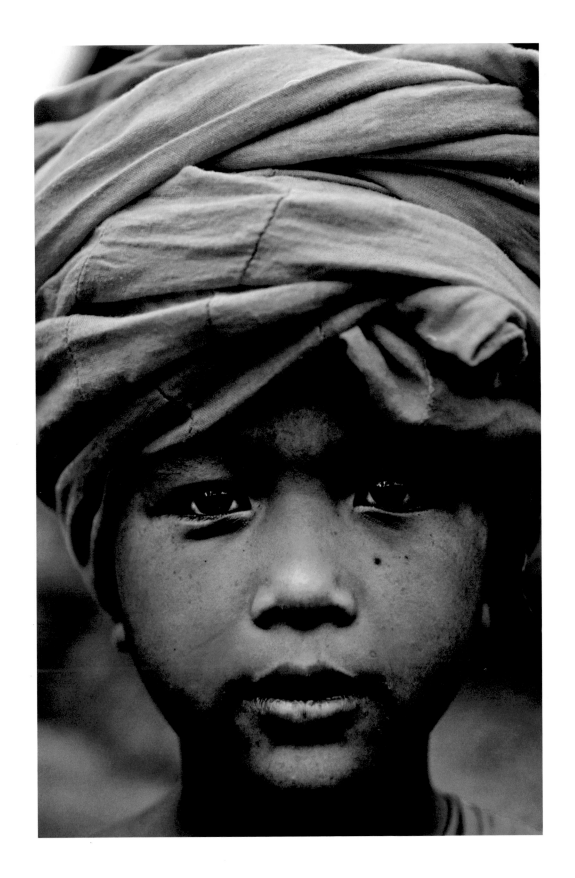

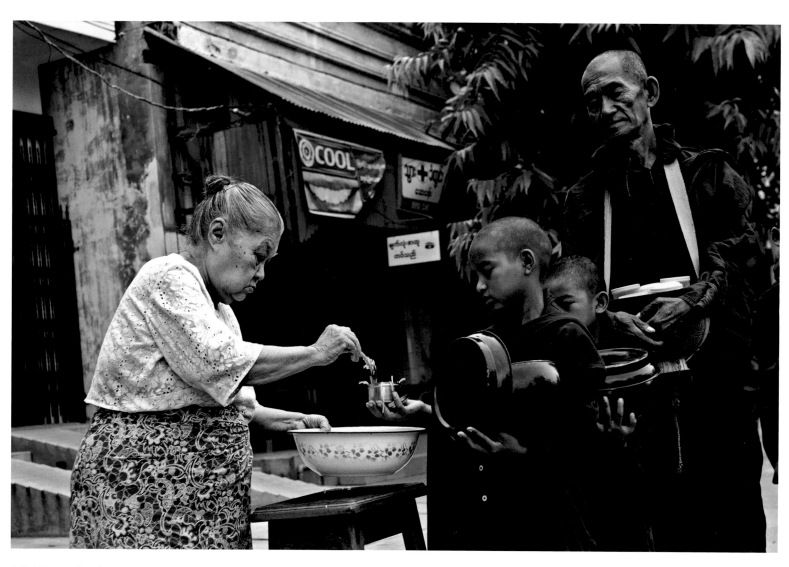

A Buddhist monk and novices receive morning alms in a Mandalay street.
Mandalay Division, 2007.

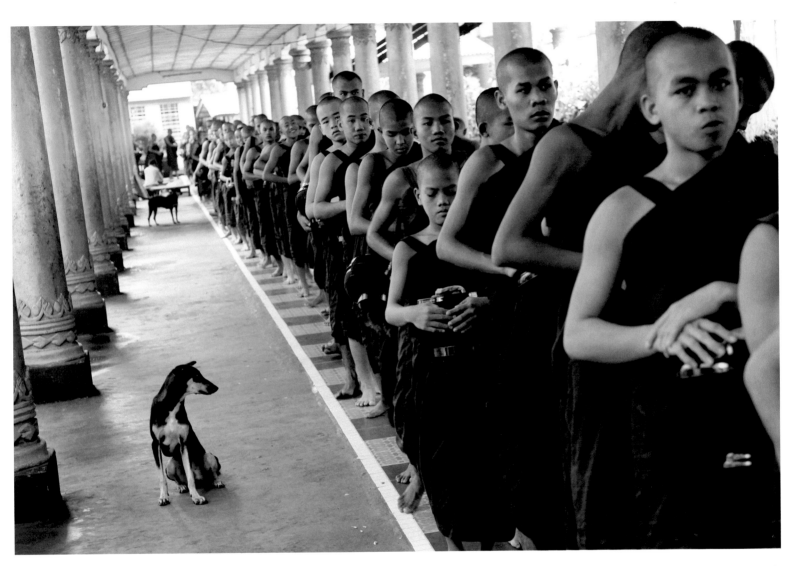

Monks queue for breakfast at Kyakhatwai Pagoda.
Pegu Division, 2008.

15

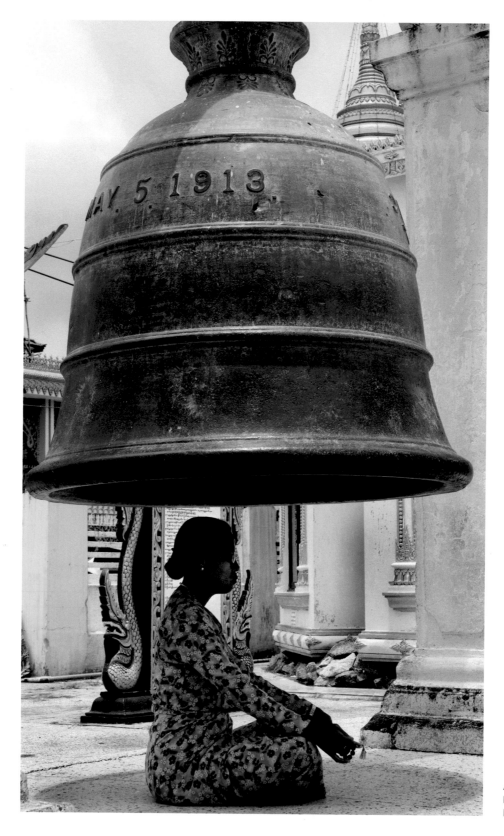

A woman meditates under a bronze bell at Botataung Pagoda. Rangoon Division, 2008.

Monks descend stairs at the Shwedagon Pagoda.
Rangoon Division, 2006.

Buddhist nuns gather for prayers at Thanbodday Pagoda.
Sagaing Division, 2009.

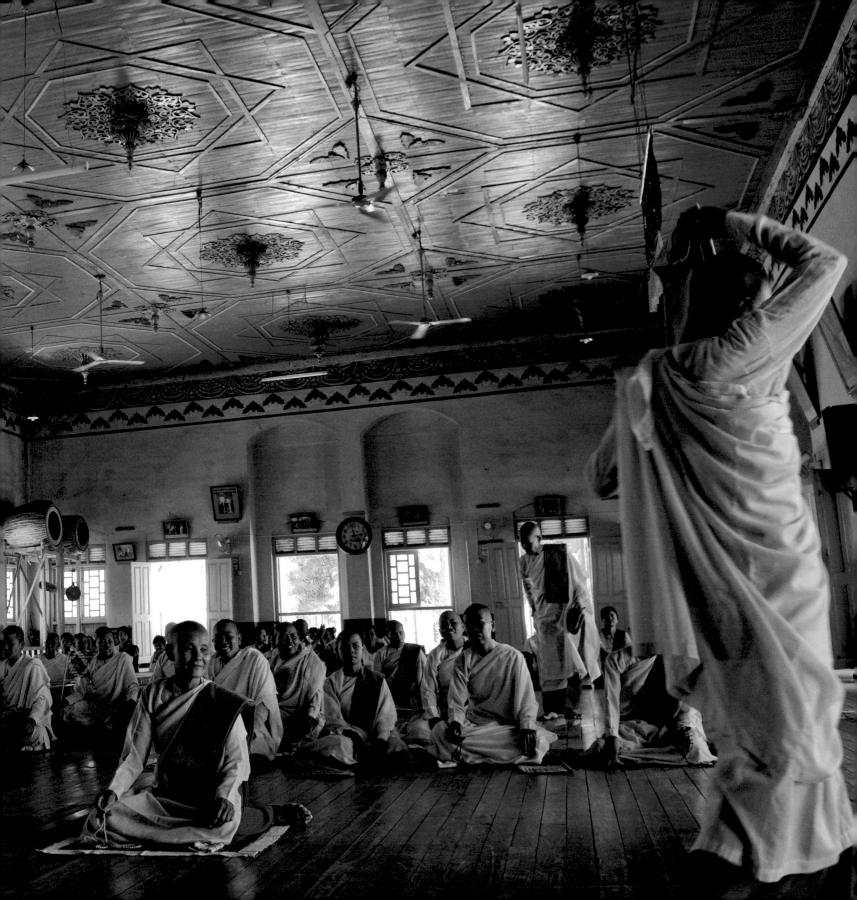

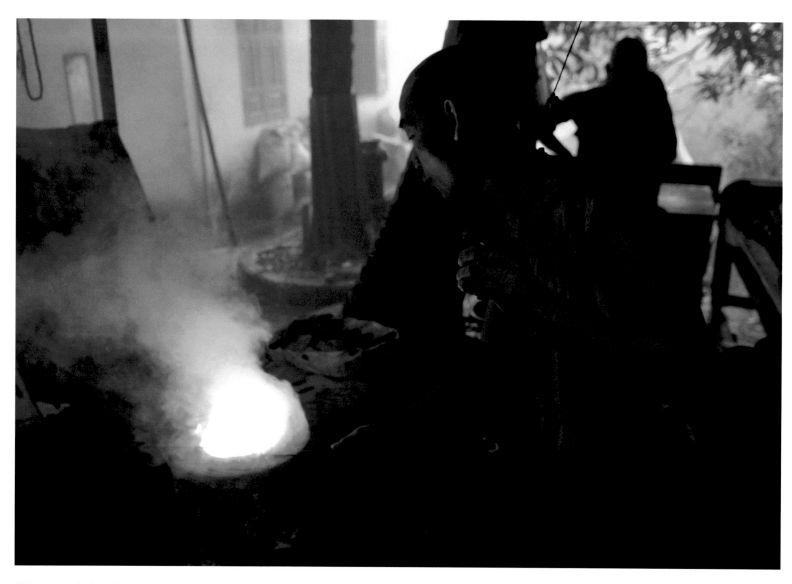

Alchemist monks from Thamanya Monastery melt zinc in an attempt to
create gold. They believe the practice will give them the power to extend
their lives so they can serve the Buddha in future incarnations.
Karen State, 2006.

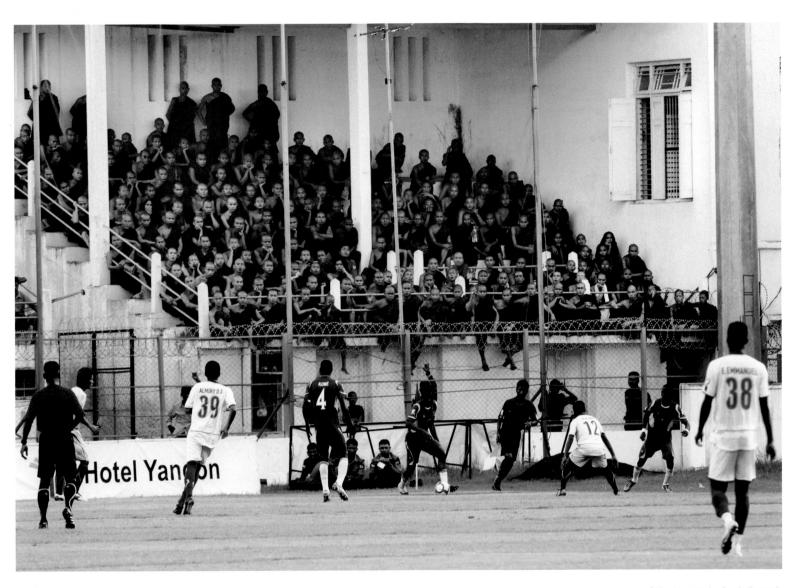

Monks attend a football match.
Mandalay Division, 2010.

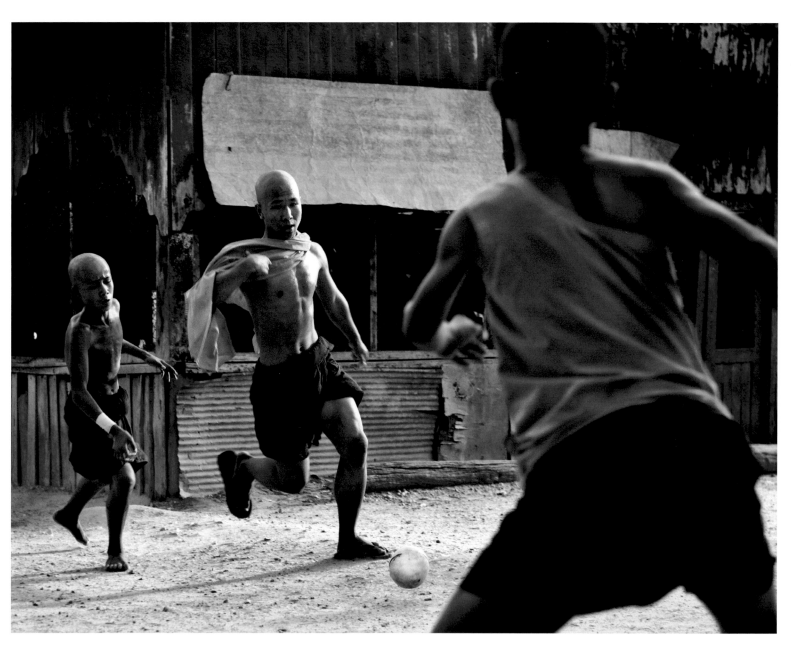

Novices play football at a Mandalay Monastery.
Mandalay Division, 2010.

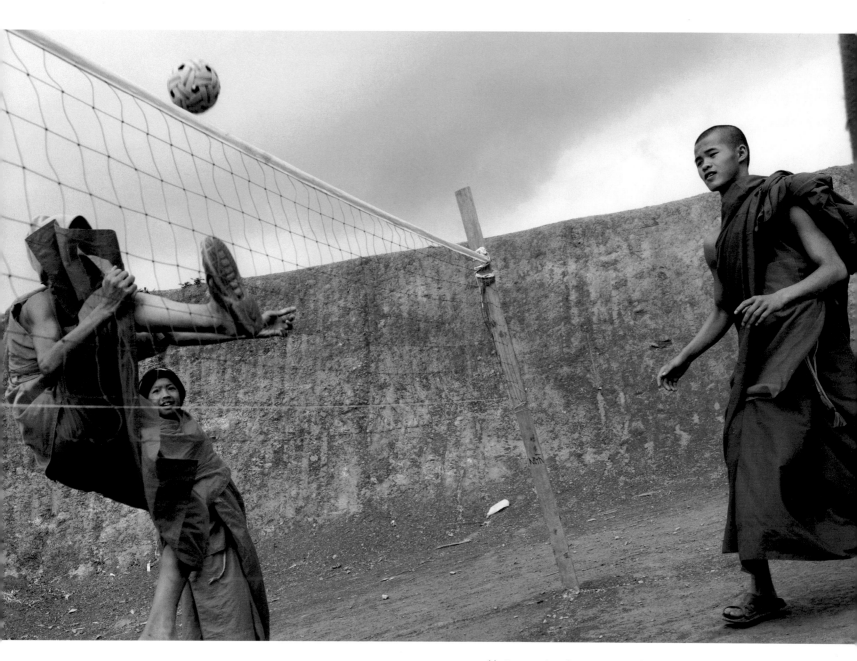

Novices practice takraw, a sport similar to volleyball which uses a hard rattan ball, where players can use their shoulders, feet and head, at Loi Tai Leng. Shan State, 2010.

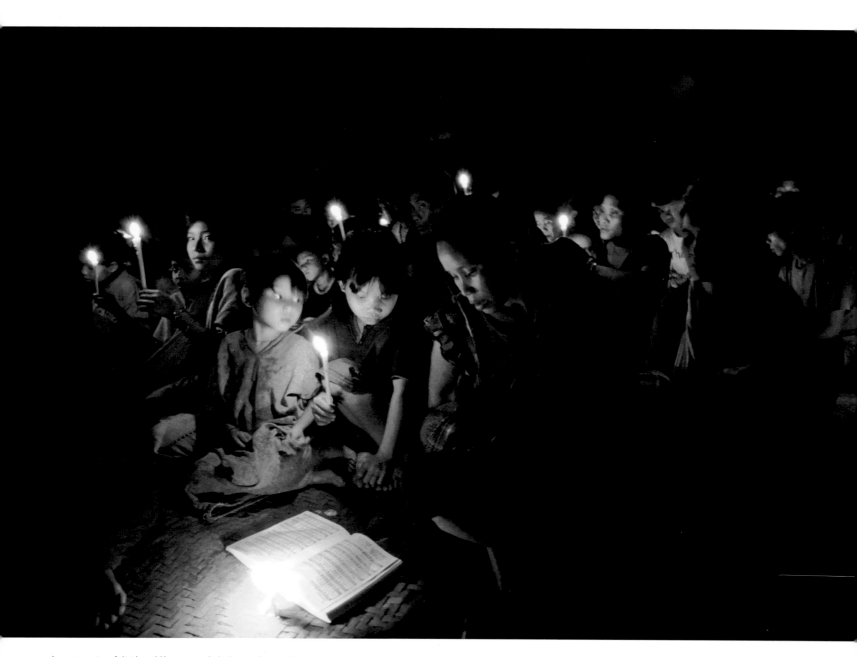

A community of displaced Karen people hiding in the jungle pray
during an improvised Christian ceremony held by candle light.
Karen State, 2000.

Chapter Two

HOW MANY WIVES?
Missionary men and rebel spirits

In 1995, I travelled with Allan Eubank, an American missionary in his sixties, into the heart of Wa territory, a large area in northern Burma which borders China. Back then the Wa, fearsome former head hunters who were considered to be one of the least developed ethnic groups in the country, had rarely ventured out into, or been exposed to the outside world.

We eventually arrived at our destination, a remote village surrounded by poppy fields. One night, we joined the village elders as they gathered in the house of the headman Kyaw Thee to listen to Eubank preach. In a dark smokey room, illuminated only by the light from candles and a wood fire in the centre, the American missionary unrolled large colour posters with somewhat crude renditions of heaven, hell and other Christian imagery and parables. Eubank implored Kyaw Thee and his fellow villagers to recant their animist beliefs which the preacher said were dominated by fear and superstition and convert to Christianity, which he claimed was more compassionate.

Kyaw Thee's initial response portrayed a pragmatic view of life as well the headman's earthy sense of humour. "But I have heard that your religion only allows a man to have one wife," he said. "The problem is that I have 12 wives, so what can we do about this?"

Before leaving the village, Eubank, who was clearly pragmatic himself, had reached a temporary accommodation with the monogamous Christian rule. It would, for the time being, be acceptable for the Wa to keep their wives if they turned towards the Christian God. The American preacher's friends sent Kyaw Thee a US$10,000 donation, which reportedly vanished on the way. The old Wa leader died a few years later without ever converting.

Despite being a colourful account, this interaction helped me develop a better understanding of the complexities surrounding religion in Burma.

In the early 19th century Christian missionaries from the US and Europe travelled with their families to remote communities in the mountains and jungles of Burma to "save the souls" of the local ethnic groups, such as the Chin, Kachin, Karen and Lahu. Conversion was the name of the game. In order to bring so-called "civilized Christian values" to these places the missionaries built churches, schools and translated the Bible into native dialects.

Some groups, such as the Wa, steadfastly resisted conversion, opting to retain their existing belief systems. Furthermore the Wa's traditional method for resolving power struggles, by decapitating and keeping the head of a given adversary, did not sit well with Christian ethics.

Over the years, however, and particularly after independence from the British in 1948, some of these Christianized minority groups drew on their faith to differentiate themselves from the Burman Buddhist majority and to resist control from Rangoon.

As with many religions around the world, Buddhism in Burma sits on top of older belief systems and ritual traditions. It has also given birth to its own esoteric schools. In the remote mountains of eastern Burma, entire communities still follow bizarre cults such as the White Elephant or the Talakon, which are Christian- and Buddhist-inspired movements, respectively.

In Burma, regardless of one's faith, the *nats* are never very far away. This animist pantheon of 37 major spirits and many more lesser nats, which range from the merely troublesome to the downright evil, is interwoven into the fabric of Burmese society, a dynamic which cuts across classes and regions, from modern cities to hill-tribe villages. Having never managed to eradicate this deeply rooted belief in spirits, Buddhism has instead syncretised these older practices within its own canon.

One of the most staggering displays of interaction with the spirit world is the Taungbyone festival. For a week every year, during the August full moon, hundreds of thousands of people from around the country descend on a dusty village to the north of Mandalay transforming it into an epicentre of spirits (of both ghostly and liquid form) and superstitions. Striking transvestite priests dressed in silk and satin enter trances, offerings are made and huge quantities of alcohol consumed, despite an official ban. Along with other key festivals, such as the Thingyan water festival which marks the Buddhist new

year in April, Taungbyone gives people a rare opportunity to temporarily release themselves from the social, economic and political constraints of everyday life. There's a carnivalesque atmosphere to the events which is not without its subversive elements, something which the authorities have become increasingly aware of, leading them to crackdown on and ban certain activities such as gambling, magic shows and bare-knuckle bouts of Burmese boxing.

Perhaps the weirdest ritual that the authorities still allow takes place in a specially designed square, where people insult each other using the most vile and outrageous profanities imaginable.

I first attended Taungbyone in 1993. When I returned some 16 years later the crowd was still large but the atmosphere and craziness I had witnessed during my initial visit had dissipated. It was as if the authorities had even managed to bring the troublesome spirits into line.

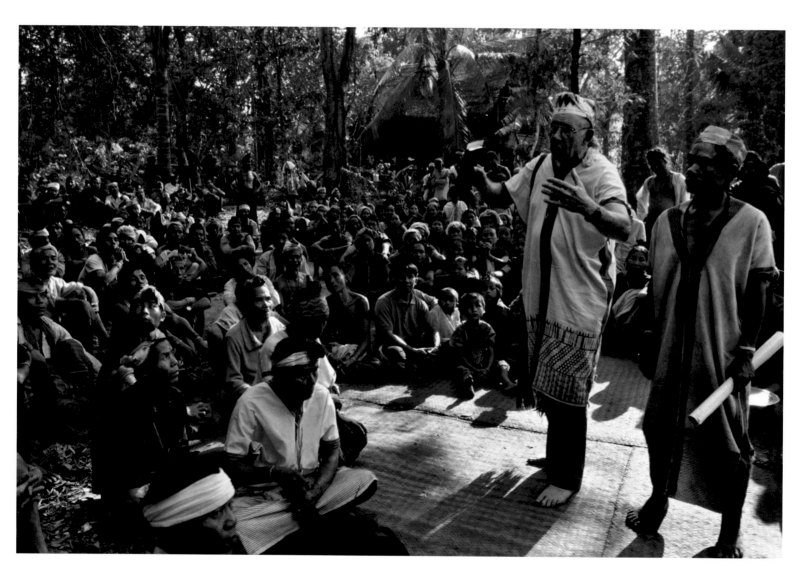

Allan Eubank, an American Christian missionary dressed in a traditional outfit, gives a sermon on the concept of sin to a gathering of Talakon followers, an animist sect whose members straddle the Thai-Burmese border.
Letangku, Thailand, 2000.

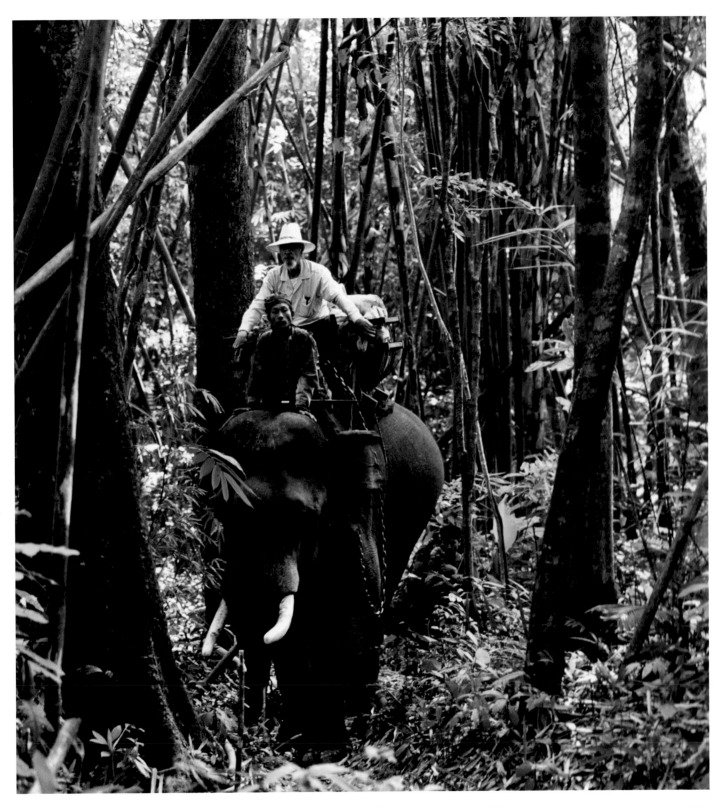

Ben Dickerson, an American Baptist Christian missionary, rides an elephant on his way back to the animist Talakon community, a trip he first made in the 1960s.
Letangku, Thailand, 2000.

Talakon worshippers gather around a tree filled with fruits and
other offerings during a ceremony dedicated to the spirits.
Letangku, Thailand, 2002.

28

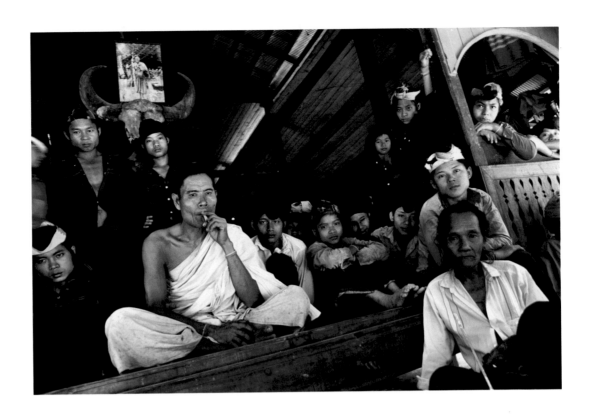

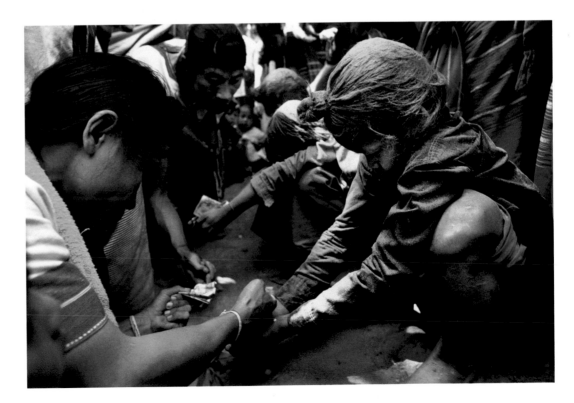

Top: The Pujai, spiritual leader of the Talakon sect whose belief and rituals are based on a syncretism of animism and Buddhism, sits with young acolytes. Letangku, Thailand, 2000.

Bottom: Talakon followers spread tamarind powder on a group of young boys and make offerings to them during a ceremony which marks the day they become Pujai's acolytes. Letangku, Thailand, 2000.

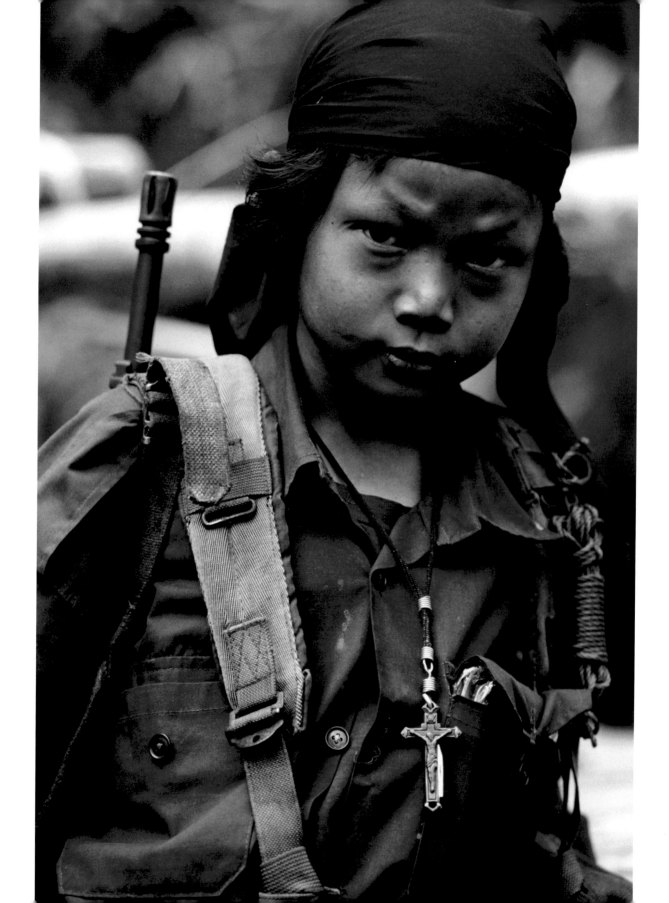

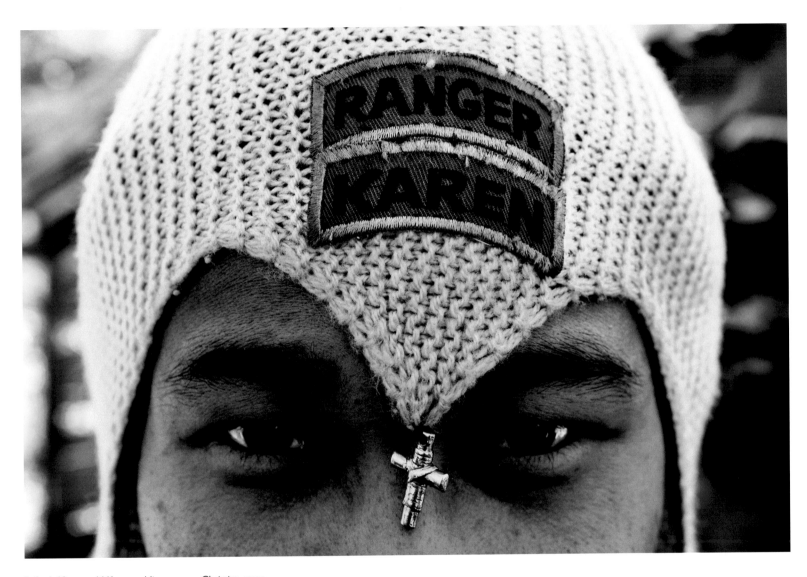

Left: A 12-year-old Karen soldier wears a Christian cross.
Karen State, 1998.

Above: A Christian cross dangles from the hat of a member of a Karen relief group.
Karen State, 2008.

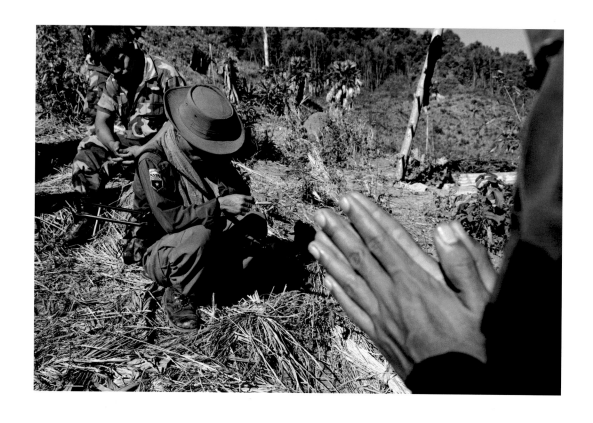

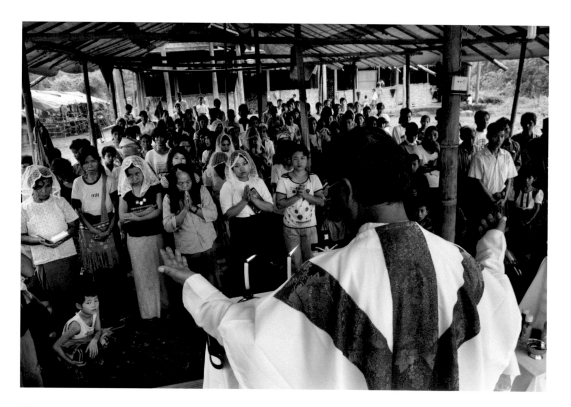

Top: Christian Karen guerillas pray before going on a reconnaissance mission.
Karen State, 2008.

Bottom: Father Nbwi Nawdin, a Kachin Catholic priest, gives a mass in a makeshift refugee camp.
Kachin State, 2011.

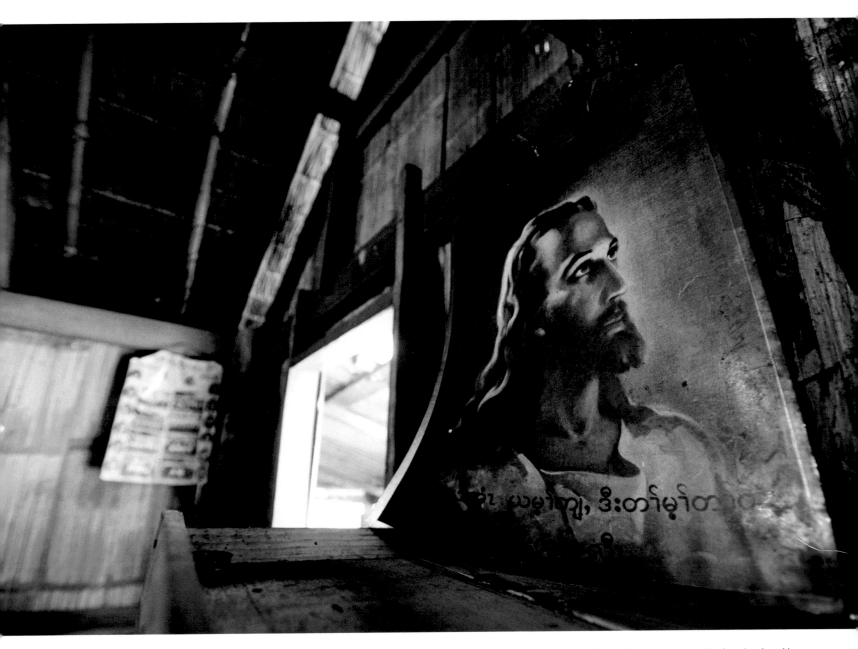

An image of Jesus Christ hangs on a wall of an abandoned house
in a village that was partially destroyed by the Burmese army.
Karen State, 2006.

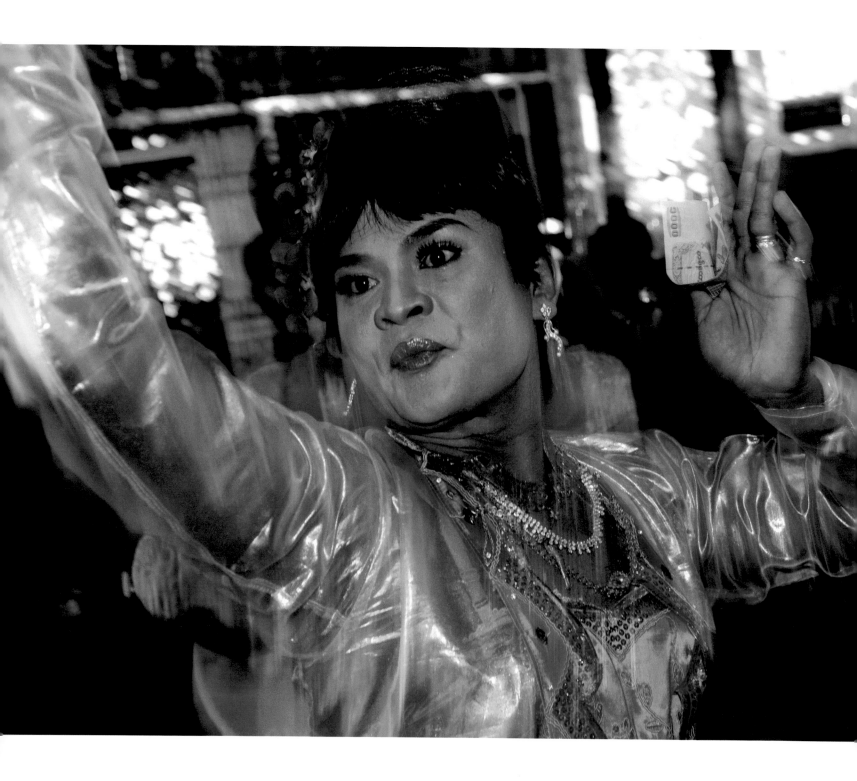

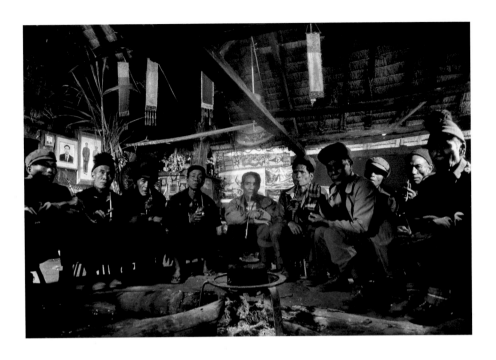

Left: Kyauw Thu Ya, a medium, dances in a shrine dedicated to the nats (spirits) during the Taungbyone festival. Mandalay Division, 2009.

Top: Wa elders gather at the headman's house. Shan State, 1995.

Bottom: A priest with the White Elephant sect, a religious group largely inspired by Christian rituals, holds mass in a camp for displaced people. Karen State, 2008.

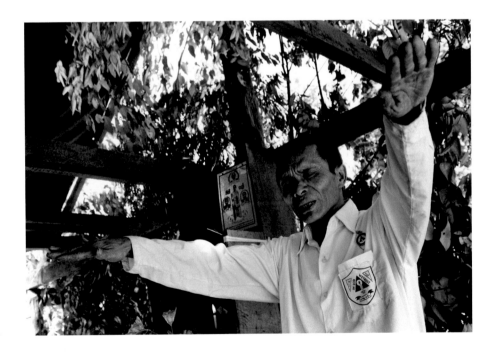

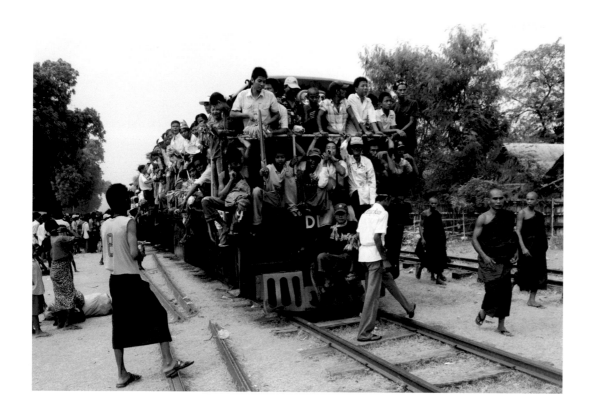

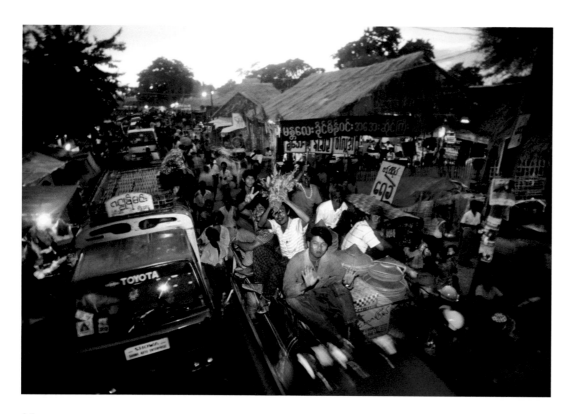

Top: People on a train from Mandalay arrive at the Taungbyone festival. Mandalay Division, 2009.

Bottom: Traffic builds up as crowds descend on the Taungbyone festival. Mandalay Division, 1993.

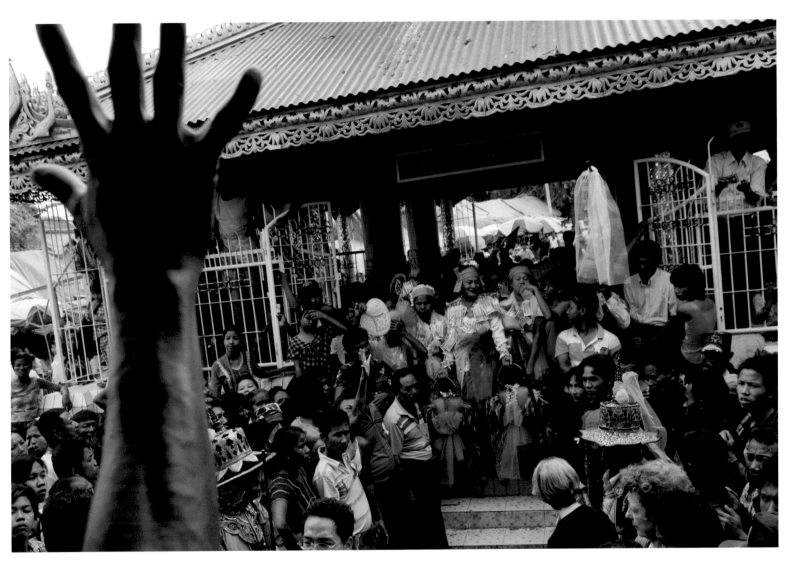

Priests wait for the arrival of a cortège of revellers who are carrying the effigy of an imaginary rabbit they hunted in their village to present as an offering to the Taungbyone Brothers, the most revered local nats.
Mandalay Division, 2009.

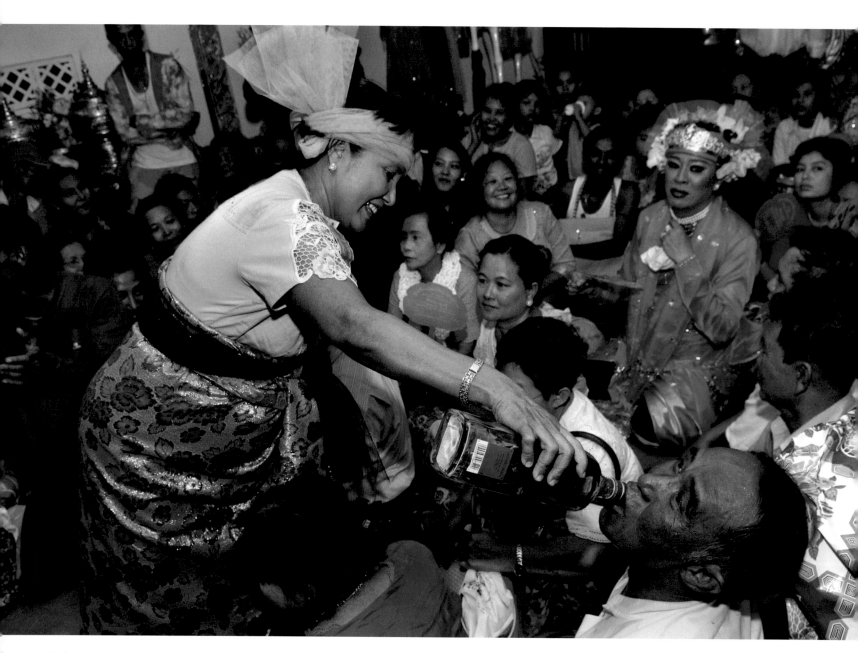

Mediums dance and, despite a ban on alcohol, offer drink to revellers at the Taungbyone festival.
Mandalay Division, 2009.

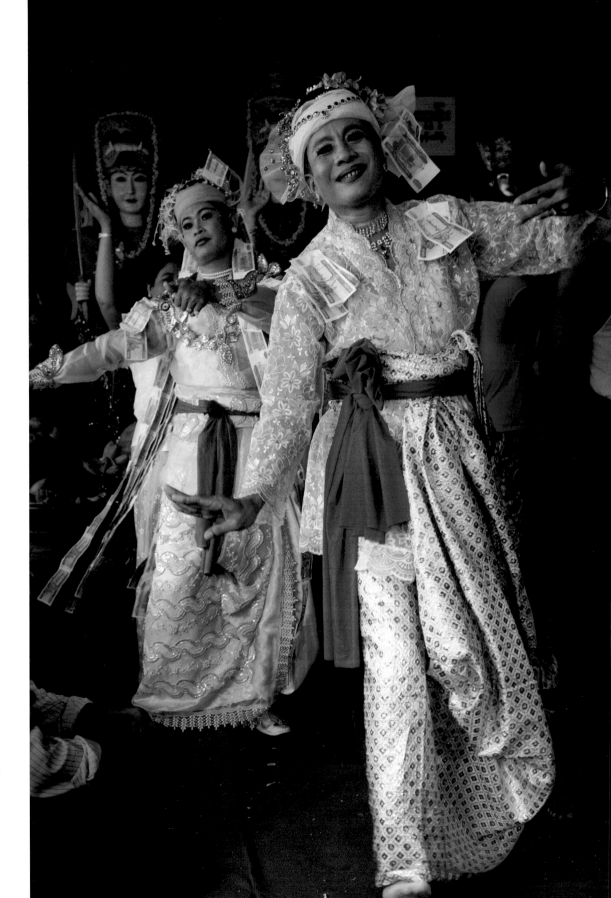

Nats are supposedly placated
by the dance conducted by
mediums at the festival.
Mandalay Division 2009.

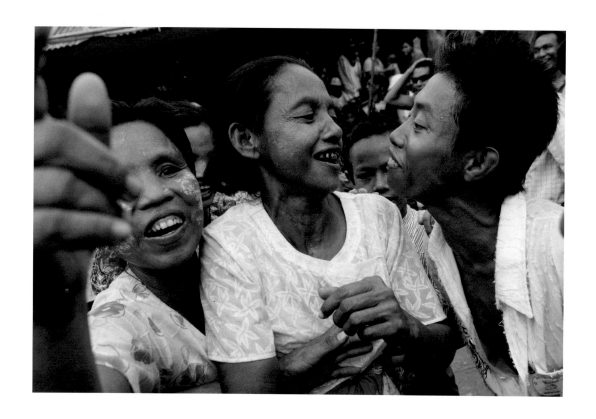

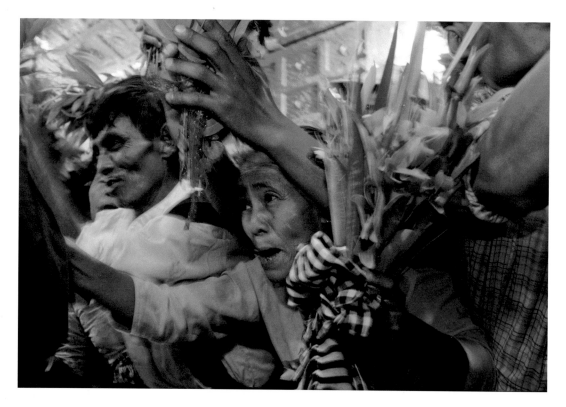

Top: Revellers dance and trade insults to scare the imaginary rabbit which will be offered to the Taungbyone Brothers, Min Gyi and Min Galay, two of the country's most famous spirits.
Mandalay Division, 2009.

Bottom: People at the festival squeeze in front of statues of Min Gyi and Min Galay.
Mandalay Division, 2009.

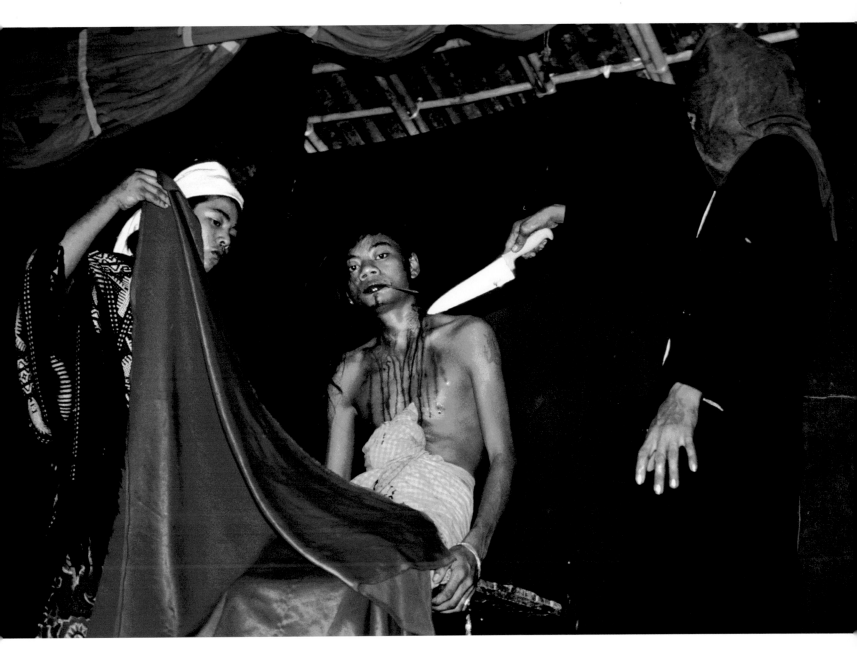

A magician performs a fake bloodletting as part of his show at the Taungbyone festival.
Mandalay Division, 1993.

41

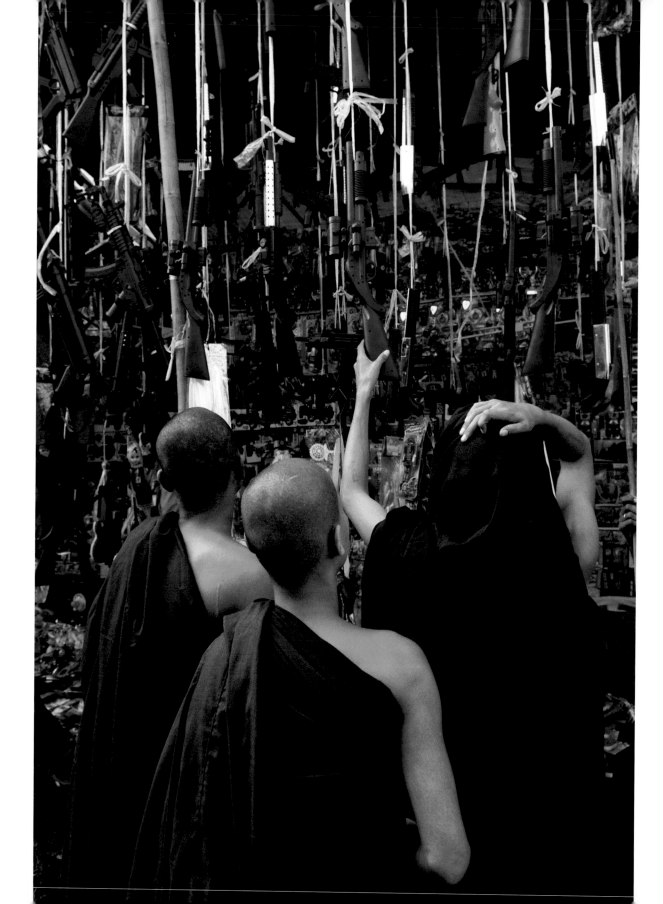

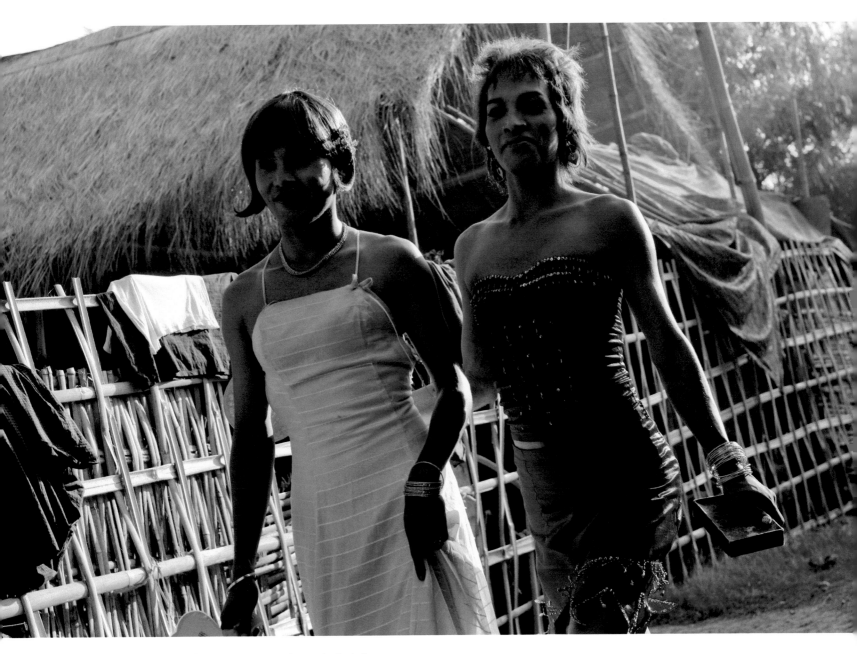

Left: Young Buddhist monks browse toy guns in a shop at the festival.
Mandalay Division, 2009.

Above: Transvestites walk along an alley at the festival.
Mandalay Division, 2009.

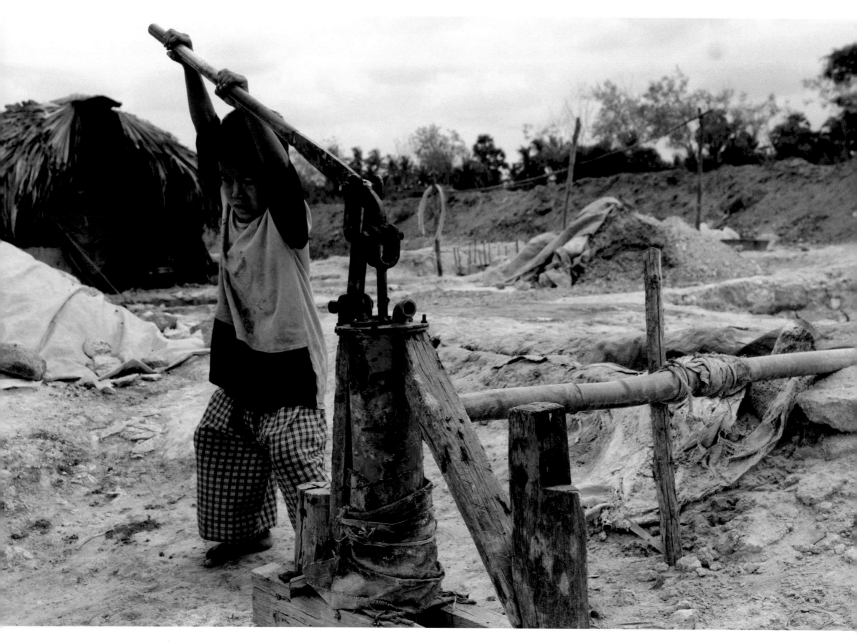

A boy pumps water on waste ground near the Monywa Copper Project, one of the largest copper mines in Southeast Asia. Settlers scratch out a living by collecting mineral deposits discharged from the mine. Sagaing Division, 2009.

Chapter Three

THE COPPER CHILD
Hard lives and daily struggles

One scorching day in 2009, I was riding pillion as my guide navigated his motorcycle along a dusty road which meandered across a landscape of cracked, dried mud that formed part of the Central Plains. In the distance, we could see giant tractors loaded with tonnes of earth extracted from the nearby Monywa Copper Project, a joint venture between a state-owned enterprise and a Canadian company, which is one of the largest copper mines in Southeast Asia.

A little further along the road we stopped to watch a young boy who was enduring significant pain from his efforts to draw a mere trickle of water from an antique hand-pump that was taller than himself. He was from one of the hundreds of families who had settled locally, on land polluted with heavy metals, acid and other toxins from the mining operations, to scratch out a living sifting through the waste.

All over the country people living in desperate poverty toil away in fields, ports, factories and markets often in slave-like conditions. Such conditions are not the exclusive preserve of Burma; they are a shared reality for people who live in undeveloped or developing countries around the world. But this serves as little consolation for those enduring such hardships. For me, this small boy, a copper child, is a quintessential symbol of how decades of extreme incompetence, economic mismanagement and barefaced corruption under military rule have ravaged the country. As recently as 1962, when General Ne Win seized power in a coup d'état – which at the time received reasonable support from the public – Burma prided itself as having one of the best educated and wealthiest populations in Asia. It was the world's leading rice exporter and boasted a wealth of natural resources, including timber, minerals, natural gas, gems and precious metals. Rather than using this natural wealth to develop the country, however, the junta set about syphoning off resources to fill their own pockets. Within less than a decade productivity, wealth and opportunity had been decimated. Burma was relegated to a subsistence economy where by 2011 international bodies, such as the Asian Development Bank, estimated that at least a quarter to one third of the population of 55 million was living in poverty. Health, education and crucial infrastructure is lacking while resources are being looted by Chinese and other foreign companies for the sole benefit of a handful of generals.

While much of the population is impoverished, it would be wrong to believe that there is no development in Burma. Contrary to common perceptions, urban life has in many ways modernized in recent years. The middle class has grown, while the trappings of consumer society – department stores, mobile phones, cars, trendy coffee shops – have proliferated.

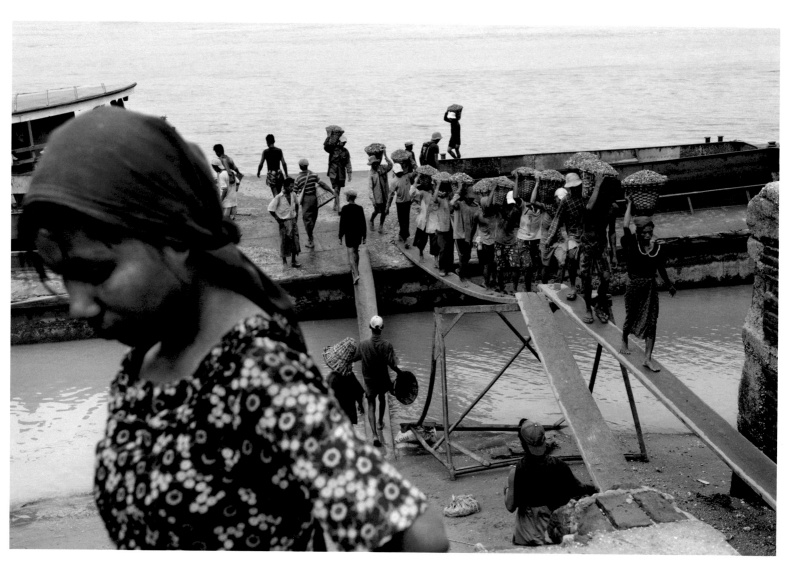

Workers unload gravel from a boat on the banks of the Rangoon River.
Rangoon Division, 2010.

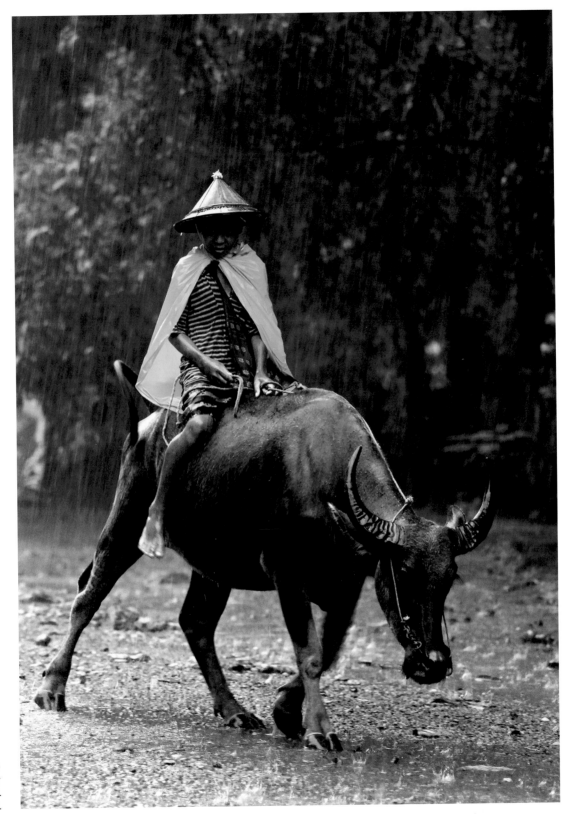

A boy rides a buffalo
during heavy
monsoon rain.
Mon State, 2006.

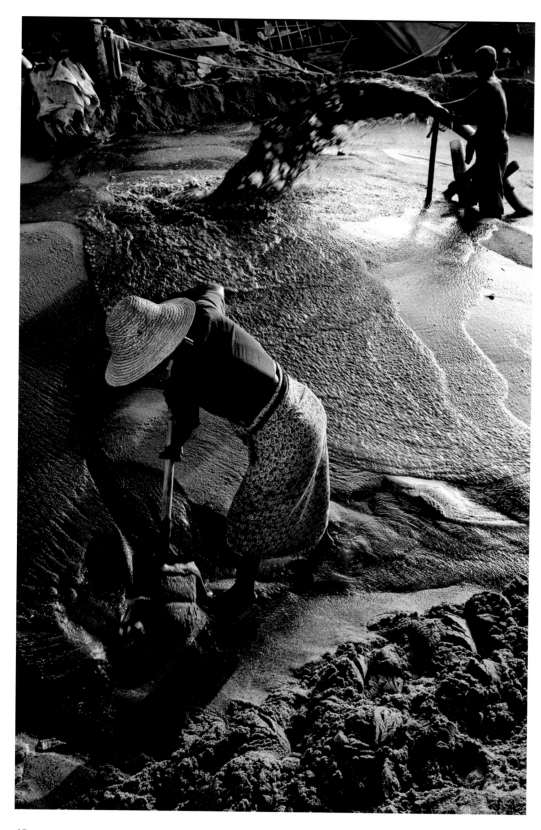

Workers pump sand from the Irrawaddy River.
Mandalay Division, 2007.

A rice field during the monsoon.
Karen State, 2006.

49

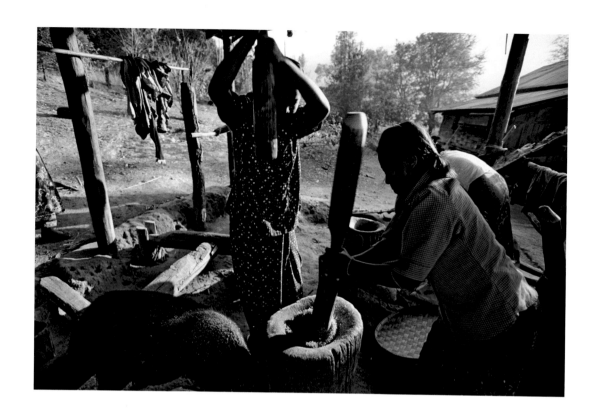

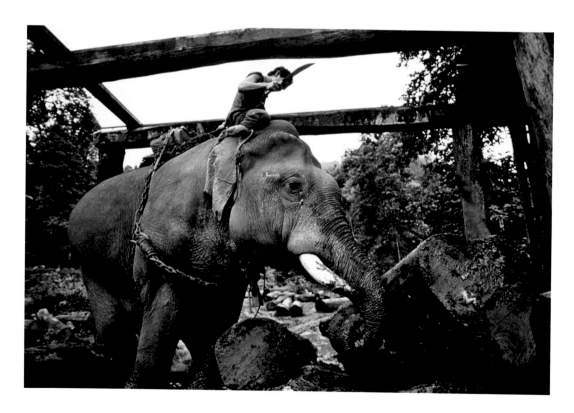

Top: Women pound rice in a Shan village.
Shan State, 2003.

Bottom: An elephant shifts logs in a sawmill.
Karen State, 1988.

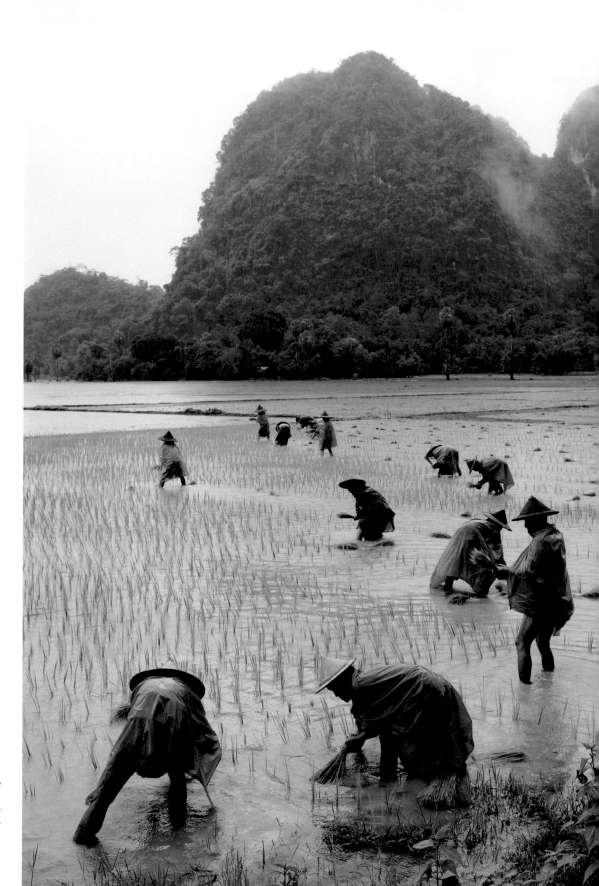

Planting rice is backbreaking work, especially during the monsoon rains. Karen State, 2006.

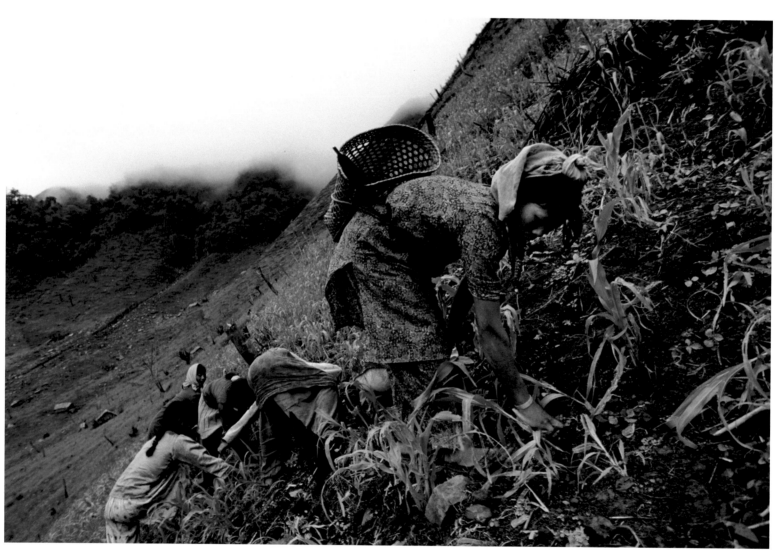

Naga women work on a hillside.
Sagaing Division, 1998.

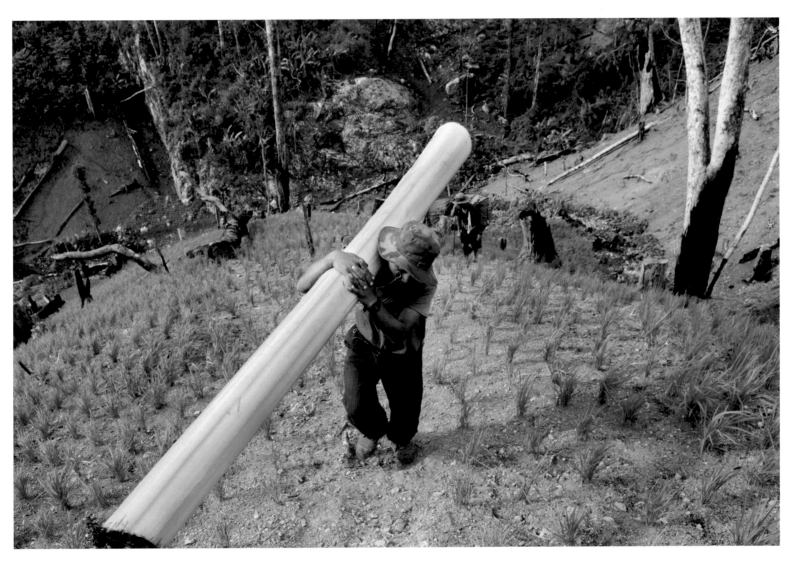

A man carries the trunk of a banana plant up a hill.
Shan State, 2010.

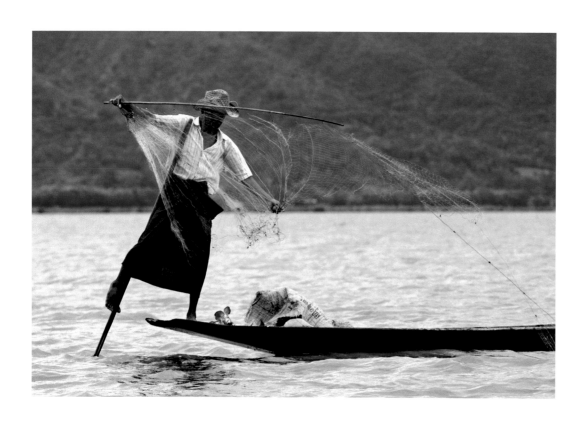

Top: A man fishes on Inle Lake.
Shan State, 2011.

Bottom: A local energy-saving way
of piloting a boat.
Irrawaddy Division, 2008.

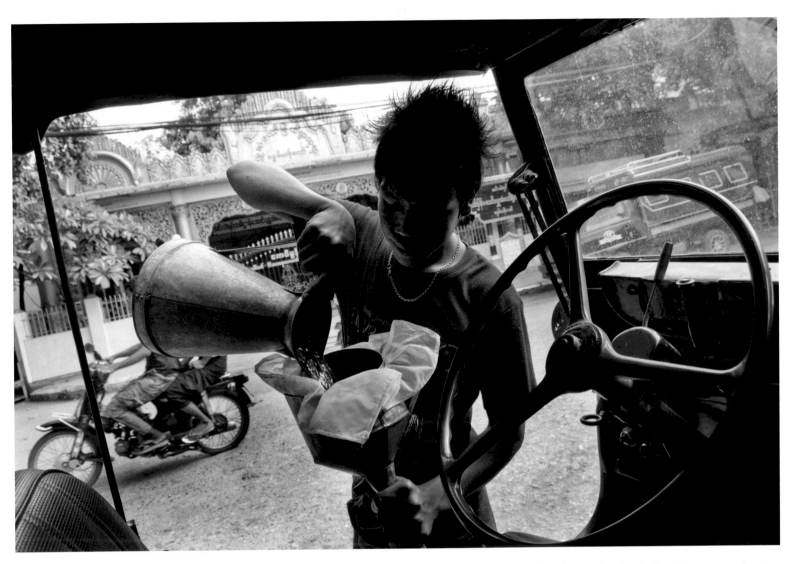

Black market petrol stations in Mandalay are very rudimentary.
Mandalay Division 2010.

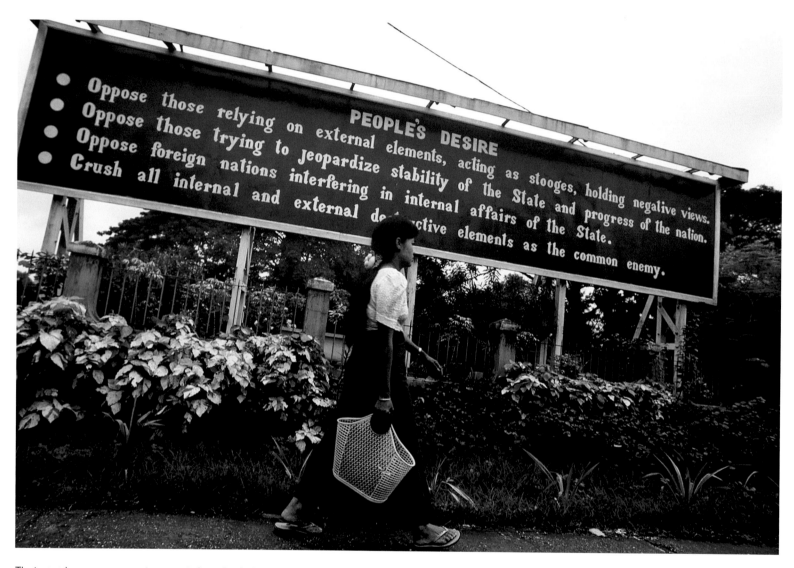

The junta takes every opportunity to remind people of what constitutes proper desire.
Rangoon Division, 1993.

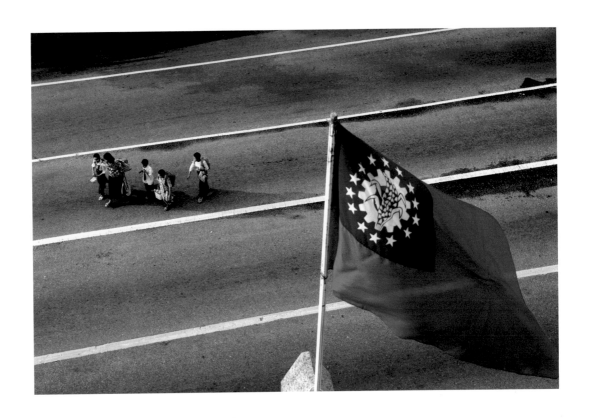

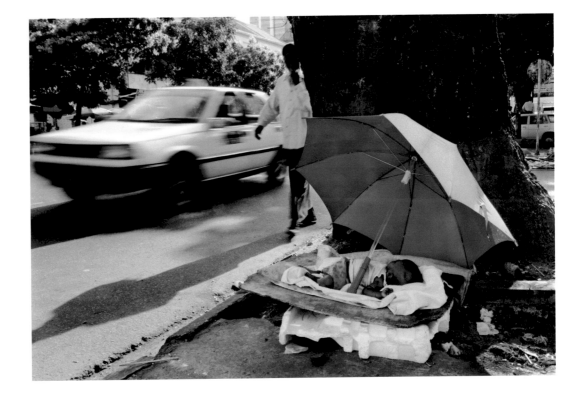

Top: People walk under the former flag
of the Union of Myanmar.
Rangoon Division, 2008.

Bottom: A baby sleeps amid the chaos
of traffic in downtown Rangoon.
Rangoon Division, 2010.

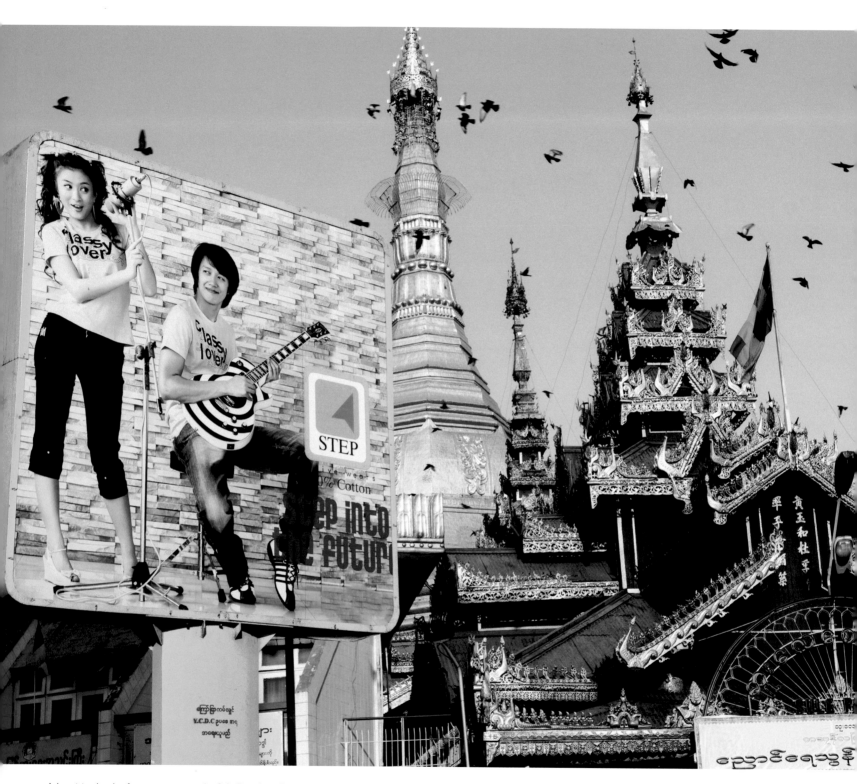

Advertising battles for space next to the Sule Pagoda in Rangoon.
Rangoon Division, 2010.

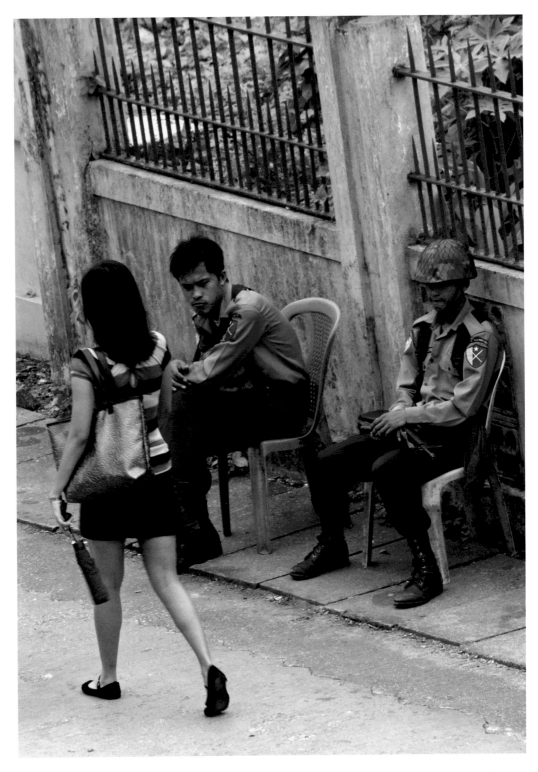

Policemen eye a young woman as she walks along a road in downtown Rangoon.
Rangoon Division, 2007.

Burma is much more than pagodas and Buddha images. Contemporary
youth culture is flourishing in Rangoon and other urban areas.
Rangoon Division 2010.

Rangoon may be slowly modernising but its
electricity grid remains very haphazard.
Rangoon Division, 2006.

Zaw Win Htut, the "Emperor", one of the most popular rock stars in Burma, performs at a Rangoon hotel.
Rangoon Division, 2006.

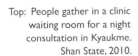

Top: People gather in a clinic waiting room for a night consultation in Kyaukme. Shan State, 2010.

Bottom: A wall painting showing scenes from Burma's royal past adorns a wall at Yangon International Airport. Rangoon Division, 2010.

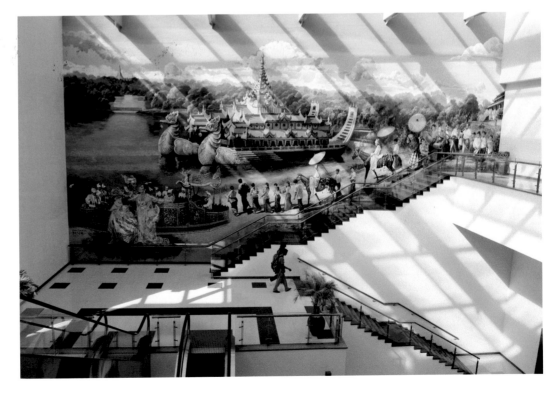

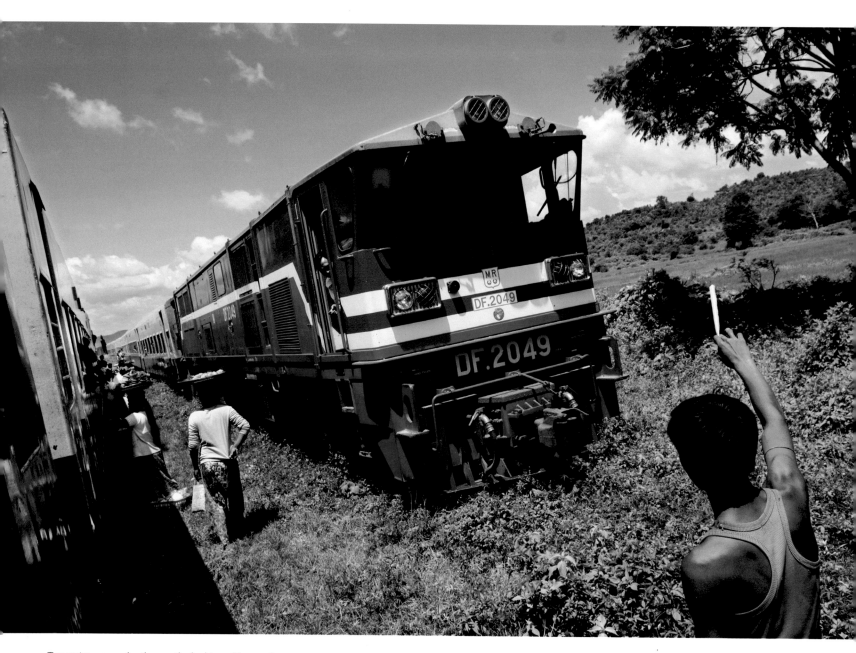

Two trains pass each other on the Lashio to Maymyo line.
Shan State, 2010.

A group of young men share their improvised football
pitch in a Mandalay suburb with a herd of cows.
Mandalay Division, 2010.

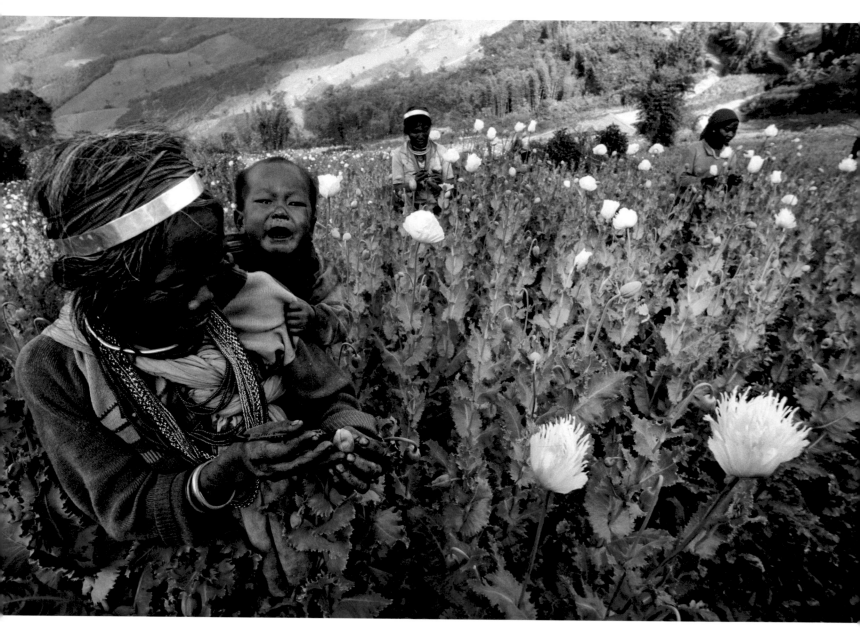

Wa women score the pods of opium poppies with a knife
to start the "milking" process. Once dried, the latex will
be collected and refined into opium and heroin.
Shan State, 1995.

66

Chapter Four

POPPIES AND PILLS
Drugs, guns and the Golden Triangle

Receiving an invitation from one of the world's leading heroin producers to venture into their territory and observe life on the ground is far from an everyday event. But in 1993 this rare opportunity was extended to two journalist friends and me by the United Wa State Army (UWSA).

At that time the UWSA lorded over the "Golden Triangle", a key opium growing and drugs producing region located where Thailand, Burma and Laos meet along the banks of the Mekong River. They were also facing sharp and deadly competition from Chang Chi-Fu or "Khun Sa", a self-proclaimed Shan-Chinese nationalist and leader of the Mong Tai Army, who had carved out his own empire along the Thai border. Both organizations had well-trained and well-equipped armies – Khun Sa had even acquired SAM-7 anti-aircraft missiles – comprising tens of thousands of professional soldiers who had been recruited from local ethnic groups.

A split in the UWSA leadership had led to our invitation. A pragmatic faction wanted to show the outside world that it was serious about abandoning the narcotics trade but it also wanted to send a message that assistance was required for it to diversify into alternative activities. Meanwhile a business faction wanted to continue with the hugely lucrative trade which was run with the complicity of senior officers within the Burmese junta.

We trekked some 600 kilometres on foot and by mule through the jungles and mountains of Northern Shan State, travelling all the way from the Thai to the Chinese border and back again. Our Wa hosts had promised total transparency. "We will show you everything you want to see," they said.

One day, after a tour of a vast poppy field and a local opium market, we asked to visit one of their heroin refineries. We knew from reports we had read before our departure that there was a major facility in the village we had just stopped in. The leaders argued among themselves for what seemed like a long and tense moment. Finally, we were told that they would have liked to please us but there was no such infrastructure in their territory. The business faction had closed the door. There was little we could do to change their minds. Pushing the matter too hard could prove dangerous in a land with a vibrant gun culture where the tradition of head hunting was only just a recent memory. Despite evidence to the contrary, Burma's warlords have never admitted their involvement in drug production, at best acknowledging that they "taxed" suppliers and traffickers within their territories.

I revisited the Wa two years later, at which time opium fields were flourishing and the pragmatists had been confined to fruit and tea production. Then in 1996, after assisting government troops to defeat Khun Sa and taking over part of his territory, the Wa diversified their drugs production into methamphetamines, a highly profitable product which required much less space than opium to produce and one which mainly targeted the regional market.

While they were significant players in the business, both the Wa and the Mong Tai Army only accounted for a small portion of Burma's overall drug trade, a trade dating back centuries and one which had flourished under the British Raj when opium was exported to China to subdue and chattel the population. It is a trade which further exploded during the 1950s when the sale of opium and heroin became a major source of finance for anti-communist groups, many of which were supported and trained by the US military.

To this day, the Wa compete with dozens of other militias in Shan State, many of which are backed by the government. Even though Afghanistan regained its title as the world's main heroin producer in 2002, Burma's Golden Triangle is still producing more than its fair share of the drug. In 2012, according to a United Nations Office on Drugs and Crime (UNODC) report, the production of opium – and thus heroin – increased for the fifth consecutive year, positioning Burma as the source of one-fifth of the world's cultivation of opium poppies. The agency quoted "food insecurity, poverty, conflict" as the main causes for this increase. Today, the bulk of the drug warlords' profits stem from synthetic drugs. Unlike poppy

fields, which are easily spotted by aircraft and satellites, methamphetamine factories are much harder to detect. Anti-narcotics agencies won't say how many millions of methamphetamine pills are being produced each year, they can only give an estimate of the seizures – 133 million pills originating from Burma were seized in 2010, according to UNODC. One thing they all agree on is how production has dramatically increased in recent years and that Burma remains one of the world's leading narco-states.

As one of Khun Sa's aides once told me, "if we make business from narcotics is because we have customers in the west". This man's cynical, business-oriented remark was certainly right, but he also had conveniently forgotten that the money earned from opium and heroin was mostly spent enriching his boss and on strengthening their army. You only had to trek through the region's opium-producing communities to realize how poor the villagers remained despite the millions of dollars made from their product. As long as there's money to be made, and the authorities fail to address issues of poverty and corruption, opium, heroin and methamphetamines will continue to pour across Burma's border.

A column of soldiers and mules from the United Wa State Army cross a hilltop during an expedition in the Golden Triangle. Shan State, 1993.

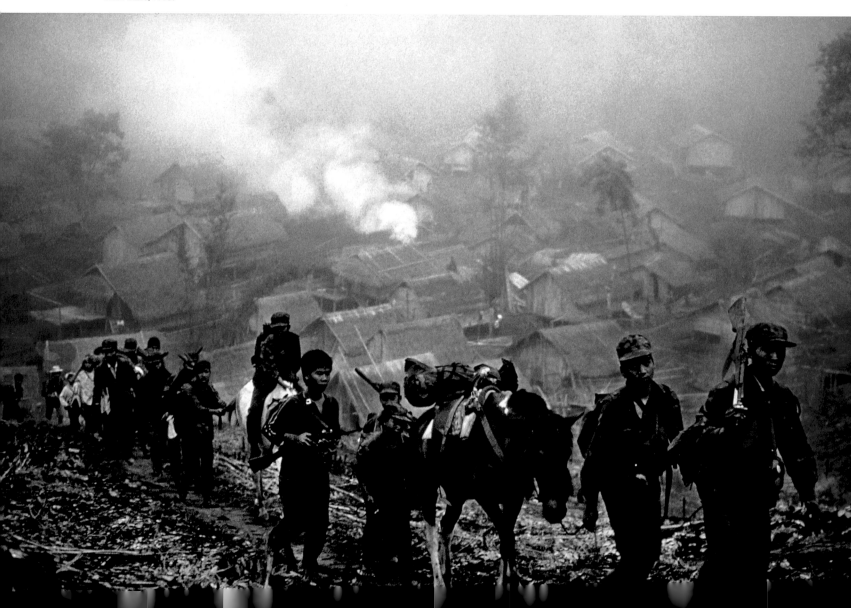

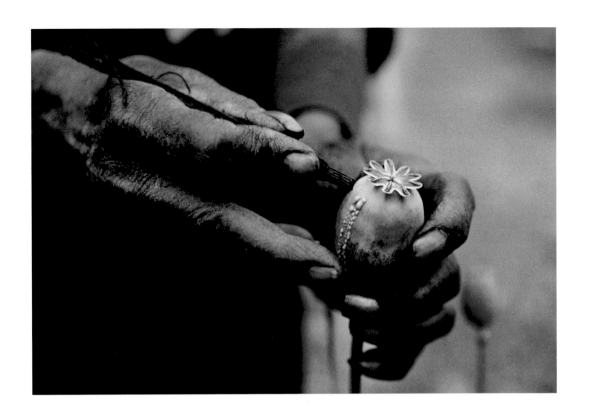

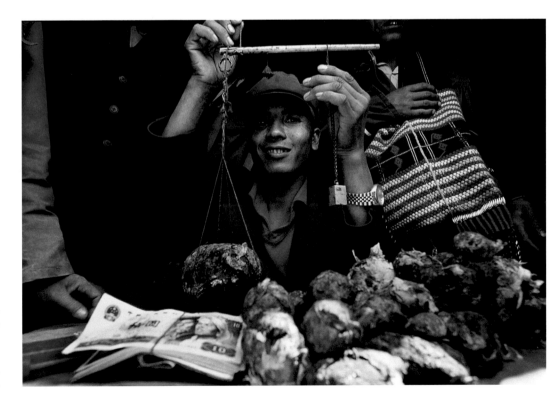

Top: A Wa woman milks an opium poppy.
Shan State, 1993.

Bottom: Opium is sold in the open at a market along the Chinese border.
Shan State, 1993.

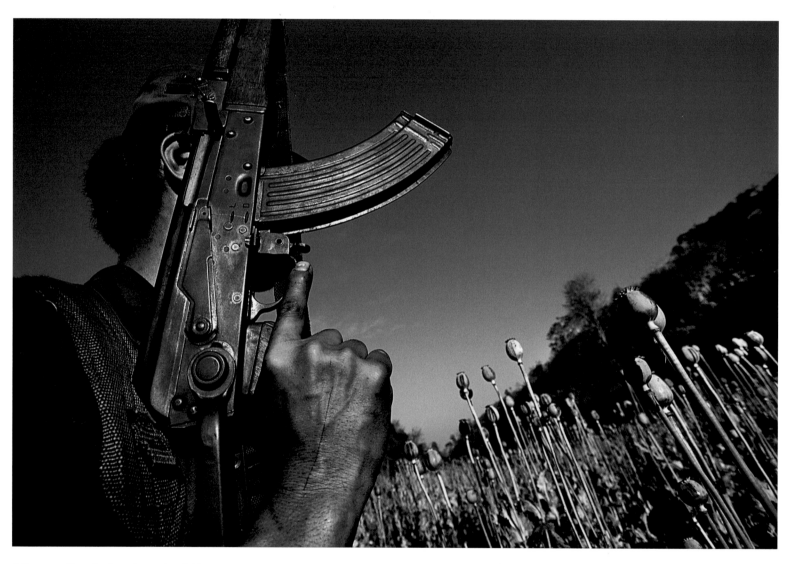

A Shan guerrilla walks through an opium field.
Shan State, 2003.

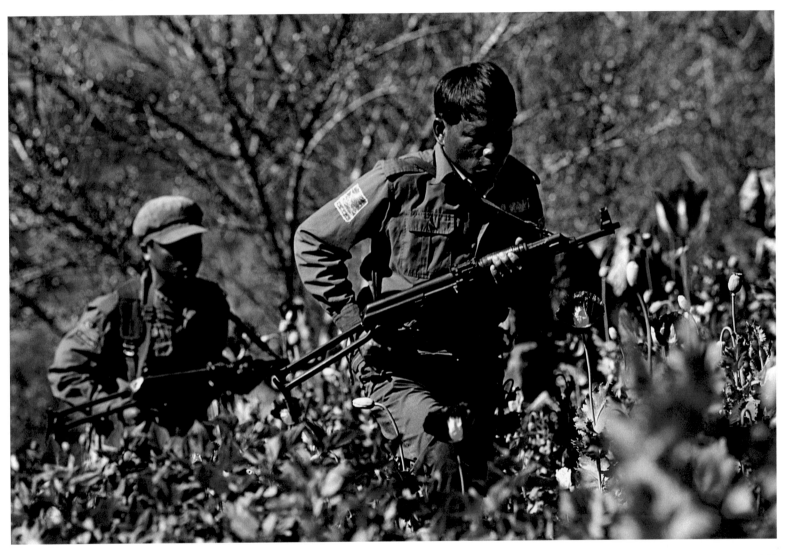

Soldiers from the United Wa State Army patrol an opium field.
Shan State, 1992.

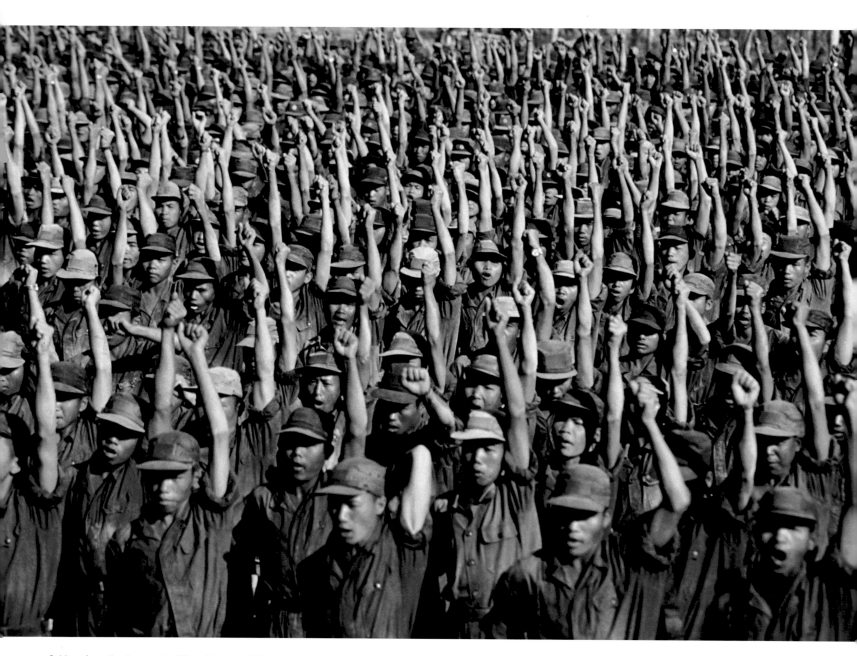

Soldiers from the drug warlord Khun Sa's army fall in on the parade ground.
Shan State, 1994.

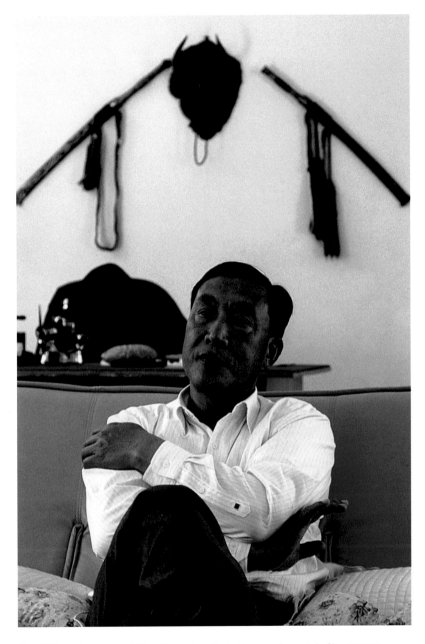

Shan-Chinese drug warlord Khun Sa sits in a villa in Homong, the capital of his territory.
Shan State 1994.

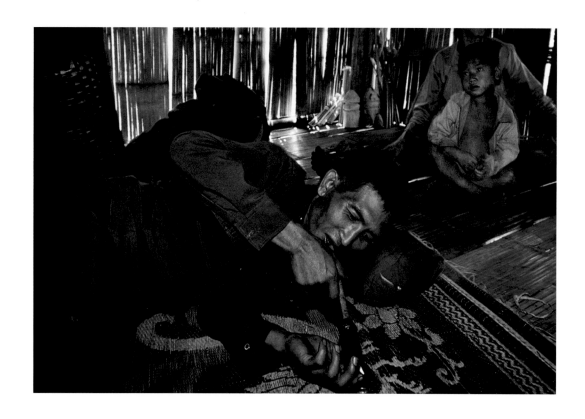

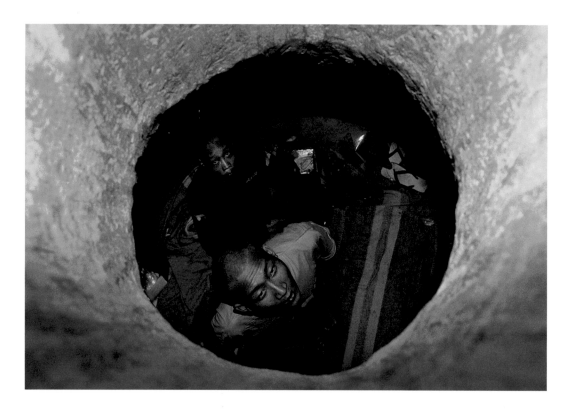

Top: A villager from a hill tribe smokes opium.
Shan State, 1993.

Bottom: Soldiers from the Mong Tai Army
who are addicted to opium or heroin are
thrown in a hole until they have gone 'cold
turkey' and detoxified their systems.
Shan State, 1994.

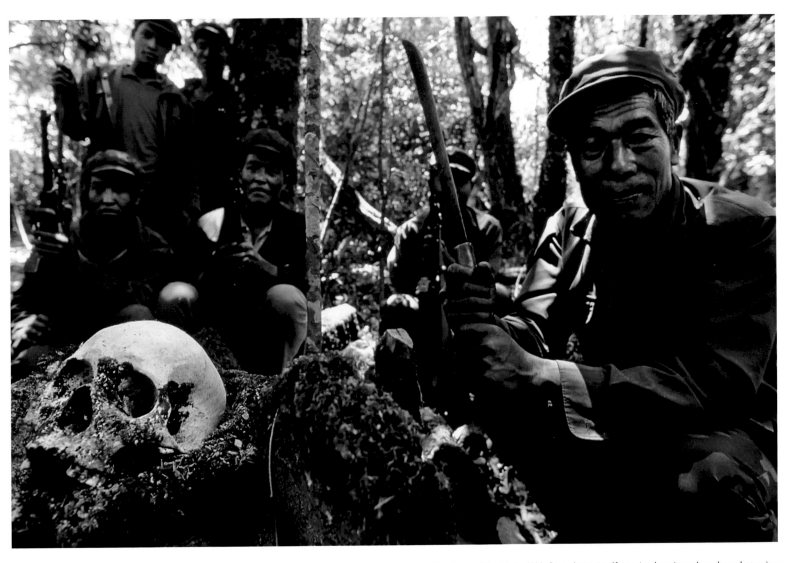

Members of the United Wa State Army, itself a major heroin and methamphetamine producer, display a human skull kept from their not too distant headhunting times. Shan State, 1993.

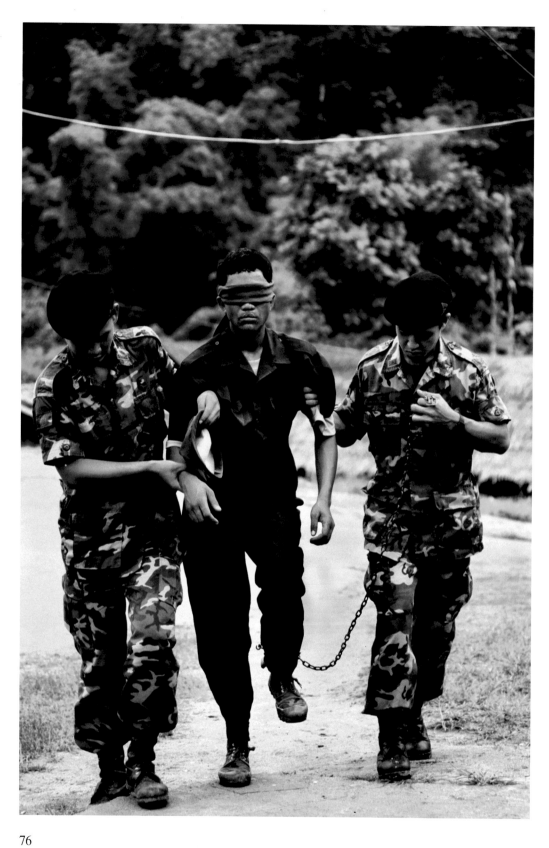

Thai soldiers arrest a United Wa State Army courier on his way to collect money from amphetamine sales. Thailand, 1999.

Addicts living along the Burmese-Thai border smoke the
methamphetamine known as 'ya baa' (Thai for 'crazy drug').
Thailand, 1999.

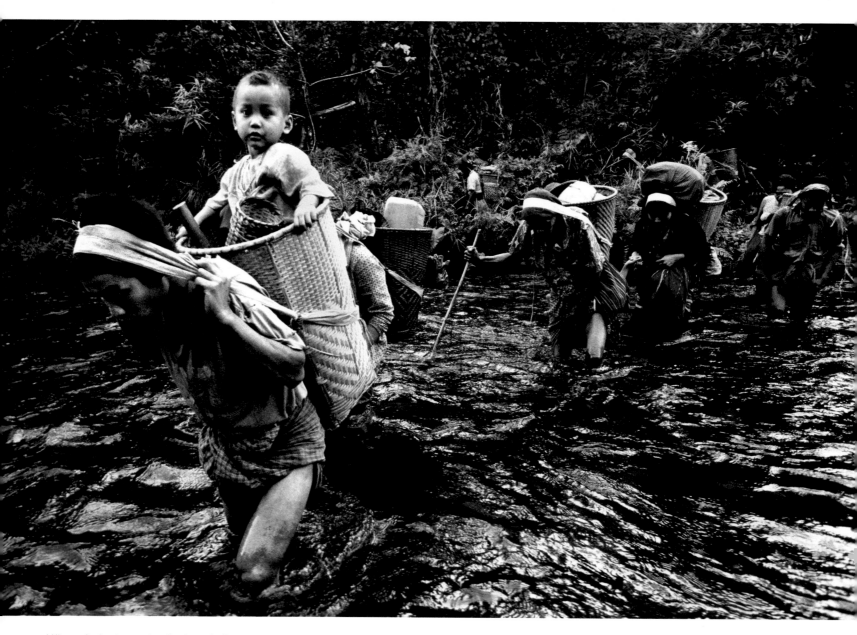

Villagers ford a river as they flee from the Burmese army.
Karen State, 2001.

Chapter Five

SCORCHED EARTH
Wrath and rebellion in ethnic territories

After more than 20 years reporting on Burma, with much of that time spent covering the plight of internally displaced persons, I thought I'd heard it all. But the conversation I had with two Karen sisters, Eh Say Paw, 18, and Hsa Moo Paw, 22, on a rainy day in 2008 shocked me to the core.

I sat with them in a tiny hut, which had been hastily built from bamboo and wild banana leaves, on a hill in a remote jungle of the Karen state. Their story was a stark contrast to the bucolic scene, a sharp reminder of how life in Burma can be extremely brutal.

"Last year, on his way back from the church, our elder brother came across some Burmese soldiers on patrol. They shot him on sight for no reason. A witness told us that he was hit in the stomach and fell to the ground. The soldiers then beat him up before they smashed his head to a pulp with their rifles. The soldiers were from Light Infantry Battalions 371 and 372."

It was a truly harrowing account. Unfortunately, their tale of tragedy only got darker. The month following their brother's brutal murder, soldiers caught their father and two other men on a trail near the village. The one man who managed to escape told the sisters of their father's grim fate. "They hanged our father from a tree by his feet with a heavy rock bound to his hands. Then they beat him and beat him and beat him. We never saw him again."

Since I started reporting from Burma's ethnic territories in 1987, I have documented countless such stories. It sobers me to think about how my notebooks have become a grim catalogue of atrocities such as murder, rape, looting, destruction, forced labour and other acts of oppression committed by Burmese soldiers during ethnic cleansing operations. Not all atrocities are conducted at the hands of the Tatmadaw, however. A number of the rebel forces have been responsible for gross human rights violations. Still, as far as I understand and have witnessed,

these tended to be the exception not the rule and such actions were certainly not part of a well-planned strategy of terror.

While the Burmese army has committed abuses across the country, the worst excesses take place in the remote but vast ethnic territories. This is where you find the so-called "black zones", or areas where the army operates a shoot-on-sight policy.

Such crimes against humanity have continued unabated since General Ne Win, the first military ruler of independent Burma, introduced the "Four Cuts" policy, a counter-insurgency strategy launched in the 1960s which aimed at routing rebel forces in central Burma, pushing them into the mountainous regions and cutting their access to food, money, intelligence and recruits.

Over decades these policies have resulted in the internal displacement of millions of people and the expropriation of their land and claims to natural resources. Villages are abandoned, inhabitants seek to scratch a living from the jungle, many attempt to restart their lives in another valley, while others move to so-called "relocation communities" which are controlled and operated by the army. Some even elect to walk to a refugee camp in Thailand.

Thousands of ethnic guerrilla fighters and civilians, have been killed, even more have been injured by landmines, bullets, mortars, chemical weapons and fire, the physical scars of which are plain to see. Many women have lost their life or dignity under the brutality of soldiers who use rape as a weapon of war.

The recent move from absolute military rule to a civilian government has resulted in some improvements in conditions in many of the black zones. In Kachin State, however, where conflict resumed in 2011 after almost two decades of cease-fire, reports of murder, rape, destruction and population displacement are piling up. Old habits die hard for Burma's army, it seems.

Displaced villagers cross a river.
Karen State, 2001.

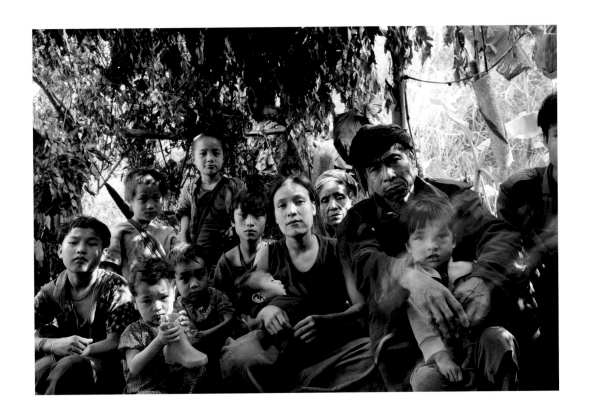

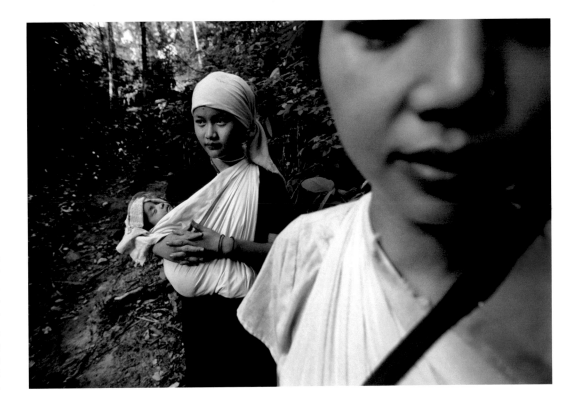

Top: A family forced by the Burmese army to abandon their village sits in a hut made from leaves and branches in the jungle. Karen State, 2008.

Bottom: A mother and her two daughters run away from the Burmese army on their way to the Thai border. Karen State, 2000.

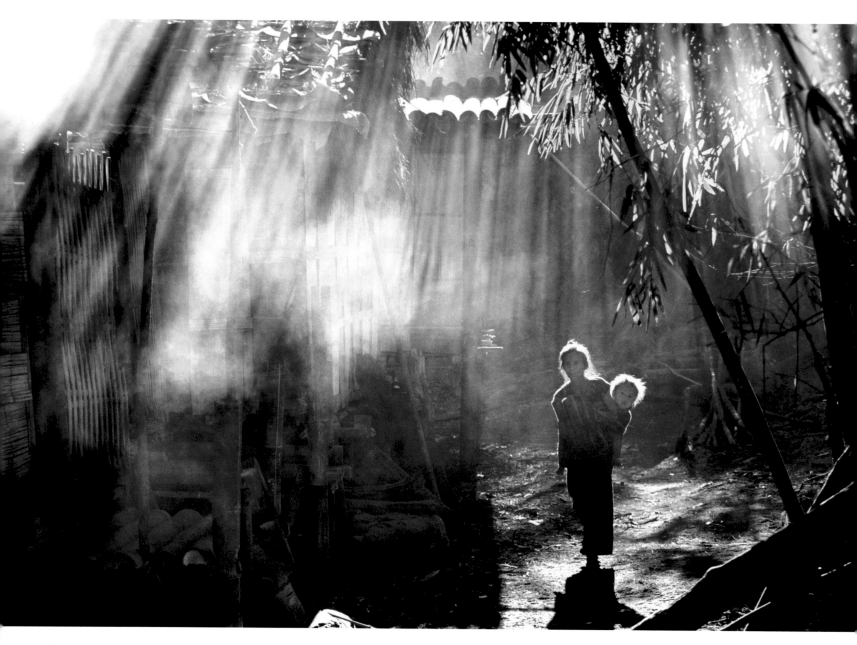

A woman carrying a baby walks through an IDP community.
Kayah State, 2005.

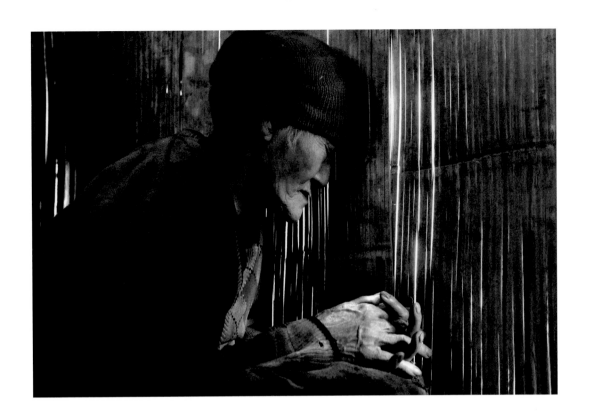

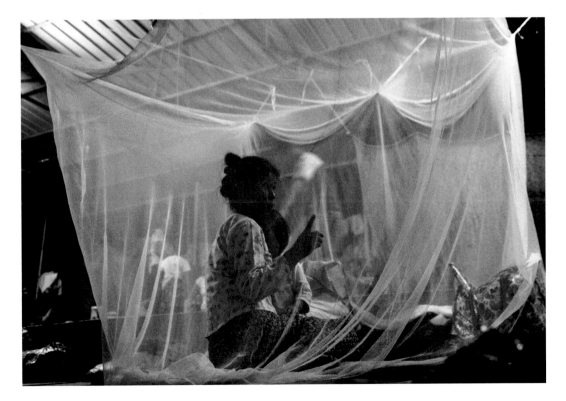

Above: An old displaced woman sits inside a hut. Karen State, 2008.

Below: A Kachin woman puts her baby to bed at a displaced persons camp. Kachin State, 2011.

83

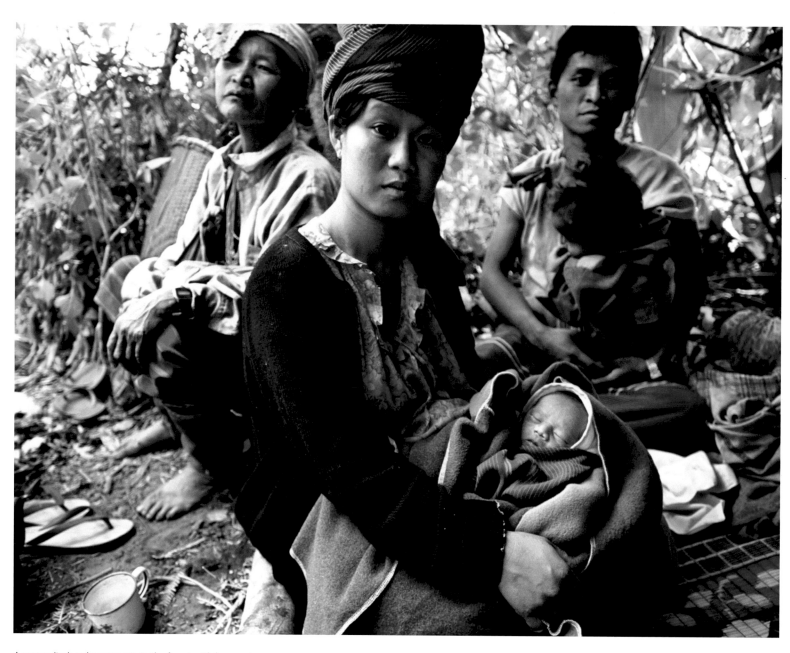

A young displaced woman sits in the forest with her newborn
son who was delivered during the previous night.
Karen State, 2004.

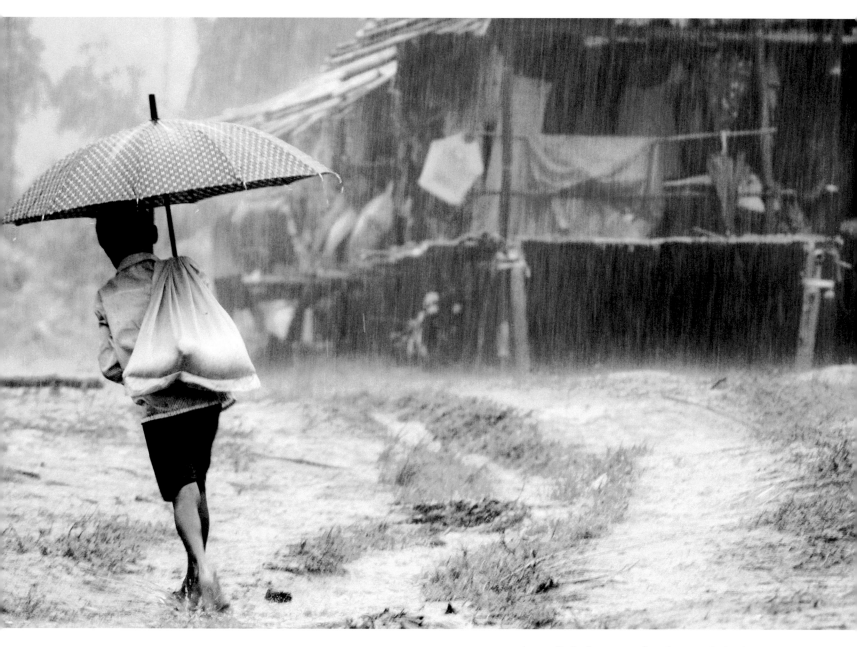

A young Kachin boy carries a bag of rice in a displaced persons camp.
Kachin State, 2011.

Kachin who have fled their villages build a temporary camp along the Chinese border.
Kachin State, 2011.

Displaced Kachin make do with temporary shelter at a Laiza school.
Kachin State. 2011.

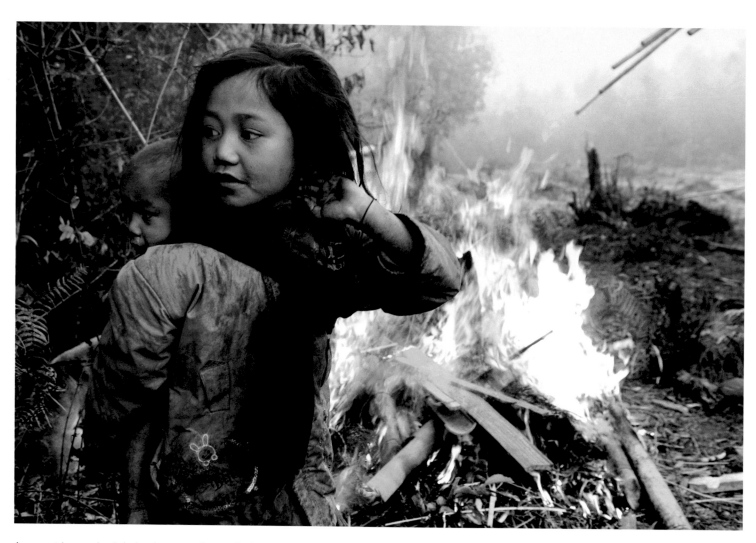

A young girl warms her baby brother near a fire in a displaced persons community.
Karen State, 2012.

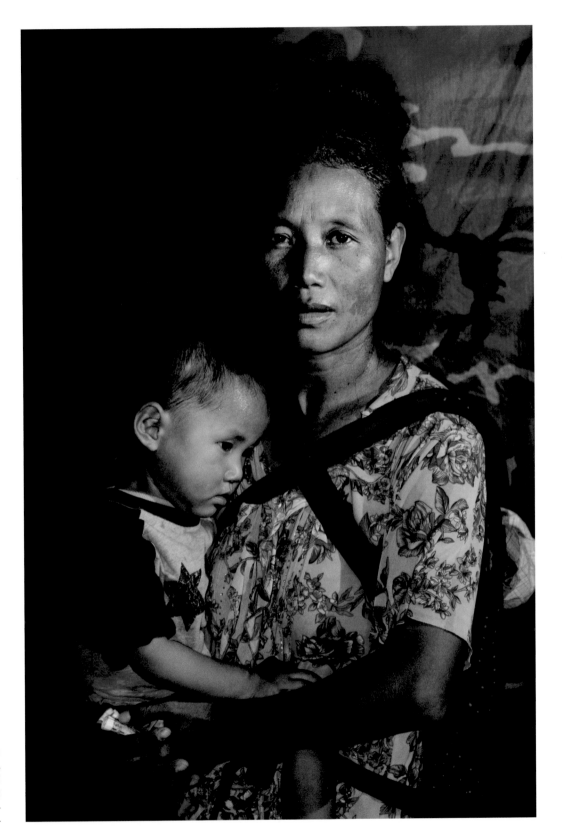

Chang Yaw, 39, a Kachin and
her baby girl Nang Roi, 2,
sought shelter in a displaced
persons camp after fighting
broke out near their village.
Kachin State, 2011.

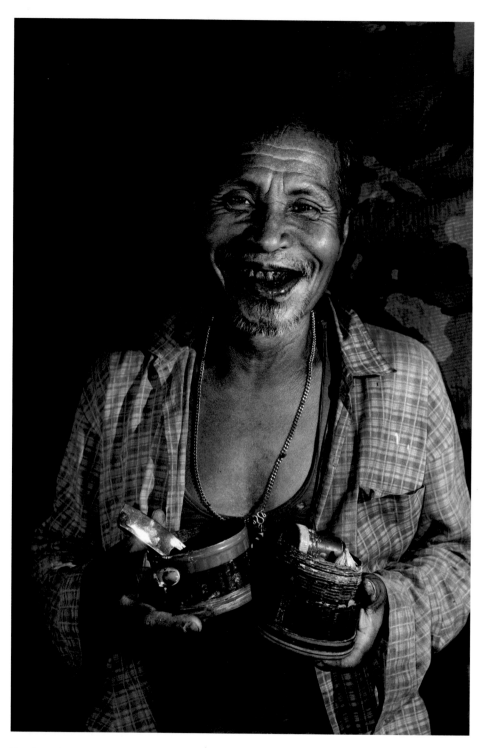

Kyar Aye, 60, a Karen, chews betel nut in a displaced persons community.
Karen State, 2011.

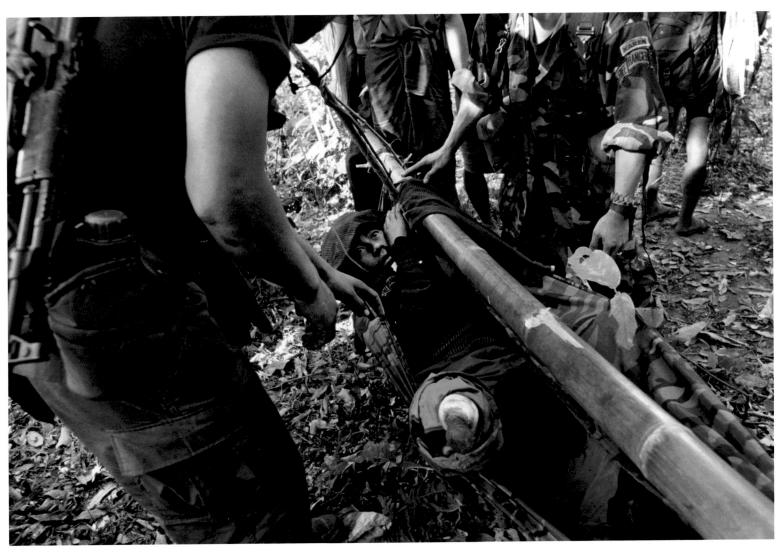

Villagers and members of a relief team carry a 17-year-old boy who has lost a leg on a landmine planted by the Burmese army at the entrance to a village.
Karen State, 2004.

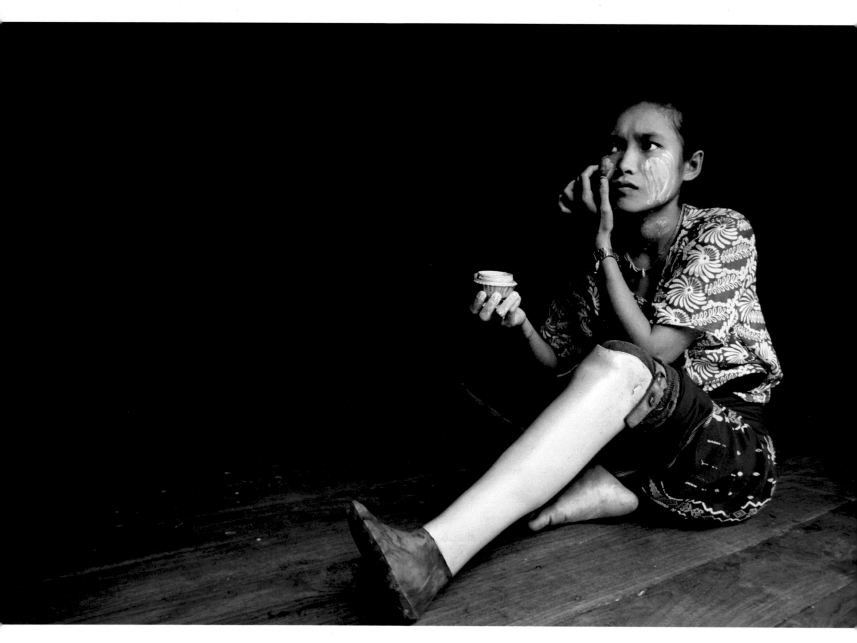

Mo Thu, a 20-year-old Karen refugee, lost her leg on a landmine planted by the Burmese in Thai territory.
Thailand, 2000.

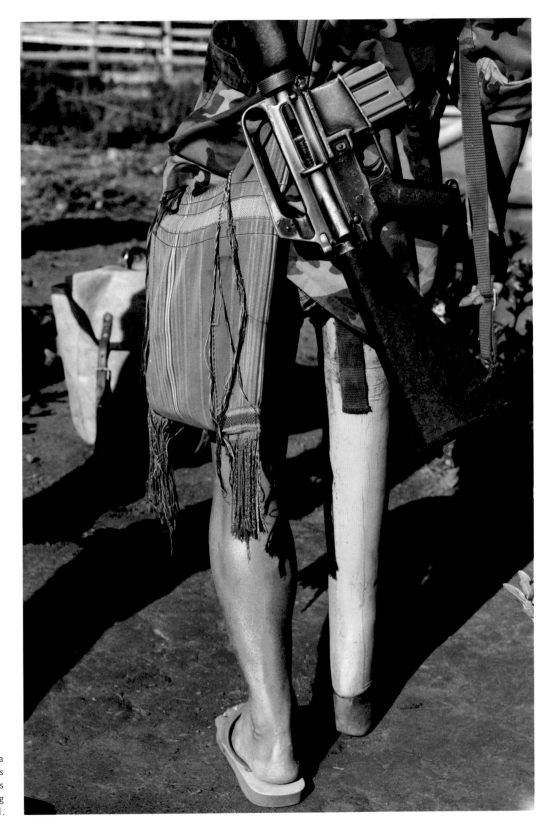

A Karen guerrilla who lost a
leg on a landmine remains
determined to bear arms
despite his prosthetic leg
Karen State, 2011.

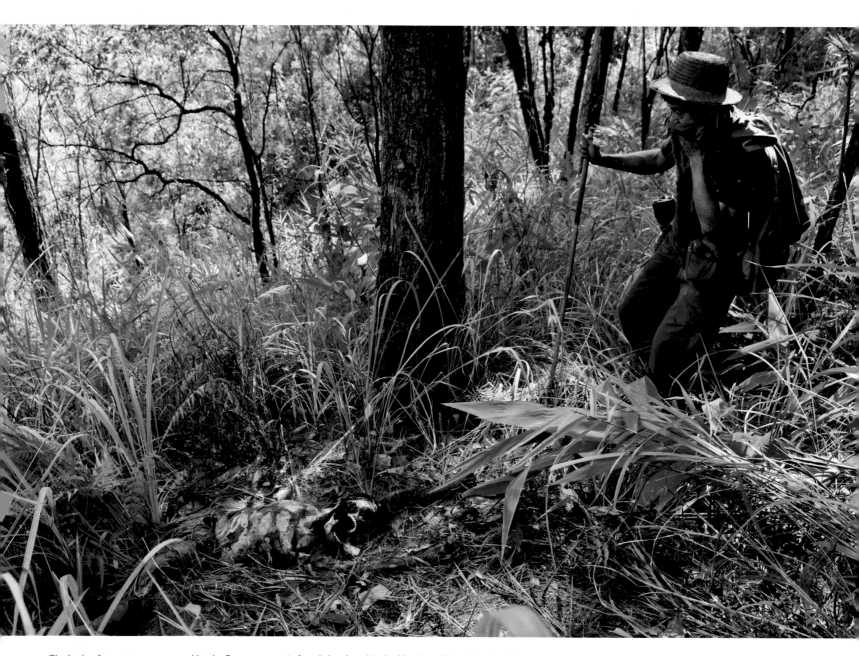

The body of a porter press-ganged by the Burmese army is found abandoned in the Northern Karen State jungle.
The corpse has a bullet hole in the back. Local sources say the porter was shot during an escape attempt.
Karen State, 2008.

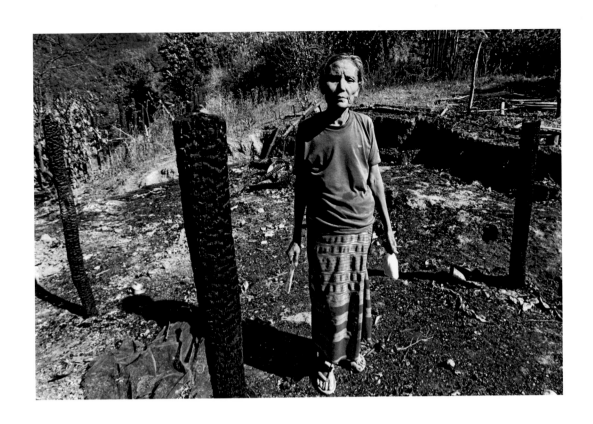

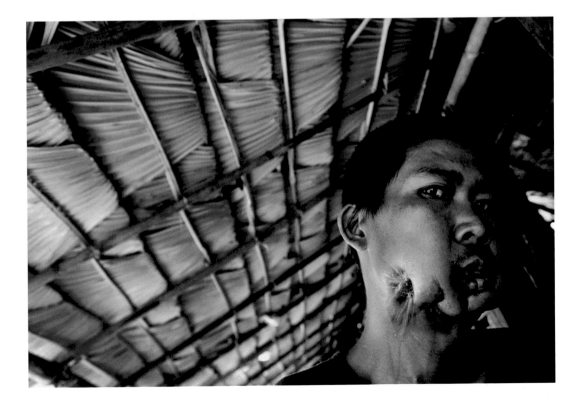

Top: An old woman stands in the ruins of her home that was burned down by the Burmese army. Karen State, 2005.

Bottom: Sai Tung, who was forcibly recruited as a porter by the Burmese army when he was 30, was shot in the face when he tried to escape. Shan State, 2003.

95

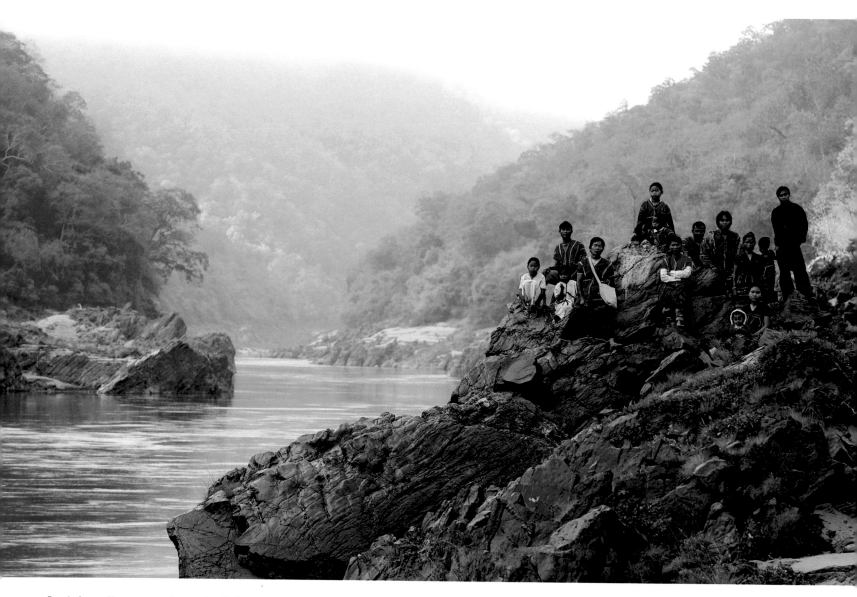

People from a Karen community stand at the location of the future Wei
Gyi dam on the Salween River. They fear that their village will be flooded,
forcing them to abandon their homes and livelihoods.
Thai-Burmese border, 2006.

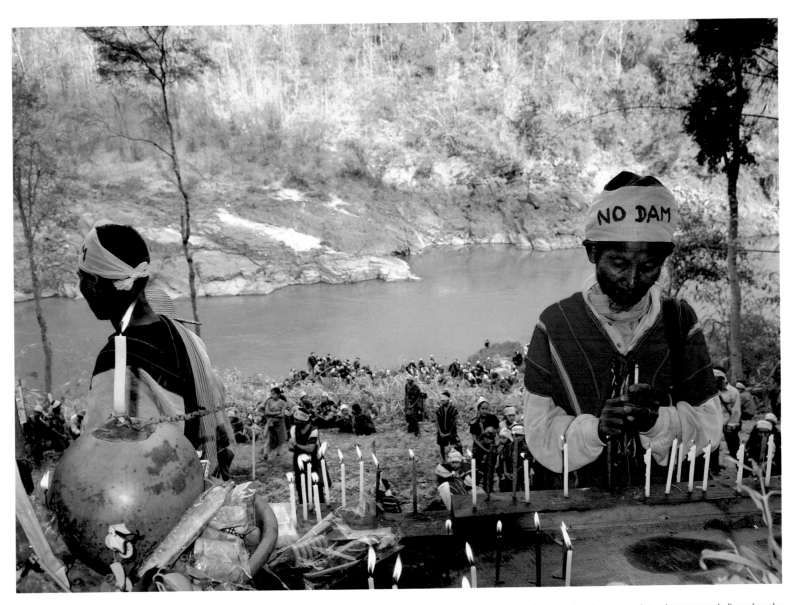

An animist priest lights candles during a traditional ceremony dedicated to the spirits of the Salween River. Hundreds of Karen people travelled from their villages in Burma and Thailand to protest at the location of a controversial dam project. Karen State, 2006.

Villagers and members of the Free Burma Rangers carry a 17-year-old boy who has lost a leg when he stepped on and detonated a landmine planted by the Burmese army near his village. Karen State, 2004.

Chapter Six

HUMANITARIAN COMMANDOS
Medical care in the black zones

Paw Htoo was the senior nurse on my first relief expedition with the Free Burma Rangers into Karen state, in 2000.

The quiet but determined young Karen woman, whose name means "Golden Flower", deftly set up makeshift medical centres in the middle of the jungle. While many of those around her would carry guns, Paw Htoo's arsenal comprised medicine boxes, stethoscopes, syringes, bandages and surgical tools.

On arrival, it became clear just how much their support is needed. I'll never forget that first time I saw patients emerging from the jungle. Most of them were civilians who had gone into hiding in the forests after being forced to abandon their villages by Burmese soldiers. They were suffering a range of ailments from malaria, dysentery and coughs to decaying teeth, tropical ulcers and anaemia. There were also far more egregious injuries caused by small arms fire, mortars and landmines. Paw Htoo and her team attended to children and adults, men and women, during the sweltering days and throughout the mosquito-ridden nights when they would carry out a range of surgical procedures – from delivering babies to amputating limbs – by candlelight.

Beneath the 30-year-old's calm exterior lurked an intensely personal tragedy, one which served only to strengthen her resolve and steadfast commitment to providing medical support to those living under tyranny. Eight years earlier, Paw Htoo had witnessed her husband, a combatant with the Karen National Liberation Army, have his throat slit by a Burmese soldier. She was then arrested for terrorism, thrown in jail where she gave birth to her son who she had to give to her mother-in-law to care for while incarcerated. Her release in 1994 did not bring an immediate reprieve from suffering. The Karen guerrillas suspected her of being a junta spy because she had befriended and become close to a Burmese woman in jail who herself had been convicted for espionage by the Karen National Liberation Army after her release. The guerrillas executed the woman after an alleged escape attempt. Paw Htoo herself only evaded death thanks to a respected Karen officer intervening on her behalf.

However, these dramatic developments only made Paw Htoo more determined to work for her people. She was given this opportunity in 1997 when, following a new exodus of ethnic refugees along the Thai border, a former US special forces officer joined up with a handful of Karen volunteers to form the Free Burma Rangers. This group of what are probably best described as humanitarian commandos was established with the express aim of delivering essential medical care to civilians in Burma, particularly those inhabiting the so-called "black zones" where the army operates a shoot-on-sight policy. As such the Rangers travel with an armed escort provided by local guerrillas. While conflict is always to be avoided where possible, there is no way they would be able to provide much-needed medical care if they were not prepared to defend themselves with deadly force.

In secret jungle camps the Rangers train young ethnic volunteers in basic medicine, psychology, intelligence and media. Once they've passed through boot camp the new Rangers embark on expeditions deep into the black zones. Accompanied by armed escort and porters, these relief teams trek for weeks or months through Burmese army lines and minefields to reach displaced people and provide them with emergency relief. The Rangers say some 60 teams have performed more than 500 missions, bringing medical assistance to more than 750,000 people over the past 15 years.

Since 2000, I have accompanied the Rangers on one or two of these typically month-long expeditions almost every year. For the journalist, these missions provide an unparalleled opportunity to witness and bring to light this hidden story of how hundreds of thousands of Burmese people survive the Tatmadaw's oppression. For the jungle patients, the Free Burma Rangers provide nothing less than a lifeline.

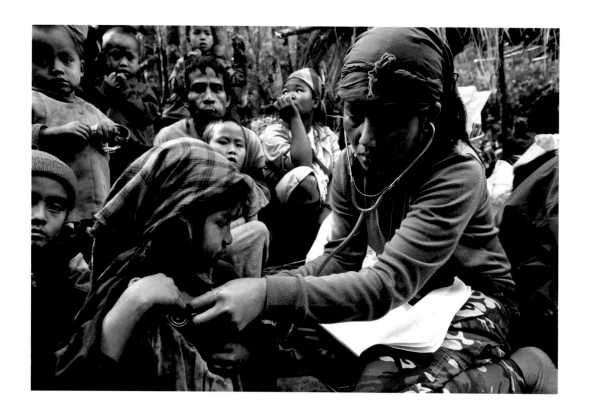

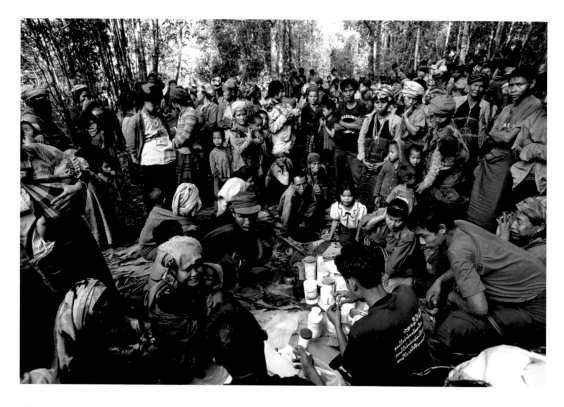

Top: Paw Htoo, a Karen nurse and a founding member of the Free Burma Rangers, provides medical treatment to displaced villagers who are hiding in the jungle.
Karen State, 2004.

Bottom: Displaced villagers gather to receive treatment from a Free Burma Rangers team.
Karen State, 2004.

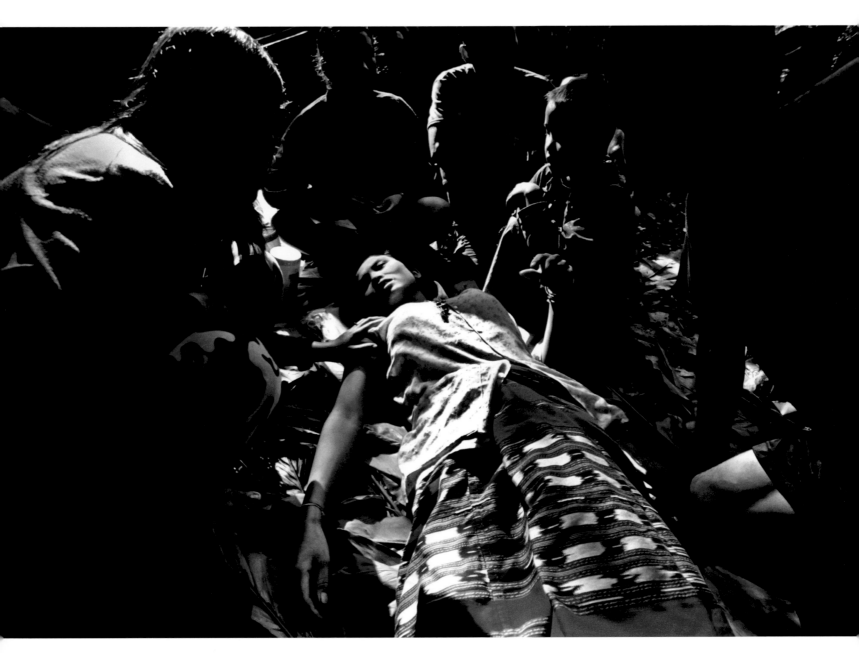

Free Burma Rangers treat a young displaced woman who is suffering from malaria.
Karen State, 2004.

101

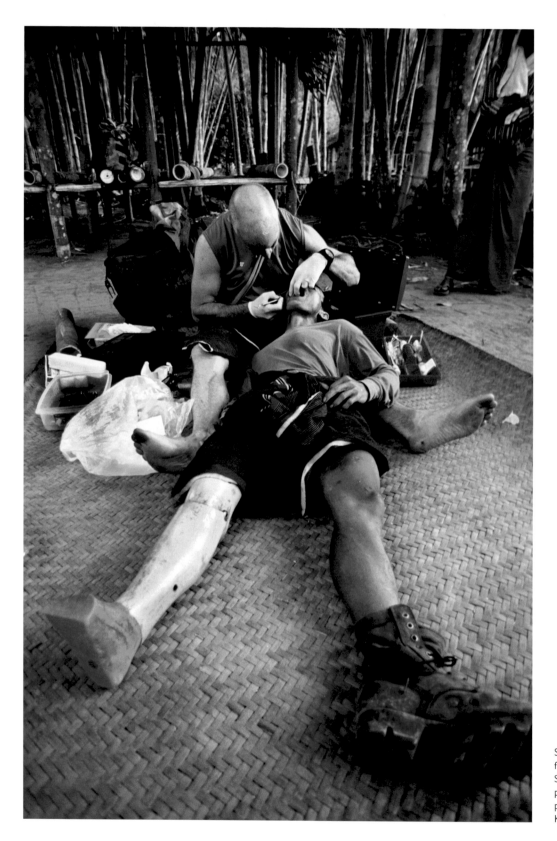

Shannon Allison, an American dentist from Louisiana and a former US Army Special Forces officer, has volunteered to provide dental treatment to displaced people almost every year since 1999. Karen State, 2001.

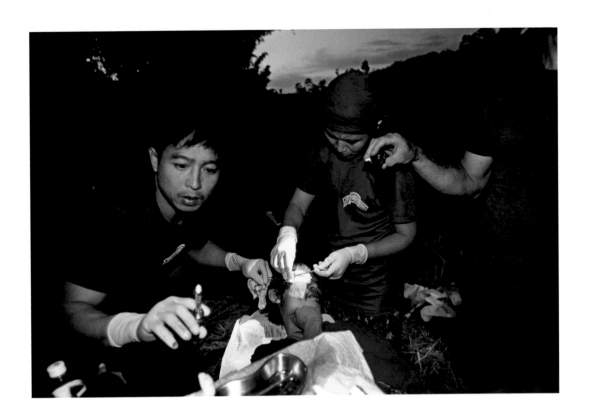

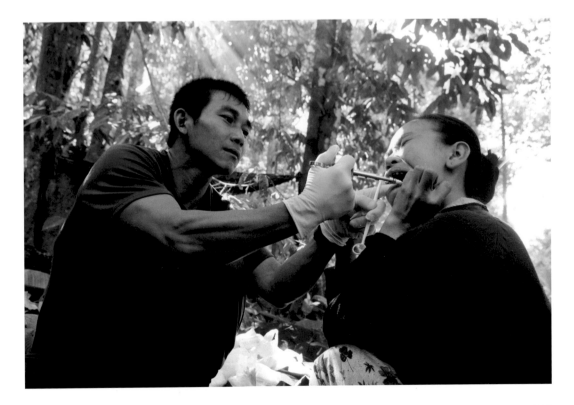

Medical staff from a Free Burma
Rangers team treat a man suffering
from an eye infection who they have
met in a field during a relief expedition.
Karen State, 2004.

Saw Maw Nam, a member of the Free
Burma Rangers, provides much-needed
dental treatment to a villager.
Karen State, 2011.

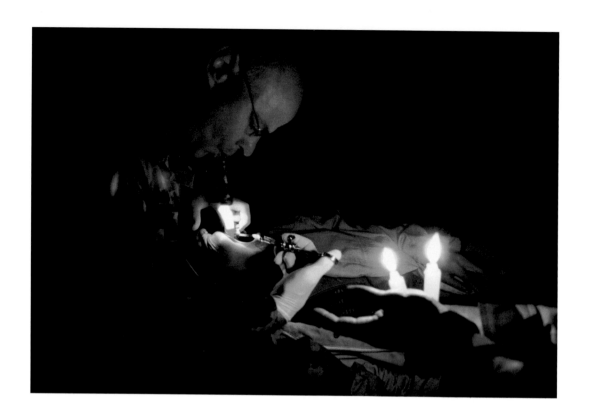

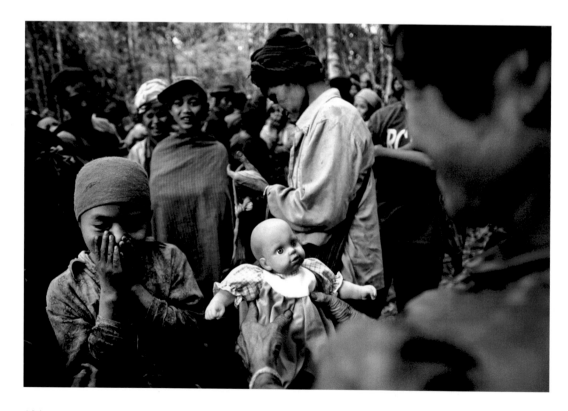

Top: Shannon Allison provides dental
treatment by candlelight.
Karen State, 2001.

Bottom: Children from a displaced
community receive gifts, such as this
doll, from a Free Burma Rangers team.
Karen State, 2004.

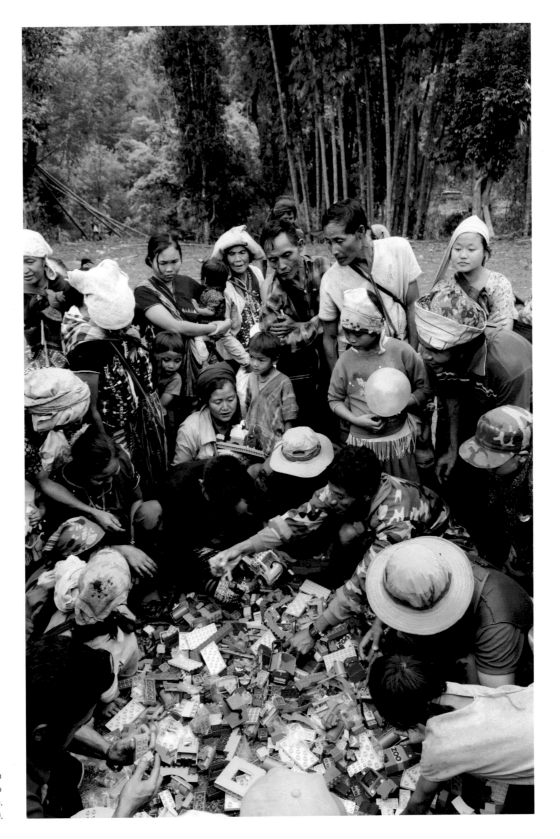

A Free Burma Rangers team
distributes more than 400kg of Lego
to hundreds of displaced people.
Karen State, 2010.

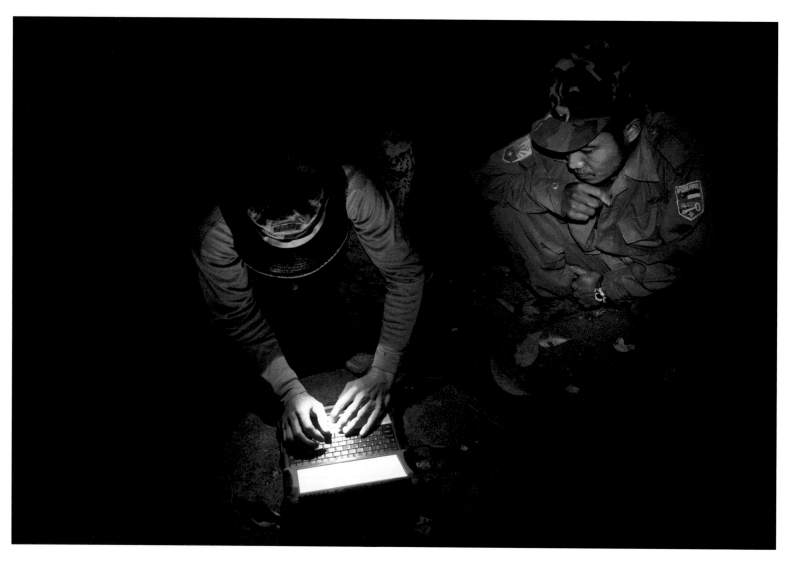

A Karen guerrilla working as an armed escort for a Free Burma Rangers relief
team observes a Ranger sending email from a laptop
Karen State, 2011.

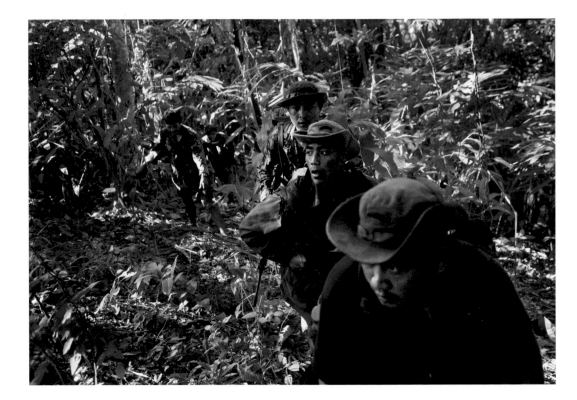

Top: Porters with the Free Burma Rangers warm themselves around a fire. Karen State, 2012.

Bottom: A security team escorting a Free Burma Rangers expedition pass between two Burmese army positions on a path riddled with landmines. Karen State, 2008.

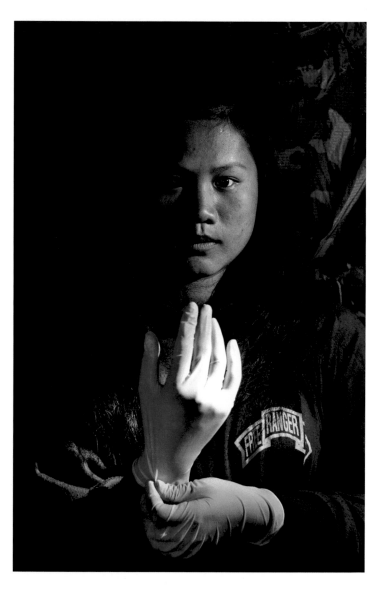

Naw Pel Htoo, 19, an ethnic Pa-O nurse with the Free Burma Rangers.
Karen State 2011.

Sai Noung, 35, an ethnic Shan team leader with the Free Burma Rangers.
Karen State, 2011.

Daniel Pan Dhone, 33, an ethnic Karen,
quit his job as a pianist at a five-star hotel
in Rangoon to join the Rangers.
Karen State, 2011.

Sai Ye, 29, an ethnic Shan was forced to work as a porter for the
Burmese army after being jailed for a drugs offence. He escaped to
Karen State where he started working as a porter for the Rangers.
Karen State, 2011.

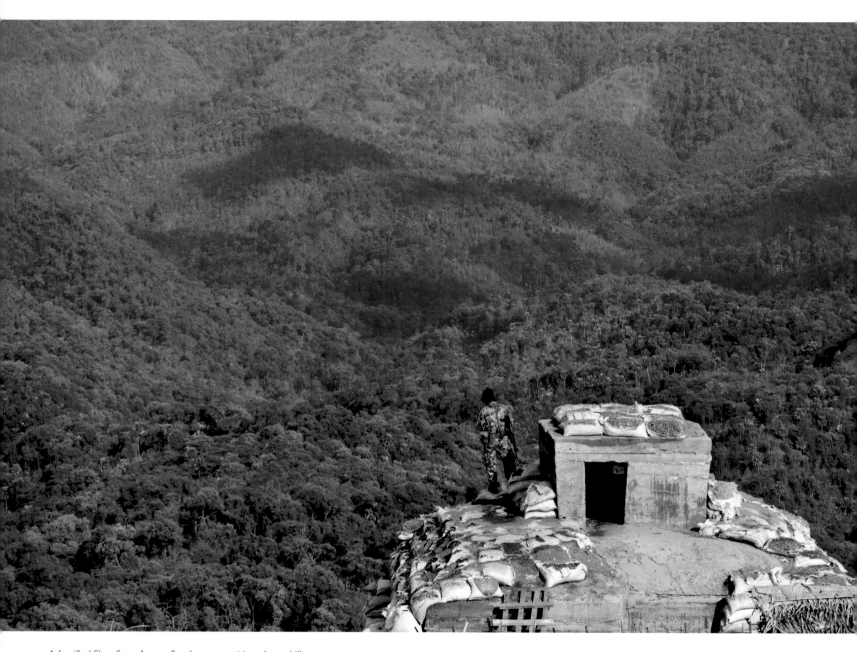

A fortified Shan State Army - South camp positioned on a hilltop.
Shan State, 2010.

Chapter Seven

BAPTISM OF FIRE
Ethnic armies

In 1988, I was embedded with a guerrilla platoon from the Karen National Liberation Army (KNLA) that was heading over the border from Thailand to reinforce another unit some four or five days walk inside Karen State. After scaling a mountain range and fording the Salween River, one of Burma's main waterways, we crossed a plain covered with rice fields and betel nut plantations. The second day at dawn, after a terrible rainy night where I had only managed to catch a couple of hours sleep squatting in a bush under a leaking poncho, the Karen started to shell a fortified Burmese army position a few hundreds metres away with mortars. It was a brief, noisy fusillade and the attack offered nothing to photograph. At midday, after a couple of hours of awkward calm, the commander gave the order to move ahead. We had barely started to walk along the bed of a small river located on the far side of the field when we drew a deluge of fire from Burmese soldiers hidden in vantage points on both sides of the stream. I was ordered to crouch down and take what cover was afforded by the brook's slightly elevated bank while the guerrilla's fired back.

It was an intense, anxious moment, during which I hoped we would somehow retreat from the firefight to safer ground. Then I spotted a young porter, who had accompanied us since the beginning of the journey, nearby. He was stuck to the muddy bank, frozen in fear, looking at me with wide eyes, seemingly screaming silently, "what the hell am I doing here?" He was experiencing his baptism of fire.

The KNLA managed to force a Burmese withdrawal. After a nerve-wracking hour, the firefight was over and the platoon managed to leave the riverbed and take shelter on a nearby hill.

Two days later we rendezvoused with the Karen unit the platoon was sent to reinforce. After a day of rest and planning, the guerrillas reached a plateau overgrown with bush and bamboo. They patiently waited until a column of Burmese soldiers appeared in the distance walking in a rice field. When the enemy set foot on the plateau, they started what they call "a killing range", which basically meant that

they fired blindly through the bush. The commander told me the attack had killed two enemy soldiers.

As terrifying as these events were for the young porter and myself, they were nothing extraordinary for the KNLA or any of the ethnic armies, people for whom resistance, conflict and death have become part of everyday life since Burma won its independence from the British Empire in 1948. For almost 65 years a wide array of communist and armed ethnic groups have risen up against successive Burmese governments, democratically elected administrations and military dictatorships alike. At the peak of these rebellions in the late 1980s, there were about twenty groups fighting for independence or the autonomy of their territory. Over the past two decades, most of these movements have acquiesced and signed ceasefire agreements with the Burmese regime. At the dawn of the 21st century only a few diehard factions from the Karen, Karenni, Rakhine and Shan ethnic groups were still bearing arms against the junta and its cohorts. While the overall level of conflict may have been subdued, the battles have remained intense in the regions where ethnic forces refuse to raise a white flag.

More recently, in June 2011, the Kachin tore up a 17-year truce after refusing to abide by a Burmese order to transform into a local militia under the Tatmadaw's rule. This return to conflict demonstrates the fragility of ceasefire agreements which most ethnic groups claim have only focused on some sort of economic development without answering essential political claims such as creating genuine autonomy in their territory.

Over the years I have spent a great deal of time with many of these groups. While in most cases they seemed to be fighting a common enemy – the Tatmadaw – they also demonstrated a huge amount of diversity in their ideologies, actions and motivations. Some enjoyed strong support from the local population, others were treating what should have been their support base worse than they had been treated by the regime forces they were fighting. It is also worth pointing out that the situation everywhere is far more complex than good guys on one side and bad

guys on the other. All of the rebel forces control areas according to laws which they have largely drawn up themselves. In order to buy guns and feed their soldiers all of them were involved in some form of trans-border business, which for some includes the highly lucrative drugs trade.

Many of the ethnic leaders I have met were imbued with a clear, long-term vision for their people, but a significant number had little more than the short-term ambition of a freebooter or warlord. However, having spent countless time listening to leaders, soldiers, people from the ethnic territories as well as the Burman communities, one clear line of agreement emerged – regardless of who sits in parliament in Naypyidaw, peace in Burma cannot be achieved without a political settlement supported by the ethnic groups.

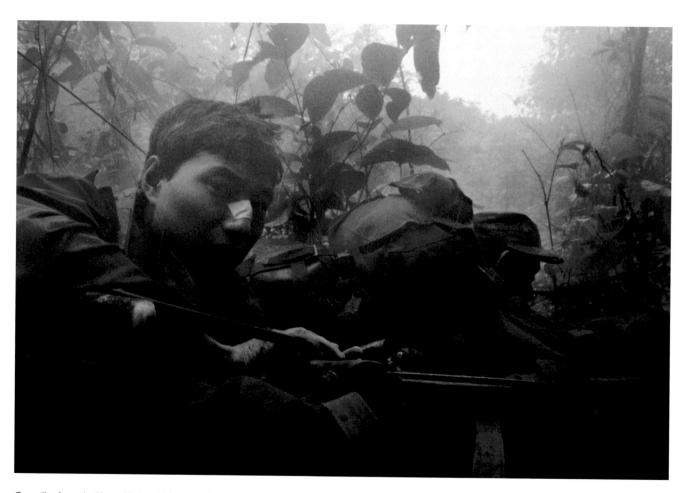

Guerrillas from the Karen National Liberation Army seek cover during a skirmish with Burmese soldiers. Karen State, 1988.

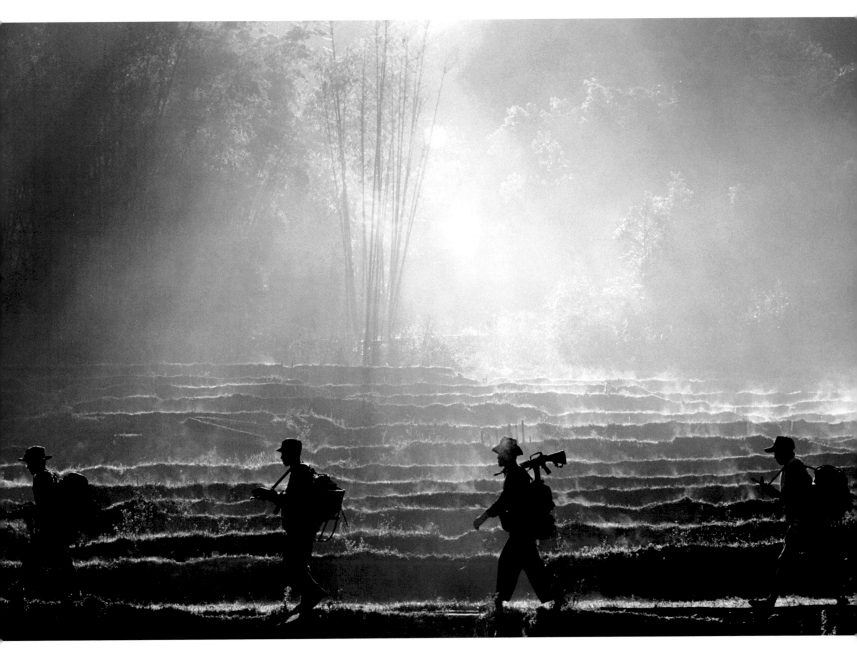

The Karen National Liberation army patrol through a rice field.
Karen State, 2001.

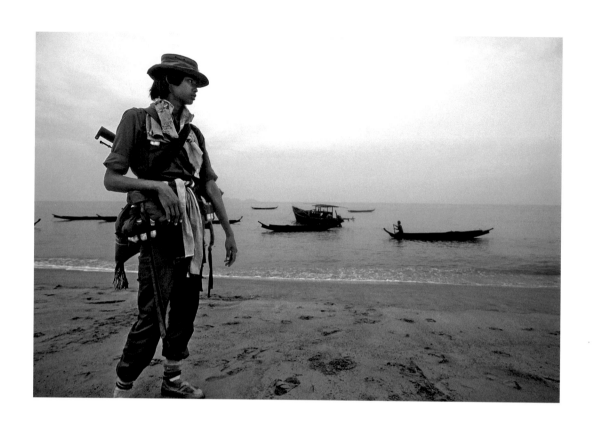

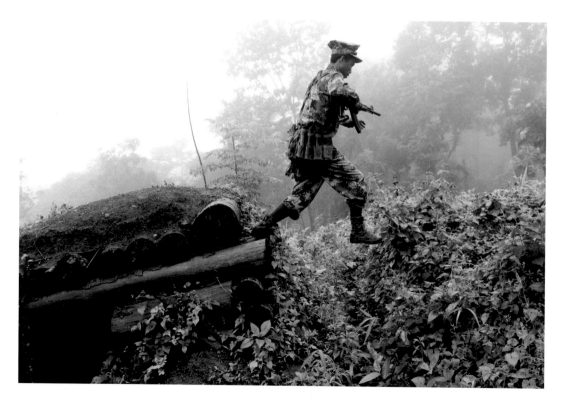

Top: A soldier from the Mon National
Liberation Army walks along a beach on
the Andaman coast.
Mon State, 1988.

Bottom: A soldier from the Kachin
Independence Army jumps from the
roof of a bunker in a frontline camp.
Kachin State, 2011.

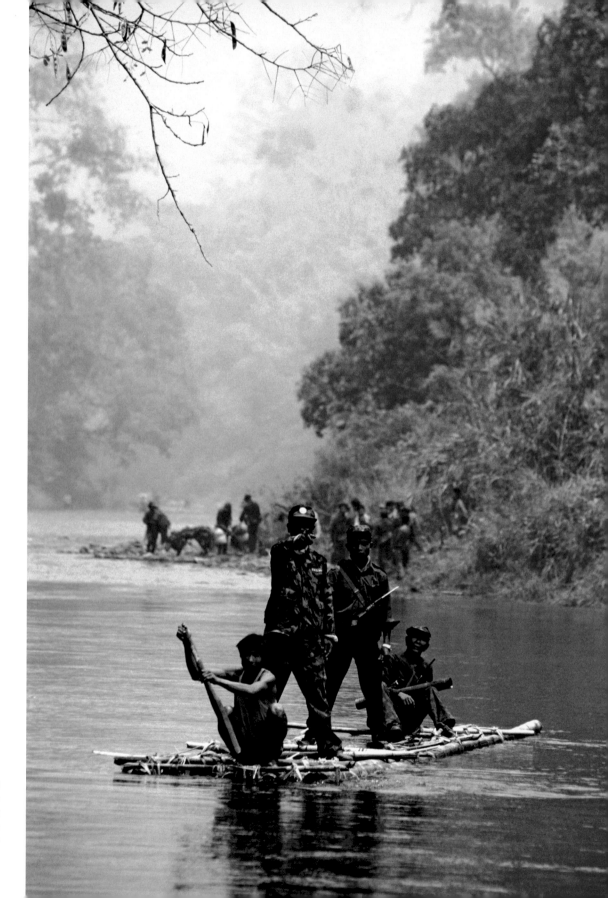

U Saul Lu, aka Ta Pluik, leader of an
anti-drug faction of the United Wa State
Army, crosses a river during an
expedition in the Golden Triangle.
Shan State, 1993.

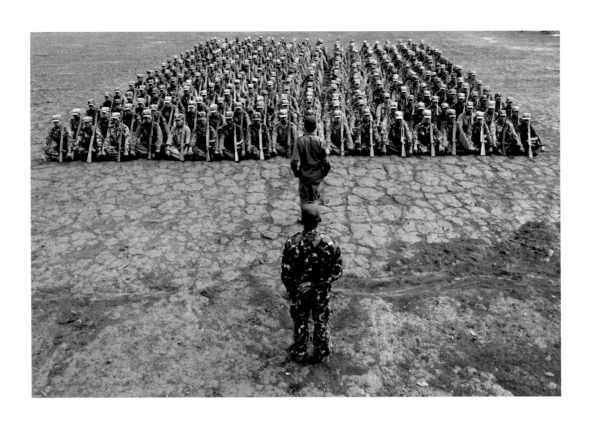

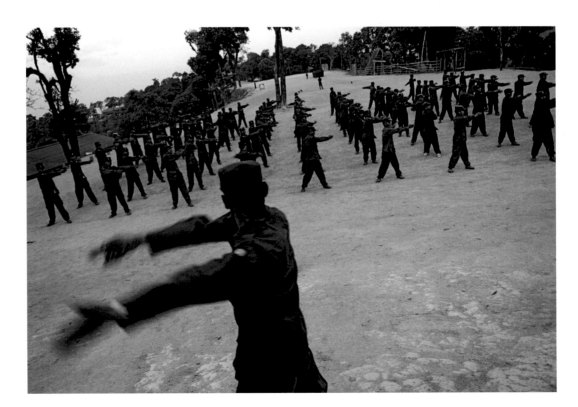

Top: Chief instructor Sai Tee leads
a training session for officers from
the Shan State Army - South.
Shan State, 2010.

Bottom: Young recruits are drilled
during a training session for Shan
State Army - South officers.
Shan State, 2003.

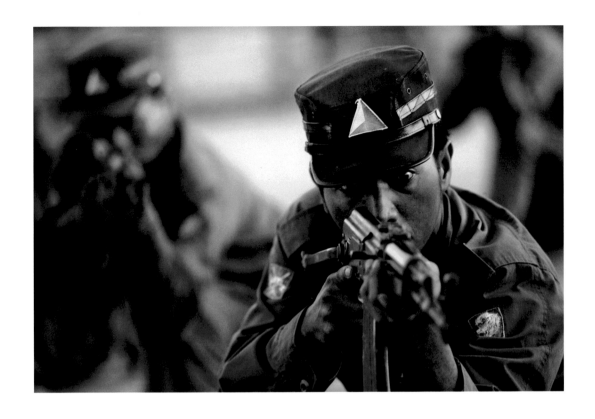

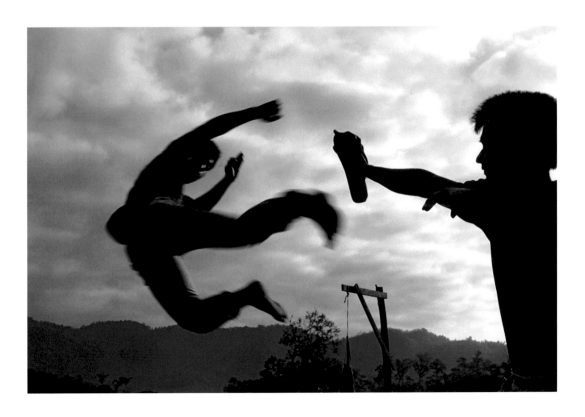

Top: Soldiers from the Shan State Army - South undergo weapons training at their Loi Tai Leng headquarters.
Shan State, 2003.

Bottom: A guerilla with the Karen National Liberation Army practices martial arts.
Karen State, 1987.

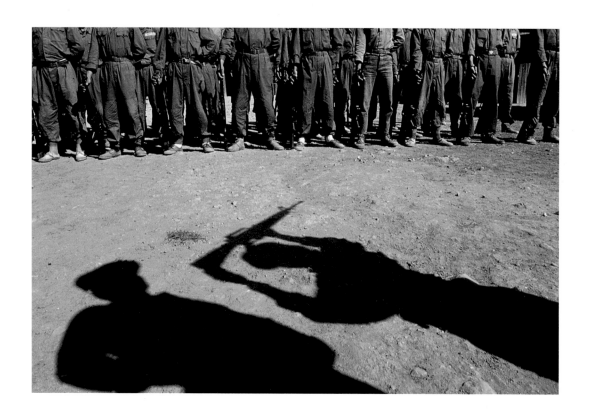

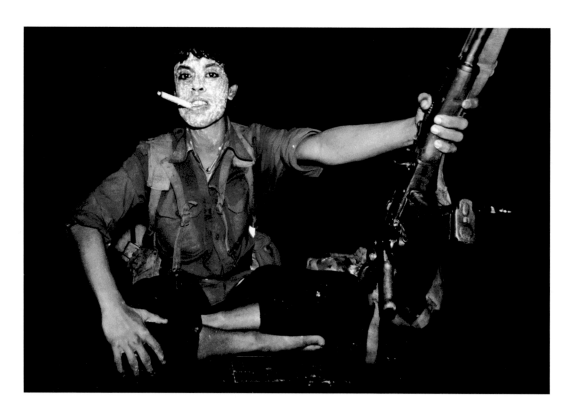

Top: A Mong Tai Army officer
casts a distinctive silhouette on
the parade ground.
Shan State, 1994.

Bottom: A soldier from the Mon
National Liberation Army poses
during a military expedition.
Mon State, 1988.

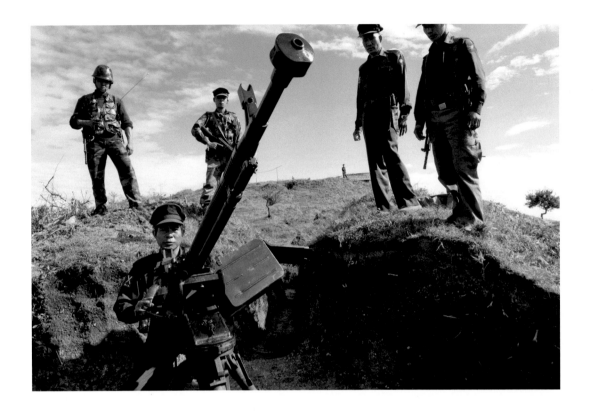

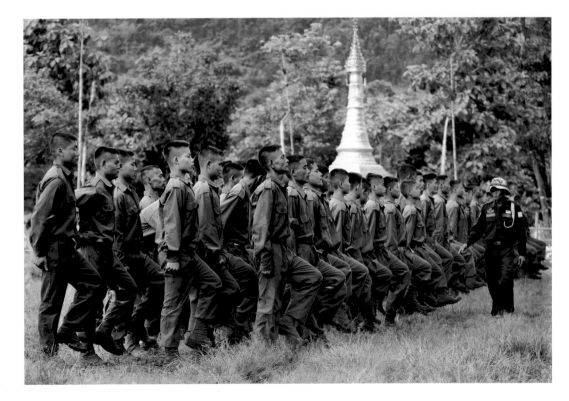

Top: Officers from the Kachin
Independence Army inspect one
of their positions which is
armed with a Chinese-made
anti-aircraft gun.
Kachin State, 2010.

Bottom: An instructor from the
Democratic Karen Buddhist
Army drills new recruits.
Karen State, 2010.

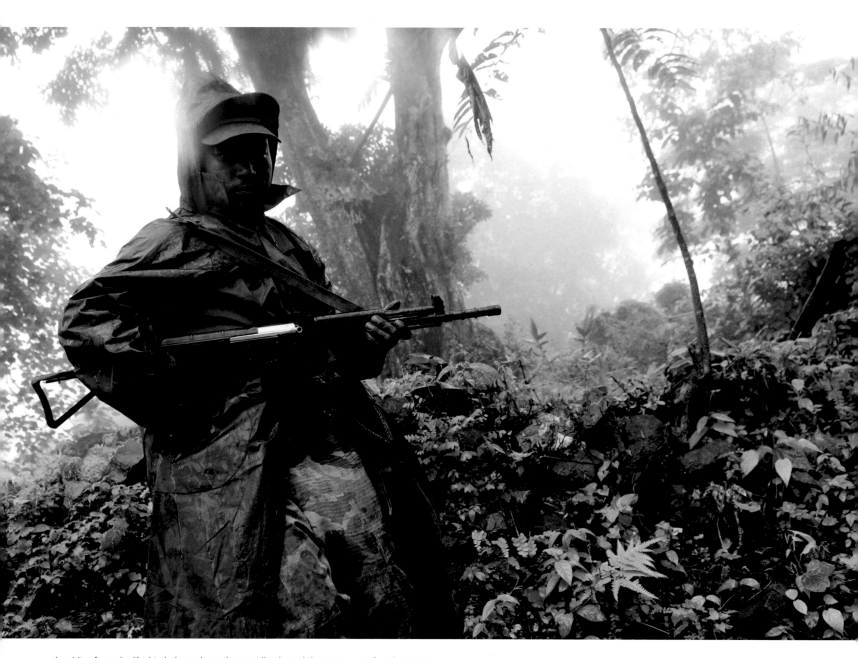

A soldier from the Kachin Independence Army walks through heavy rain in a frontline camp.
Kachin State, 2011.

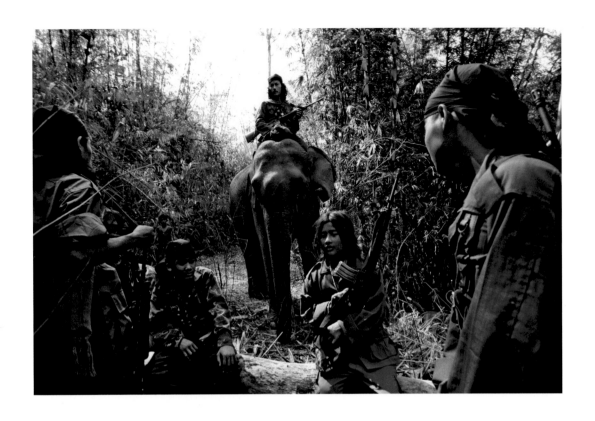

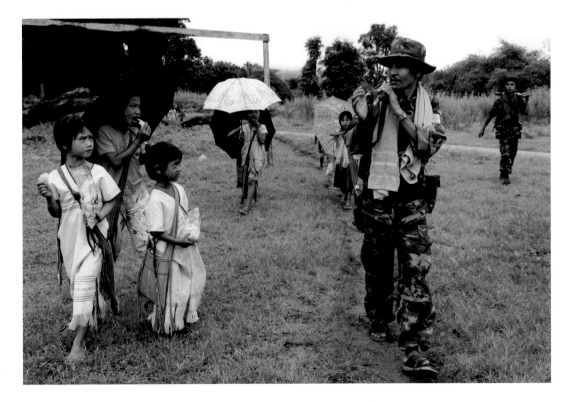

Top: Guerrillas from the Karen splinter group God's Army use an elephant to transport supplies and ammunition. Karen State, 1998.

Bottom: A Democratic Karen Buddhist Army patrol passes through a village. Karen State, 2010.

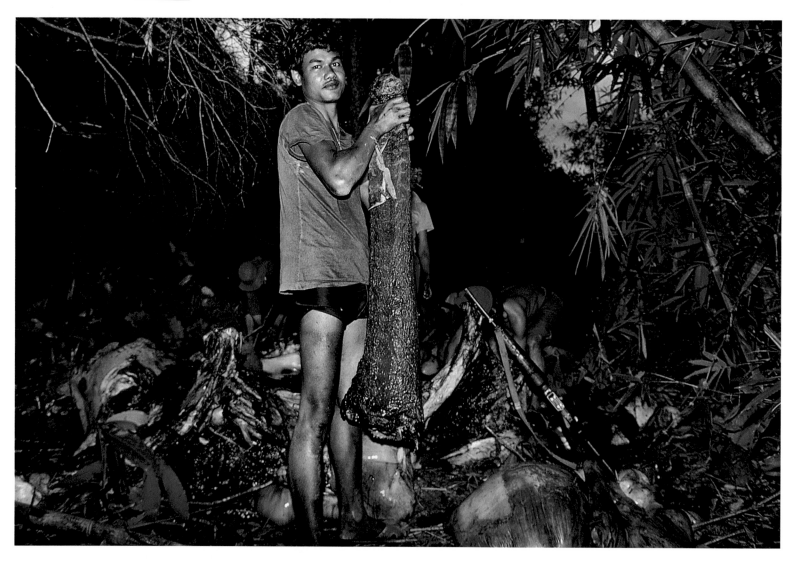

A guerrilla from the Mon National Liberation Army displays the trunk of a young elephant that
he and his comrades have trapped and killed in the jungle. The soldiers will eat the animal.
Mon State, 1988.

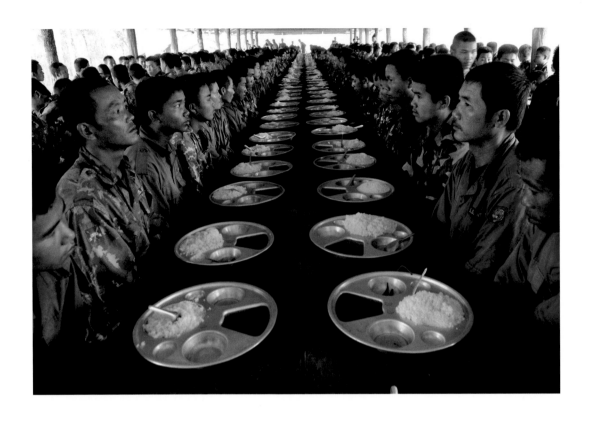

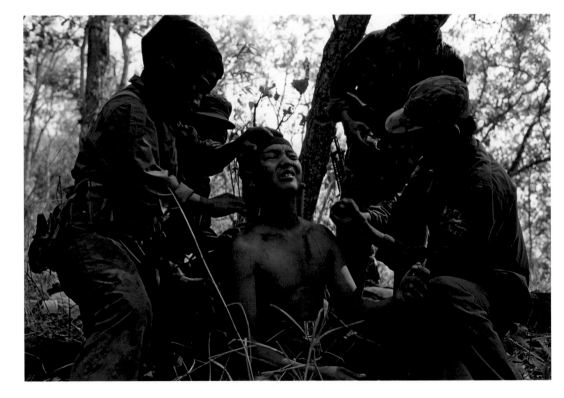

Top: Officers from the Shan State
Army - South sit at attention
before breakfast.
Shan State, 2010.

Bottom: Soldiers from the United
Wa State Army treat their
comrade who is suffering from
malaria, during an expedition in
the Golden Triangle.
Shan State, 1993.

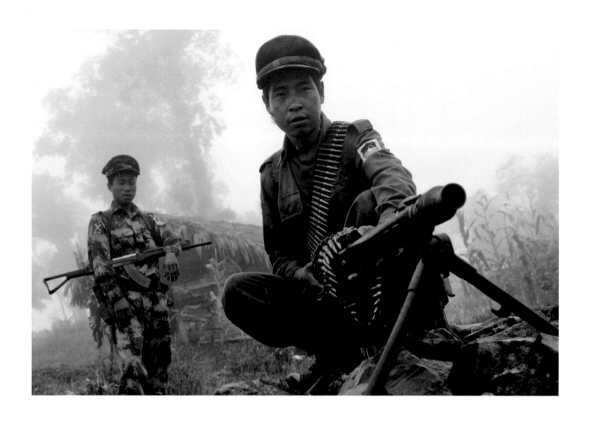

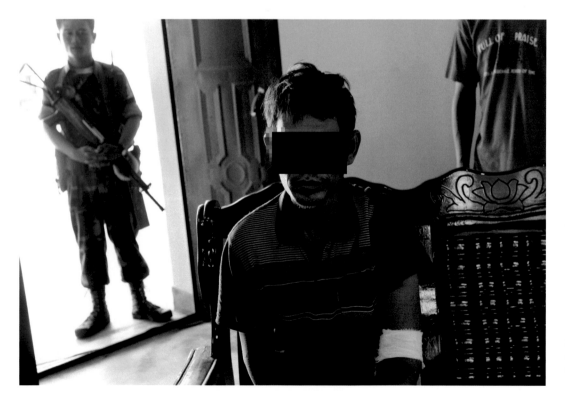

Top: A soldier from the Kachin Independence Army shows a German-made machine gun seized from the Burmese army during a clash.
Kachin State, 2011.

Bottom: The Kachin Independence Army interrogates a recently captured Burmese soldier (whose face has been obscured to protect his identity).
Kachin State, 2011.

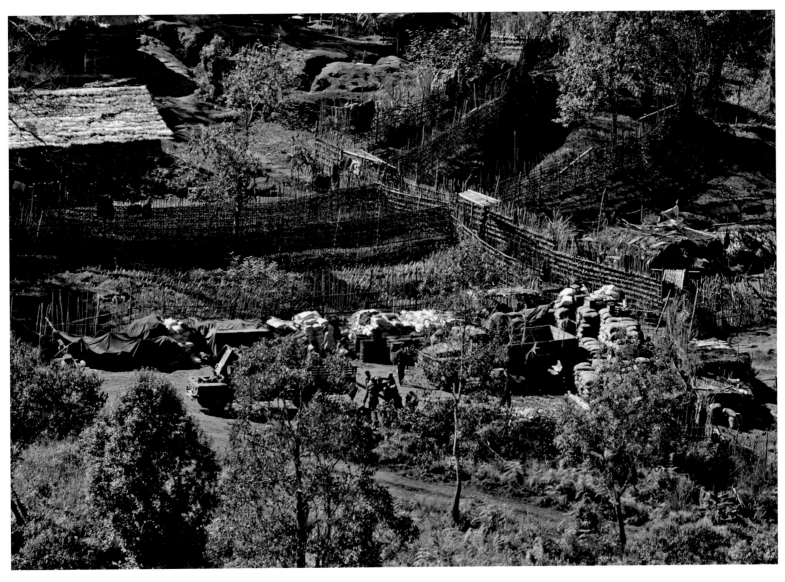

Maw Pu camp, a fortified Burmese army position.
Karen State, 2008.

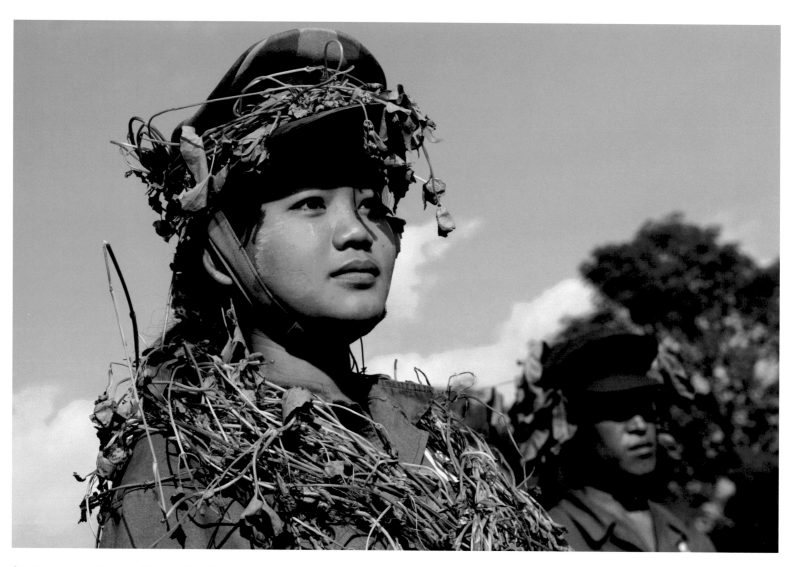

A woman recruit undergoes military training with the Kachin Independence Army.
Kachin State, 2010.

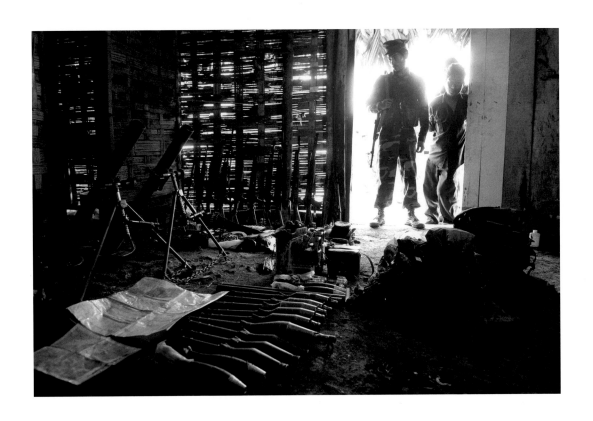

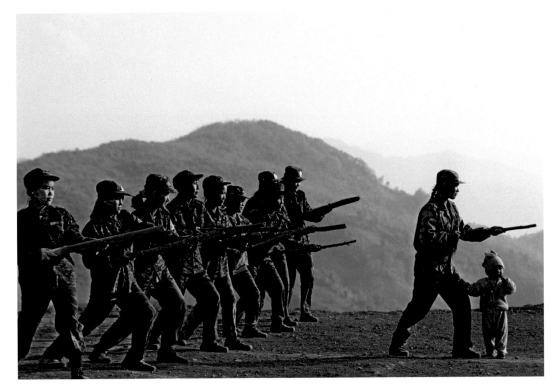

Top: Kachin Independence Army soldiers display weapons, ammunition and other items seized from Burmese soldiers during recent clashes. Kachin State, 2011.

Bottom: A young child grabs his mother who is training alongside other women soldiers with the United Wa State Army. Shan State, 1995.

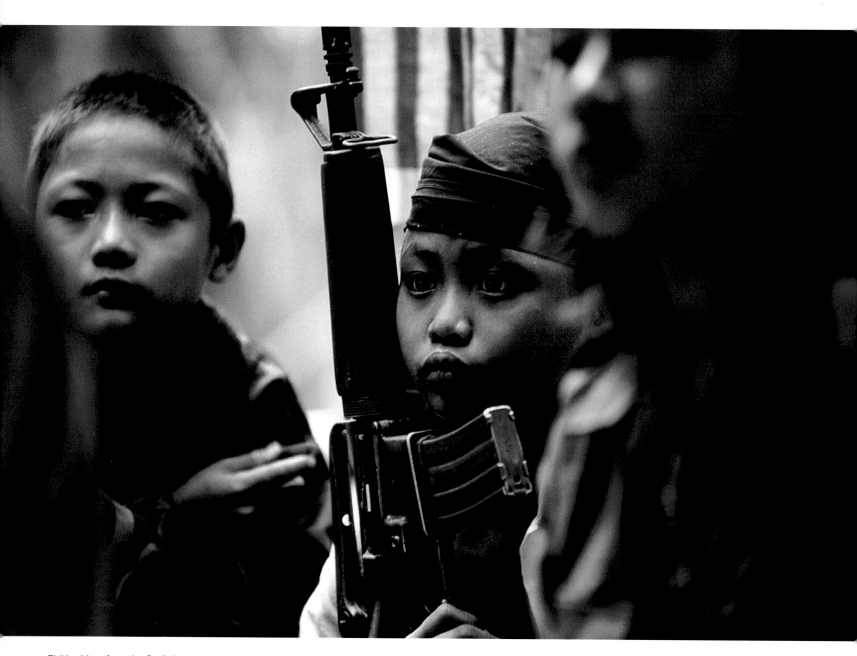

Child soldiers from the God's Army, a Karen splinter group.
Karen State, 1998.

Chapter Eight

LITTLE GENERALS
Child soldiers

It only took a day's trek from the Thai border to a makeshift bamboo camp in Kamaplaw, Karen State, and the headquarters of the God's Army, but this meeting in March 1998 was one of my most memorable. God's Army was an extraordinary group of about 200 soldiers, mostly children and teenagers, run by two generals, twin brothers Johnny and Luther Htoo who were no older than ten at the time. Nobody, even their parents who I would meet later, knew their exact age. A TV producer friend of mine and I were to be the first foreign journalists to meet with them.

At that point, I had been covering conflicts and guerrilla forces across Southeast Asia for a decade and I had seen many children in uniforms carrying guns. Without exception, whether it be Burma, Cambodia and the Philippines, these children were always part of a tragic landscape, pawns who were sent to the battle lines to fight for political or commercial causes deemed fit by respective ethnic, nationalist or drug-related armed movements. The Tatmadaw itself is infamous for recruiting, often press-ganging, soldiers under the age of 18. Human rights organizations estimate that at some stage there were tens of thousands of child soldiers in the Burmese army, including children as young as 10.

The warlords who rely on this young fighting force claim the boys – and very rarely girls – are either orphans or sons from families who are too poor to feed and educate them. Some of the ethnic rebel organizations even build jungle schools for their young conscripts. The famous drug lord Khun Sa added Chinese language to the curriculum for six-year-old pupils at the cadet school at his jungle stronghold. These students all received military training, the most academic ones would later be sent to study business in Taiwan.

Whatever the mythology built up around them by their leaders, these young soldiers were nothing more than children who were being dehumanised and exploited by adult military commanders. Only a lucky few would ever have a chance of achieving anything that came close to a normal life.

But then in Kamaplaw, I realized I was confronting a new reality. In this unique circumstance children, at least the two little generals, were on the other side of the chain of command, leading an armed movement, giving orders to children but also to adults. This bizarre inversion of military hierarchy was rooted in bizarre circumstances that led to the founding of God's Army a year before. As thousands of civilians fled their homes to hide in the jungle from a particularly brutal Burmese offensive against Karen villages in southern Burma, the twins displayed strange behaviour – not only did they appear calm and unfazed by the fracas, showing no signs of fear and not screaming like the other children, the boys reportedly told a desperate villager that they had had a vision. They ordered him to gather seven men, seven uniforms, seven weapons and to attack a specific location nearby. The tactic worked. The Burmese soldiers were routed and the twins emerged as a new hope amid a desperate situation. Their emergence worked on another level as well, as many Karen living in the area believed in an animist-inspired prophesy of the coming of a new messiah during hard times. The twins were also believed to harness all kinds of supernatural powers, including the ability to make their followers immune to enemy bullets.

Sadly, though perhaps inevitably, it did not take long for God's Army to be hijacked and manipulated by adults from within the main Karen National Liberation Army who were always ready to seize any opportunity to fight the Burmese. Johnny and Luther's story ended dramatically in 2000 after a group of ten radical Burmese students who had previously taken shelter in Kamaplaw decided to raid a hospital, which had hundreds of patients and medical staff, just over the border in Thailand. All of the students were shot dead by Thai special forces after a 24-hour standoff. God's Army was forced to disband. The luckiest of its combatants, including the twins, surrendered and were relocated to a refugee camp. Others disappeared, allegedly massacred by rogue Thai rangers.

The story came full circle a few years later, when Johnny Htoo enlisted in the Burmese army, while his brother, now a married man and a father, was relocated to Sweden by the United Nations.

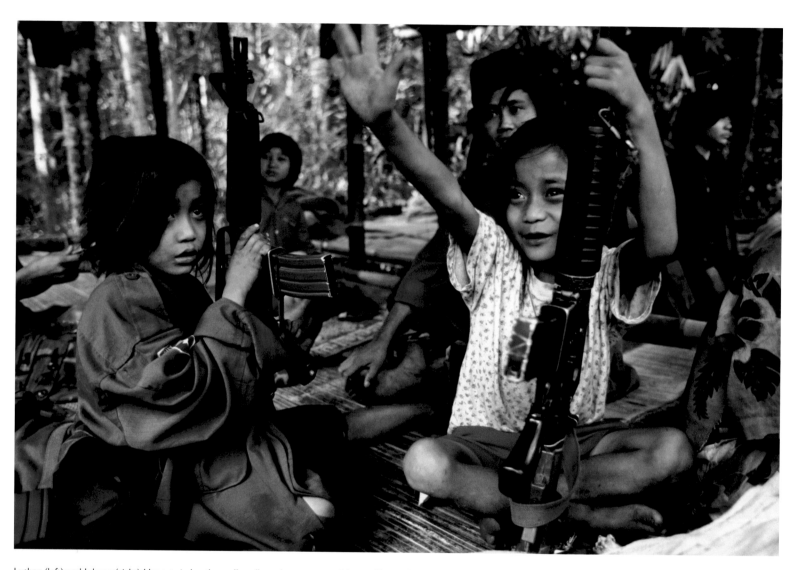

Luther (left) and Johnny (right) Htoo, twin brothers allegedly under ten years old, sit in Kamerplaw, headquarters of the
God's Army, a Karen splinter group which they led. The Karen boys, who were believed to possess magical powers that
made them immune to bullets and landmines, were worshipped as messianic figures by their followers.
Karen State, 1998.

Johnny Htoo, co-leader of God's Army smokes a cheroot.
Karen State, 1998.

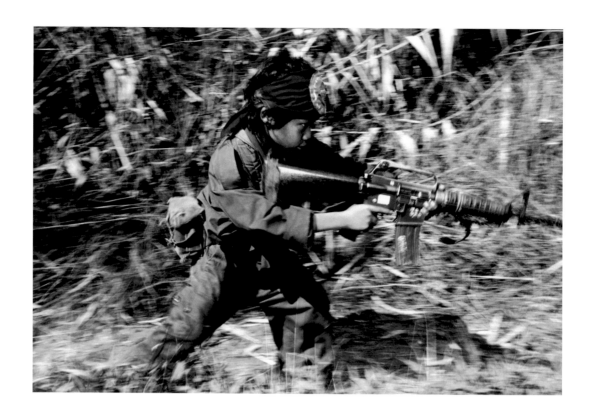

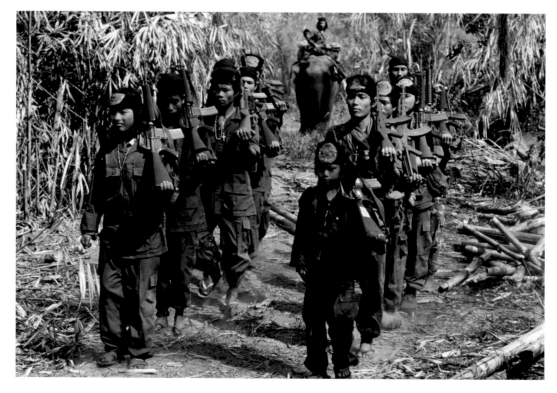

Top: A child soldier from the God's Army runs during a training session. Karen State, 1998.

Bottom: A squad of God's Army Soldiers on parade in their headquarters. Karen State, 1998.

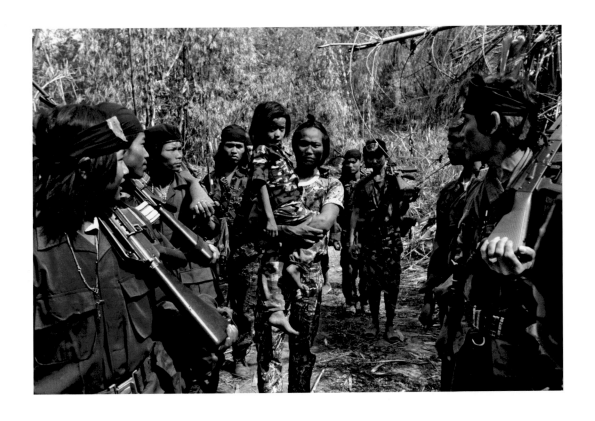

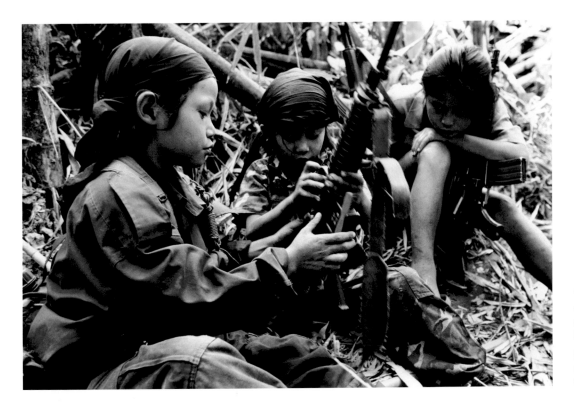

Top: A soldier carries Johnny Htoo, who with his twin brother Luther, commanded the God's Army. Karen State, 1998.

Bottom: Luther Htoo (middle), cleans his rifle. Karen State, 1998.

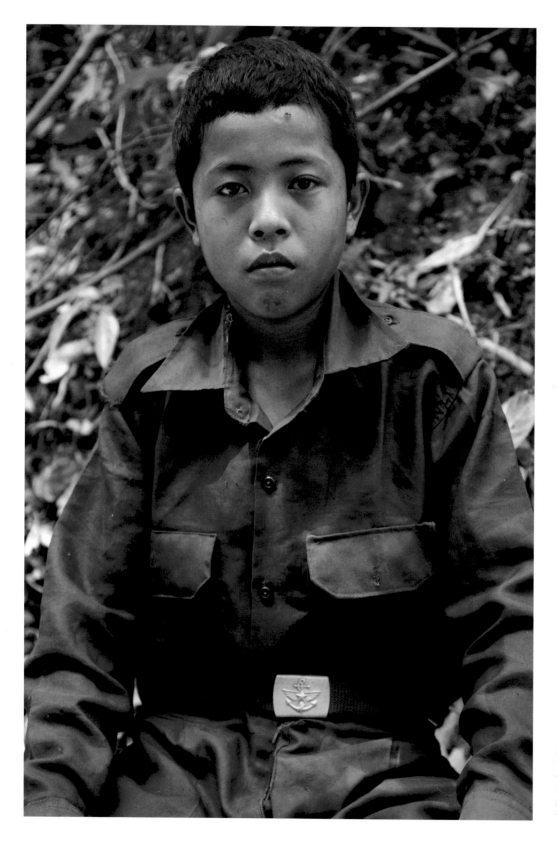

A 15-year-old soldier from the Burmese army sits in the forest after being caught and brought to Thailand by an ethnic guerrilla group. Thailand, 2005.

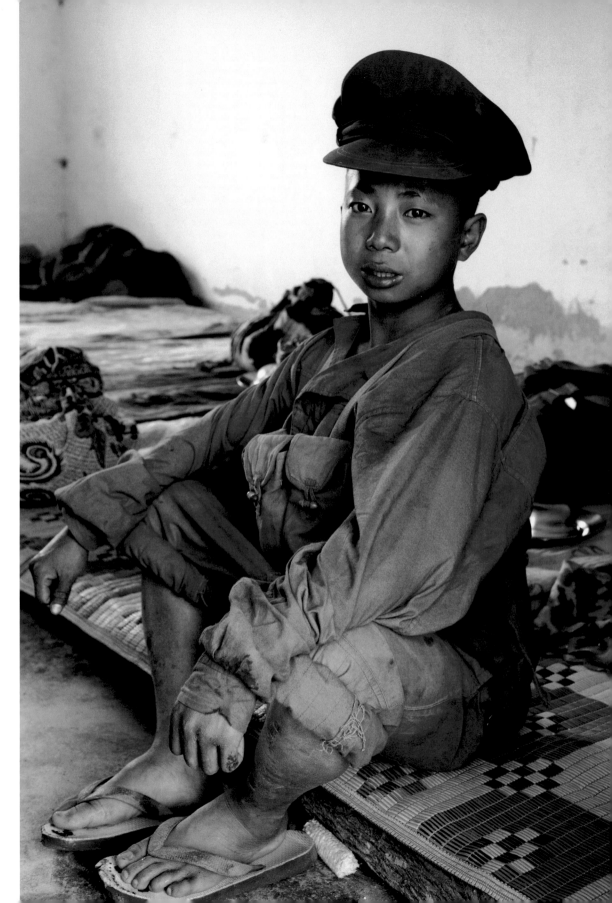

A young recruit from the Kachin
Independence Army rests.
Kachin State, 2010.

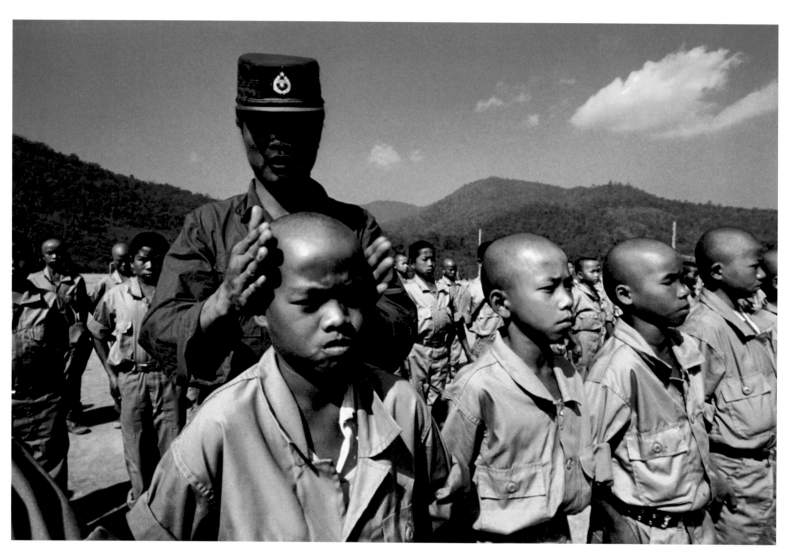

Child soldiers in drug warlord Khun Sa's Mong Tai Army train at their headquarters.
Shan State, 1994.

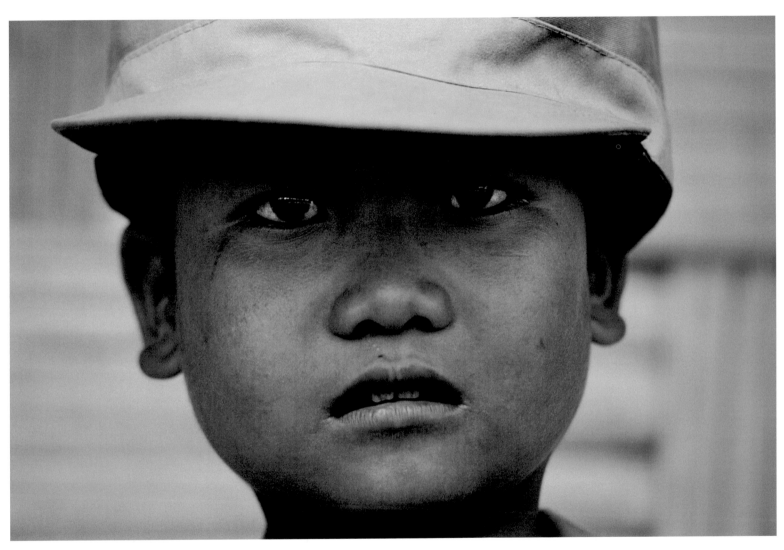

A child soldier in the Mong Tai Army.
Shan State, 1994.

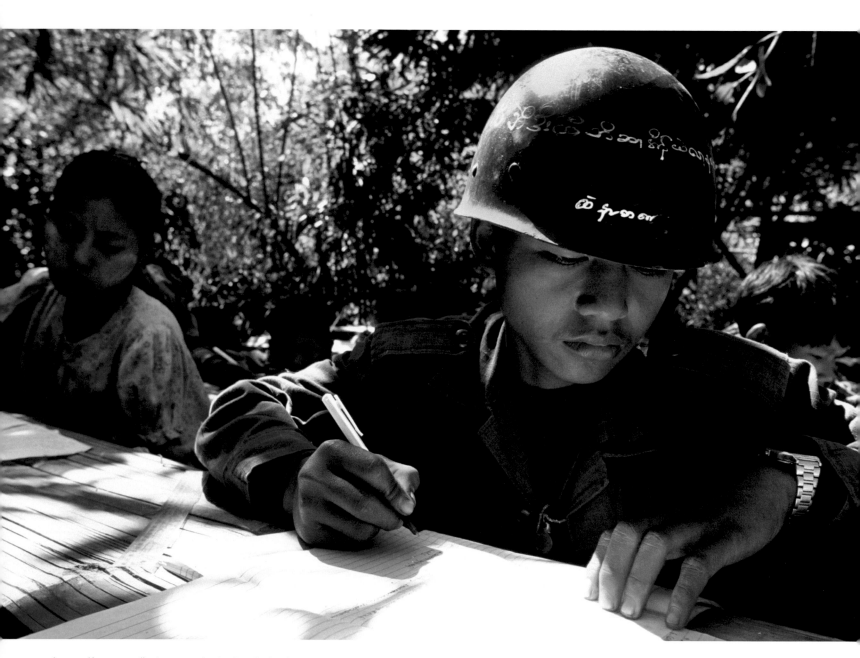

A young Karen guerrilla sits an examination in a displaced persons camp.
Karen State, 2001.

Chapter Nine

JUNGLE SCHOOLS
DIY education

About one month after the 17-year ceasefire between the Burmese government and the Kachin Independence Organisation, the main Kachin nationalist group, broke down in June 2011, I entered Kachin State from the Chinese border.

Shelling echoed around the usually quiet border area and soldiers from both sides were killed, injured or taken prisoner. Tens of thousands of civilians had fled their villages for relative safety along the border. The Kachin Independence Organisation was organising accommodation, food supplies and medical facilities in community halls, fields and other available spaces, but it also made it a priority to ensure the education of children was disrupted as little as possible. Local teachers worked overtime to teach the refugee children, while young Kachin volunteers, some of them returning from as far away as Rangoon about 1,000 kilometres away, built makeshift schools out of bamboo and other available material. "This is our way to fight the Burmese attempt to subdue us, to keep our children educated", one teacher told me.

A few months earlier, across the Eastern border in Thailand, I had witnessed another striking scene. A young exiled Burmese monk was assisting other Burmese who had fled their homeland for political or economic reasons. A small community had settled on a local rubbish dump so they could make a little money from sifting through the trash. When I say "on" I mean their houses, tiny makeshift wooden huts, were literally built on top of massive piles of refuse. Private donations enabled the monk to open the "Blue Sky School" nearby. It was a basic structure, little more than cement bricks with a thin roof and a playground built on a wasteland in Mae Sot's outskirts.

One afternoon, as the monk was taking me to look around the community, I saw two young girls sitting on a mat spread out on the trash in front of their family's shelter. They were doing their homework and reading books aloud together, not even looking up to acknowledge our presence.

The fact that hundreds of thousands of children in Burma have been relegated to learning in ramshackle schools in towns, cities and jungle is a clear sign of just how far the country has fallen from its once-hallowed status as a figurehead for education in Asia. Decades of corrupt government have left this rich heritage in tatters. After the 1988 popular uprising, universities were closed, some were demolished, others relocated to new far away cities.

Although accurate statistics on education in Burma are almost impossible to compile, estimates from a wide range of United Nations agencies all confirm low levels of primary school completion and poor secondary school enrolment, about 50 percent in both cases.

For years, government spending on education only accounted for a touch over 1 percent of the national budget, twenty to thirty times less than annual military expenditure. In 2012, the new civilian government more than tripled the budget for education while keeping the defence expenditure to a quarter of total government spending. This is certainly an improvement but it is still very far away from ensuring millions of Burmese children have a chance of receiving a decent education.

It seems, for the near- to medium-term at least, that jungle schools and makeshift learning centres on rubbish dumps and in urban centres will remain the only places of education that many Burmese children will ever know.

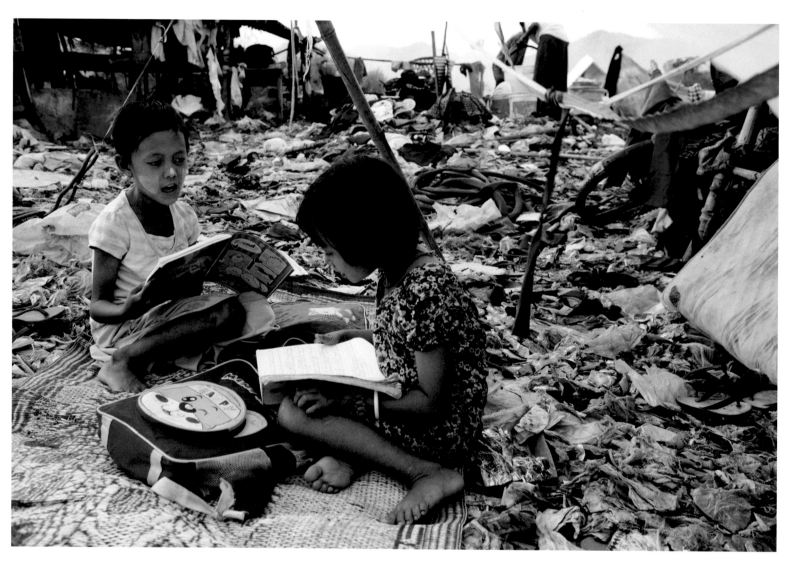

Two Burmese refugee girls do their homework outside their
makeshift home on a rubbish dump along the Thai border.
Thailand, 2010.

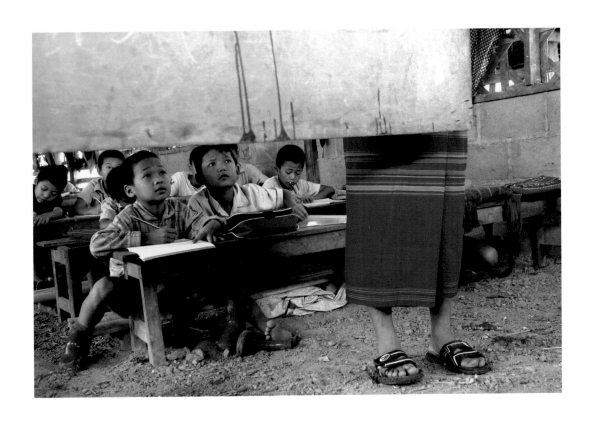

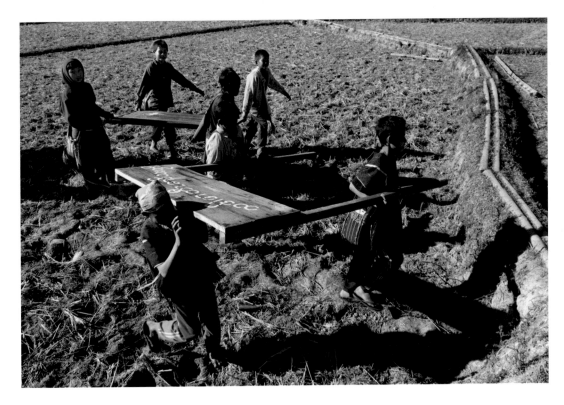

Top: Burmese refugees study at a
school at Mae La Refugee camp.
Thailand, 2006.

Bottom: Children carry blackboards back
to their village school after classes were
temporarily moved to a field following an
attack by the Burmese army.
Karen State, 2008.

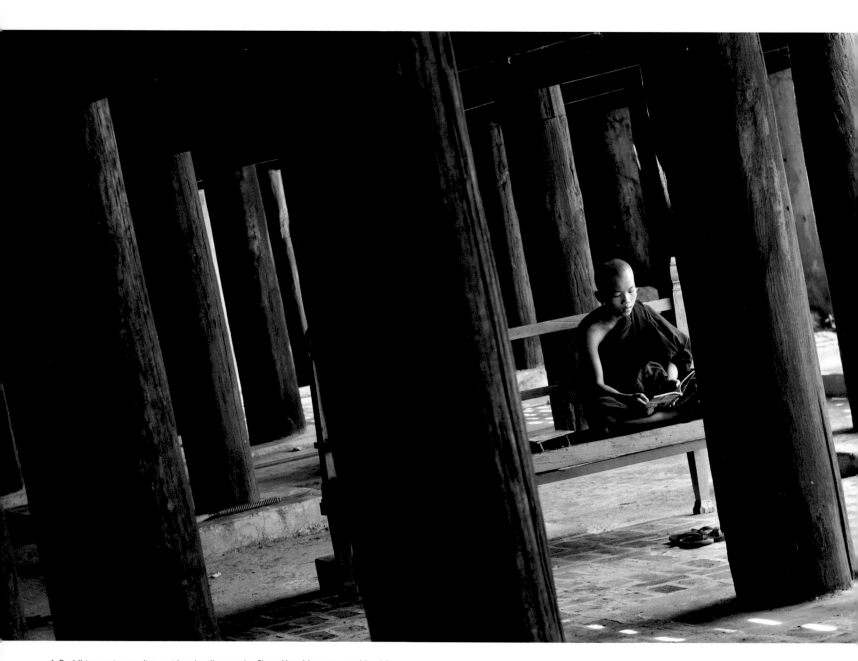

A Buddhist novice studies amid teak pillars at the Shwe Kyin Monastery in Mandalay.
Mandalay Division, 2009.

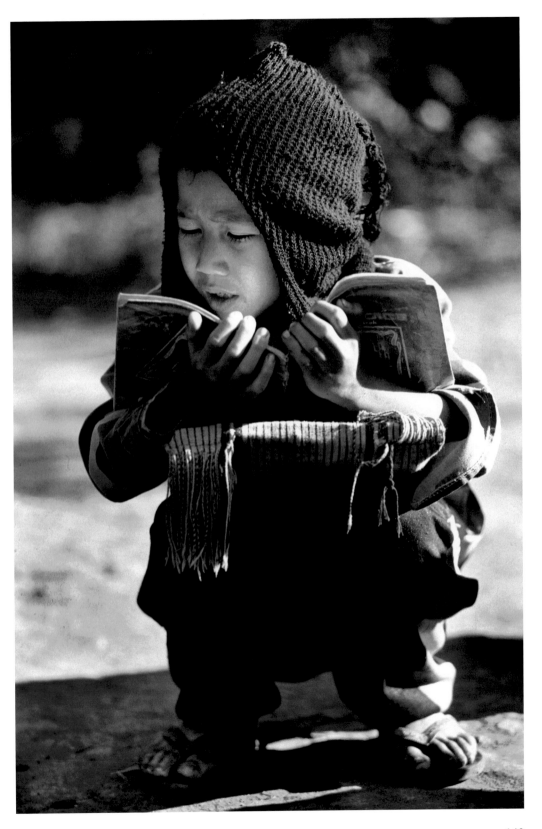

A boy from a displaced community
studies at an outdoor school.
Karen State, 2006.

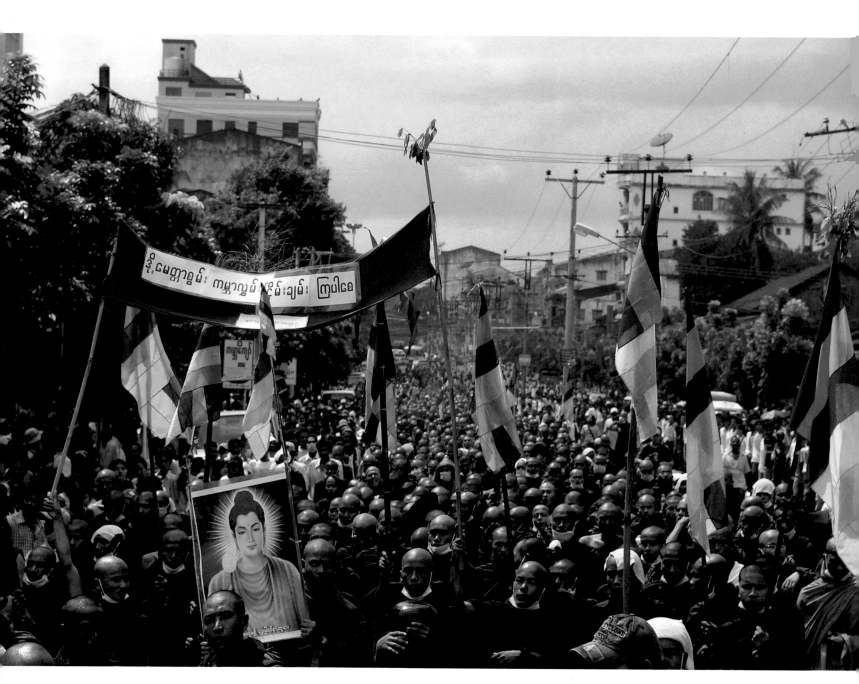

Thousands of Buddhist monks take to Rangoon's streets to demonstrate
against the rising cost of living and for greater freedom.
Rangoon Division, 2007.

144

Chapter Ten

THERE WILL BE THOUSANDS
The 2007 monks' uprising

On the afternoon of September 13, 2007 I was wandering around downtown Rangoon when a young monk from Rakhine State approached me and, after the usual informal chat, told me in a rather good English: "In four days, you must go to the Shwedagon Pagoda, there will be 100,000 people calling for democracy." Sceptical about such a bold statement, I smiled politely and replied that I would definitely be there and that I hoped to see him again. It turned out that this young monk would be wrong… but only by ten days or so.

I had arrived in Burma's former capital two days earlier. For the first time in years something was boiling away in the public psyche, pressure was building against the military regime. It was impossible to say what was going to happen, but there was a discernable tension in the air, and it felt inevitable that something significant would transpire. Initially the key catalyst for this rising tension was economic not political. In mid-August the government had triggered sporadic street protests by declaring overnight increases of up to 500 percent in the price of fuel. Three weeks later on September 5th, a demonstration in Pakokku, a small town in western Burma known for its tobacco industry and for being a centre of Buddhist education, turned nasty when soldiers beat up and arrested monks. A previously unknown, clandestine Buddhist organisation then called on monks to boycott receiving alms from soldiers and their relatives until the army made an official apology for the beatings. The political situation was more uncertain than it had been in years, but as always in Burma it was anyone's guess what the outcome would be.

The political involvement of Buddhist monks was no coincidence. Monks have always played an instrumental role in the popular uprisings that have taken place over the past few decades. At times they have paid a very high price for their actions – scores were massacred in 1988 and hundreds arrested in the 1990s.

On September 18th, a few hundred monks walked across Rangoon in the pouring rain, chanting Buddhist prayers of love and compassion. Within a few days civilians had joined the group, swelling its ranks into the largest public protest the country had witnessed since the 1988 uprising, certainly many more than the 100,000 people predicted by the young Rakhine monk. The event sparked similar demonstrations in other cities across the country. On September 26th, a huge crowd of civilians took to the streets around the Sule Pagoda in downtown Rangoon to surround and protect a gathering of thousands of monks. Many others assembled in another district where they faced down security forces who had closed access to a major monastery. In stark contrast to the growing numbers on the streets, we foreign journalists and photographers who were lucky enough to get a visa never numbered more than twenty. Alongside our Burmese colleagues, many of whom had never experienced such democratic fervour, we were somehow able to work despite the obvious presence of the regime's henchmen within the crowd, namely plain-clothes intelligence officers sporting incongruous "Press" badges or taking pictures of the crowd.

People came to us spontaneously telling us how much they hoped the demonstrations would bring about the end of Burma's military dictatorship. Such actions would have been unthinkably dangerous a couple of weeks earlier. Another interesting development was that most of these protesters were focusing their anger not on the army *per se*, but on the handful of generals who they said had usurped the people's trust and plundered the country's wealth.

In what seemed to be an inescapable fate, the same generals brutally put down the demonstrations. Policemen and soldiers fired live rounds at the crowd killing at least 39 people, including Japanese journalist Kenji Nagai. Hundreds of civilians and monks were beaten up and arrested. Thousands went into hiding.

Those tragic ten days offered up another unexpected development. For the first time since she was returned to house arrest in 2003, Aung San Suu Kyi made a furtive public appearance at the gate of her residence on

University Avenue. On September 22nd, she came out and wept as she greeted the crowd of a thousand monks, surrounded by policemen, who had gathered in the heavy rain. Only a blurred picture taken with a cell phone remains of that brief appearance but it was enough to remind the country and the world that her popularity remained intact.

The whole world had observed what was wrongly dubbed the "Saffron Revolution" – Burmese monks do not wear saffron robes and there was no revolution – in horror. Only history will tell, but there is a credible theory that the September crackdown and the disastrous handling of the Cyclone Nargis disaster seven months later (see Chapter 11) increased divisions within the military which in turn would play a significant role in delivering the positive measures initiated in 2011 by the new civilian regime with the cooperation of Aung San Suu Kyi. Against all odds, the 1991 Nobel Peace Laureate even made her debut as a member of parliament after being elected in the April 2012 by-election.

Civilians protect monks who are demonstrating for more freedom in Rangoon.
Rangoon Division, 2007.

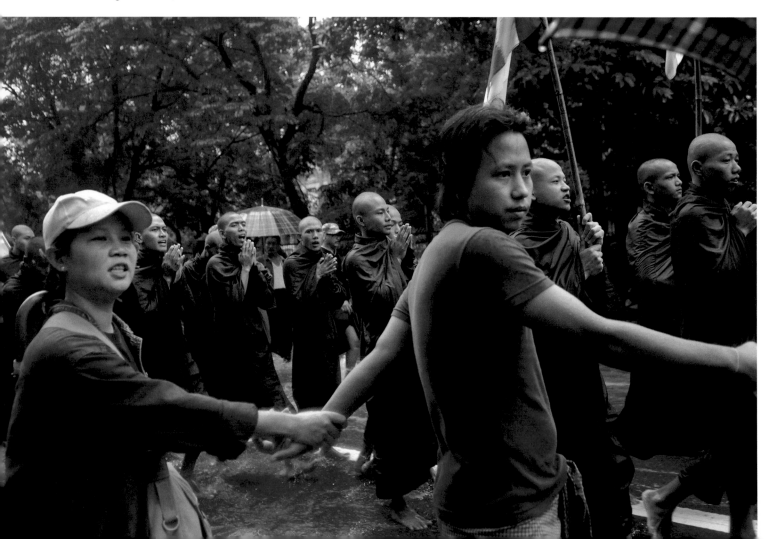

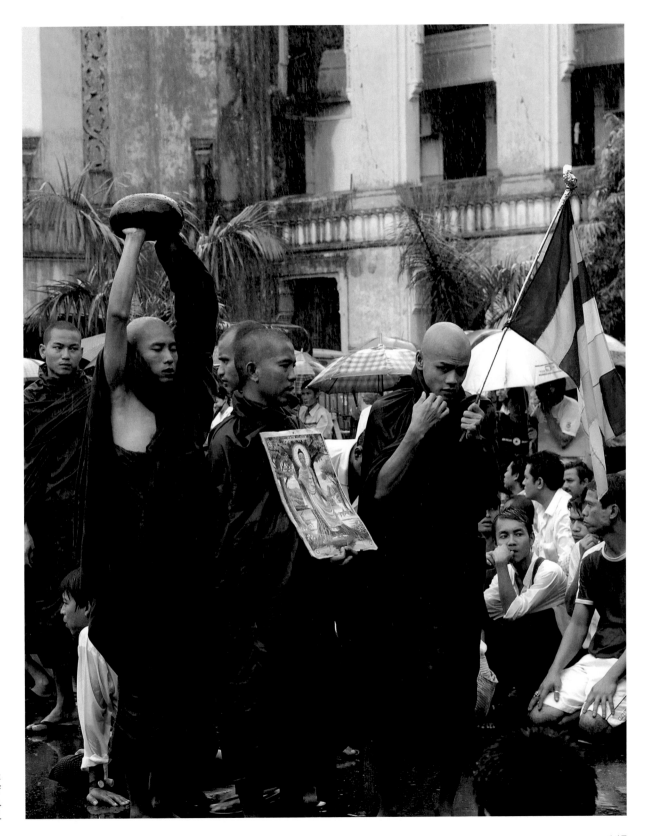

A Burmese Buddhist monk
overturns his alms bowl in a sign of
protest against the military junta.
Rangoon Division, 2007.

147

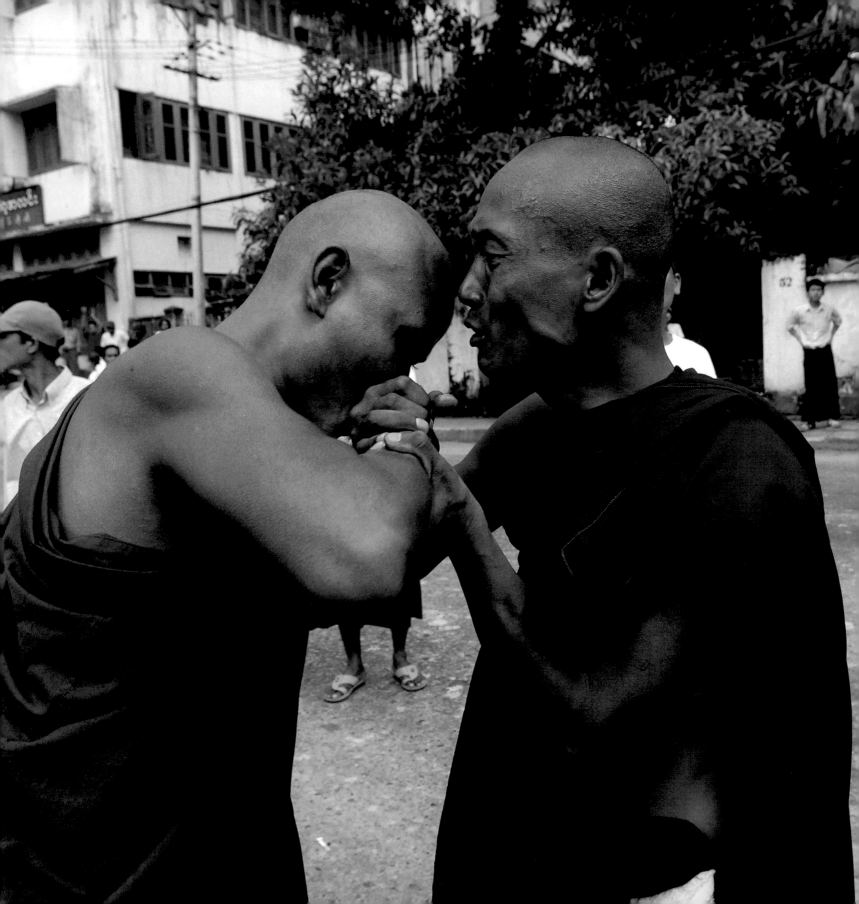

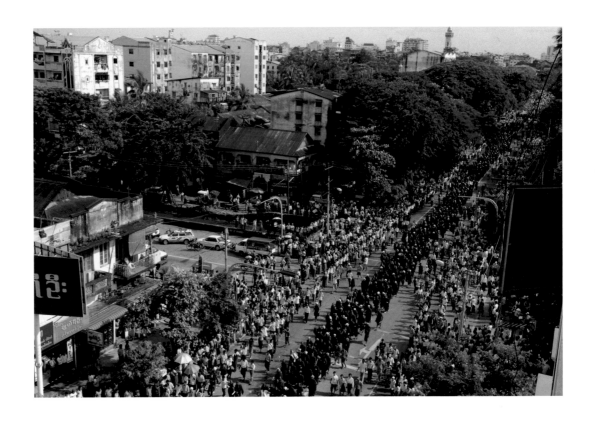

Opposite page: Two Buddhist monks protesting for more freedom embrace in an emotional encounter. Rangoon Division, 2007.

Top: Buddhist monks and civilians take to the streets of Rangoon to demonstrate for more freedom. Rangoon Division, 2007.

Bottom: Burmese soldiers guard the entrance of an official building as monks protesting for more freedom walk by. Rangoon Division, 2007.

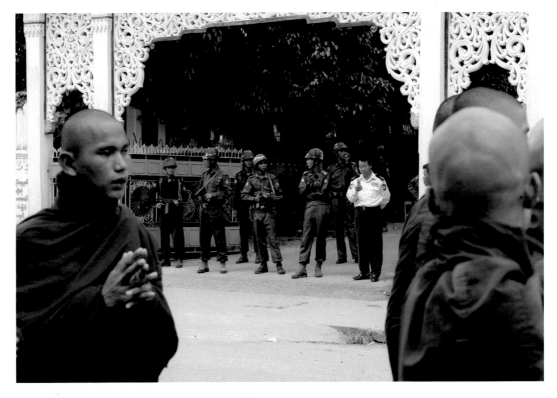

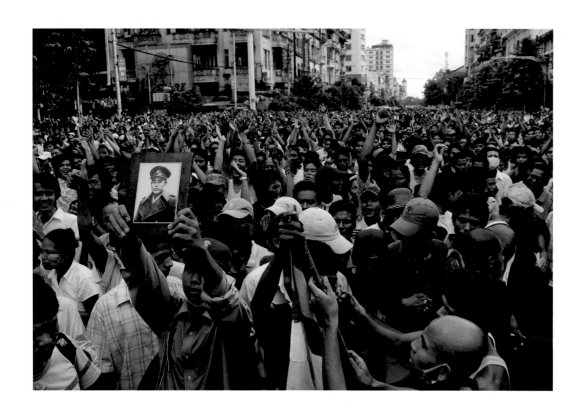

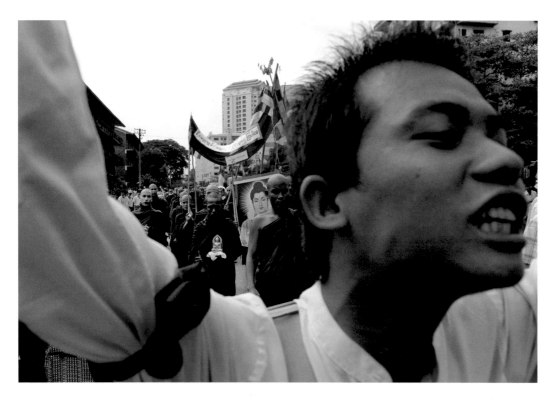

Top: A protester brandishes a
portrait of Aung San, father of
the country's independence
movement during a
pro-democracy protest.
Rangoon Division, 2007.

Bottom: Monks carrying a
Buddha image walk behind
civilians during a pro-democracy
demonstration.
Rangoon Division, 2007.

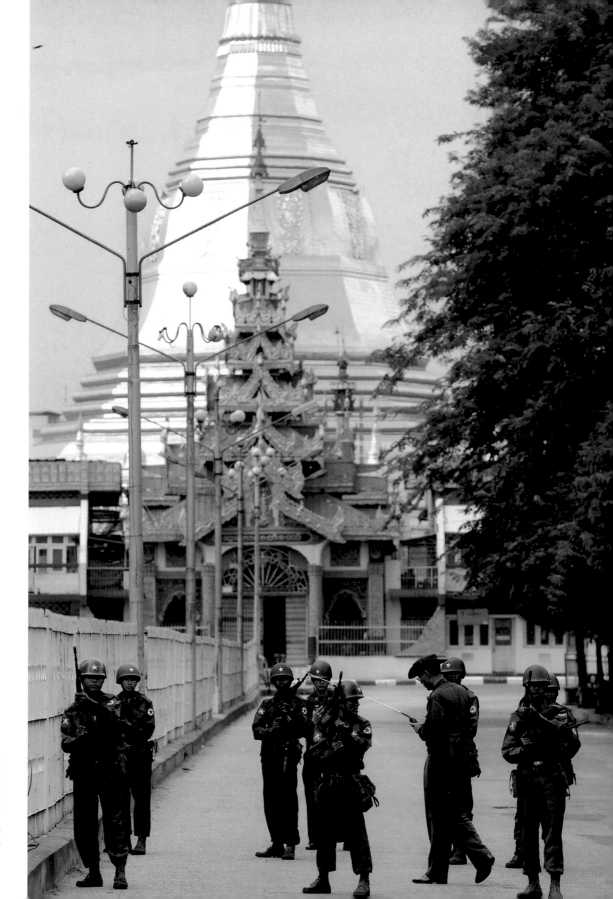

Burmese soldiers guard an access street to the Sule Pagoda, one of the most revered Buddhist shrines in Burma and a rallying point for anti-junta demonstrators. Rangoon Division, 2007.

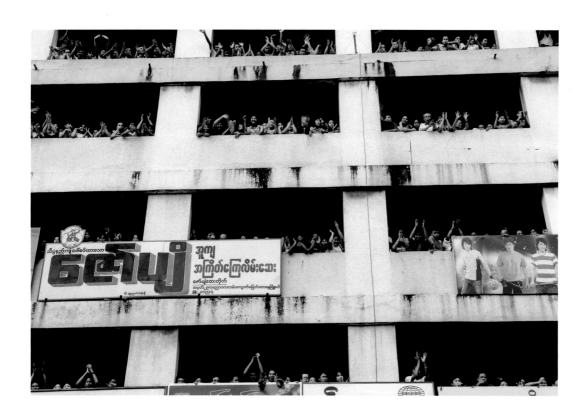

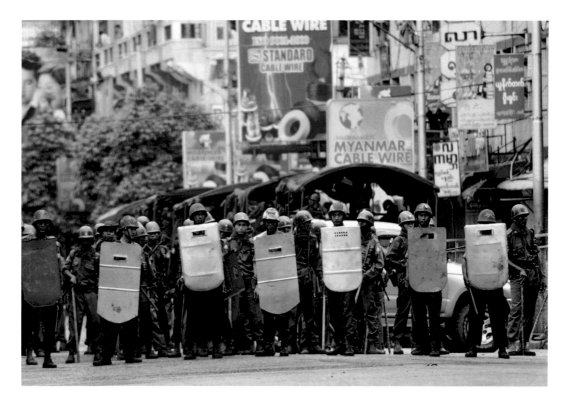

Top: Thousands of civilians cheer
protesters from a parking lot.
Rangoon Division, 2007.

Bottom: Burmese security forces
block access to a downtown street.
Rangoon Division, 2007.

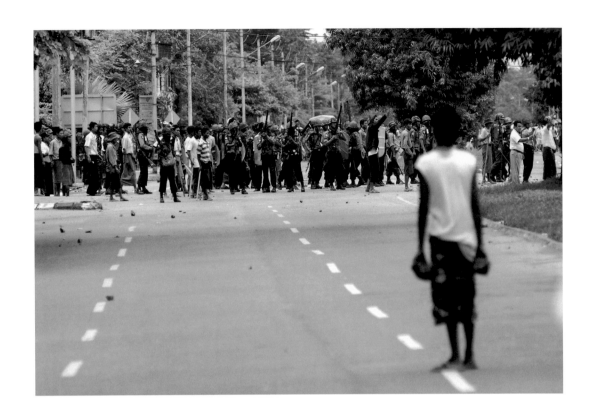

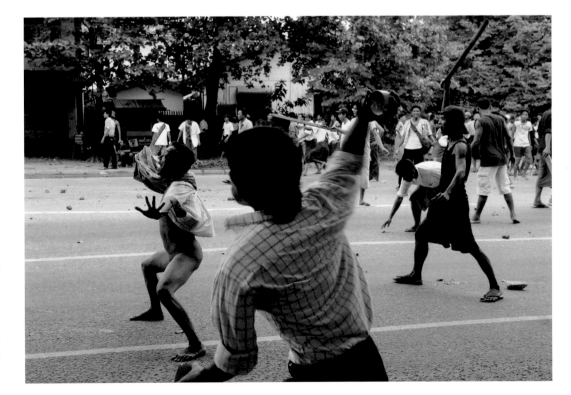

Top: A man armed with stones faces off against Burmese soldiers, policemen and civilian militia who are closing access to a Buddhist monastery during a pro-democracy demonstration. Rangoon Division, 2007.

Bottom: A man strips naked in an act of defiance against Burmese security forces who are closing access to a Buddhist monastery. Rangoon Division, 2007.

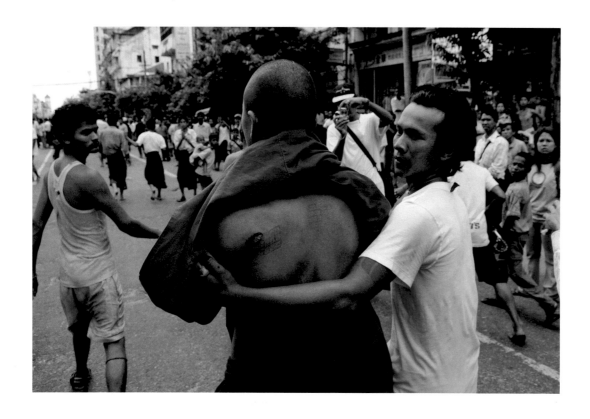

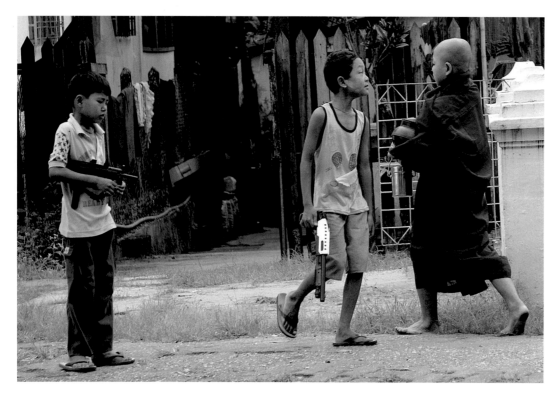

Top: A Buddhist monk who has been shot in the back by Burmese soldiers is helped away by a protester. Rangoon Division, 2007.

Bottom: Children playfully confront a Buddhist novice in a Rangoon street. This picture was taken a few days before the demonstrations. Rangoon Division, 2007.

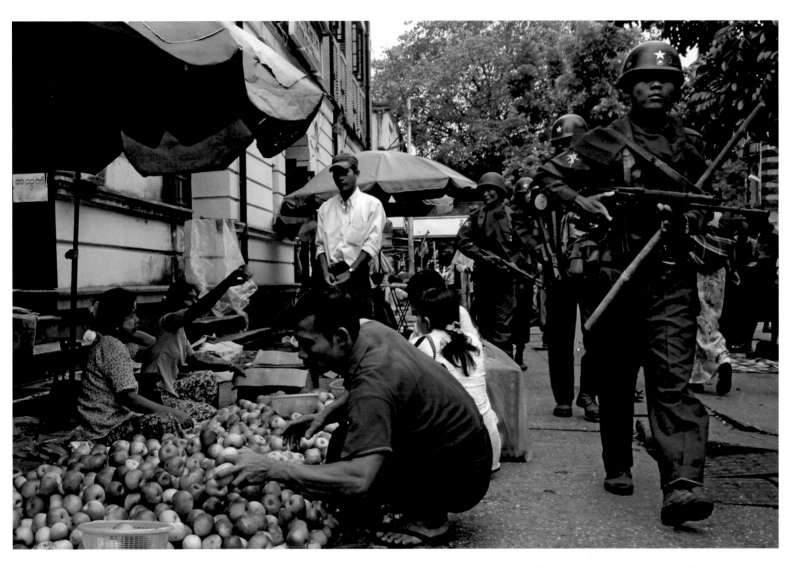

Burmese soldiers patrol a downtown Rangoon street after they suppressed the demonstrations. At least 39 unarmed people were killed and hundreds of others arrested during the crackdown. Rangoon Division, 2007.

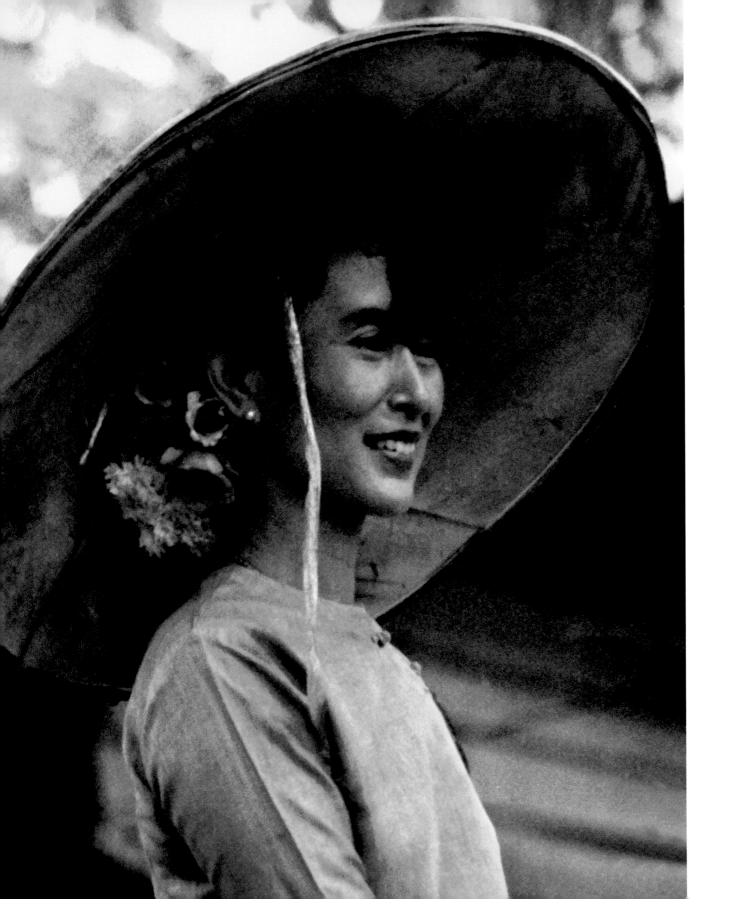

Opposite page: Aung San Suu Kyi gives a public speech from the gate of her Rangoon home in heavy rain. Rangoon Division, 1996.

Top: Aung San Suu Kyi works on the terrace of her home. Rangoon Division, 1996.

Bottom: A taxi driver shows a picture of Aung San Suu Kyi popularly known as "The Lady". Rangoon Division, 2011.

Khin San Win, 28, fell into madness after Cyclone Nargis killed her two sons. Abandoned by her husband, she is living alone in a small hut, spending days sitting idle and muttering incoherently. Irrawaddy Division, 2008.

Chapter Eleven

LOCKED IN HER MIND
Cyclone Nargis

Cyclone Nargis hit Burma's Irrawaddy Delta region on May 2, 2008, and in the space of 24 hours laid waste to farmland and property, leaving more than 140,000 dead and millions homeless. In August 2008, I travelled down to the delta, officially under the guise of a mangrove expert but in reality to report on the recovery efforts and to carry out research for a book I later wrote for a French publisher.

On arrival in the area I spent a whole day interviewing and photographing survivors in Sein Yati, a village where 201 of the 528 residents had been killed in the storm. I was getting ready to leave and take the boat back to Bogale, the nearest town, when somebody took me to the end of a long row of makeshift houses set along a canal. Slowly swaying in a hammock that was hung across a tiny bamboo hut with a tarpaulin roof, a young woman was babbling incoherently as she stared unfocused into the distance. She was wearing a silk blouse and had daubed her face with cheap makeup as if she was getting ready to go out for a party. Through the interpreter I started to ask her questions. "She does not understand you", an older woman replied. She sat down and told us that the girl was her 28-year-old daughter, Khin San Win, who during the horrific night of May 2nd, had witnessed her two children, three- and eight-year-old boys, swept away into the water by the cyclone. Since then she had retreated into her own mind, locking herself in a world nobody else

had access to. Her distraught husband had left in despair, leaving her to the care of surviving relatives.

We heard stories like Khin San Win's again and again all over the delta. Unfortunately the government's response was shocking in the face of the mass suffering. At first, the top generals driven by a mixture of incompetence, paranoia and xenophobia were totally overwhelmed by the extent of the catastrophe, which was Burma's worst natural disaster since records began. For weeks, international relief teams were all but prevented from accessing the devastated areas. Still, a magnificent solidarity effort improvised by Burma's fledgling civil society, religious networks, local and international private companies, as well as non-governmental organisations already at work in the country, provided support and emergency relief for survivors. Eventually the government initiated its own recovery plan and allowed international humanitarian organisations to work in the cyclone-hit area. Ministers and cronies were ordered by Than Shwe, the junta's most powerful general, to share the job. Some inevitably took advantage of the situation and used the opportunity to fill their own pockets with funds provided by foreign aid. Others, such as the then prime minister Thein Sein, who in 2011 would emerge as a progressive president, engaged proactively with foreign and Burmese NGOs to devise projects and initiatives which would help survivors recover and start a new life.

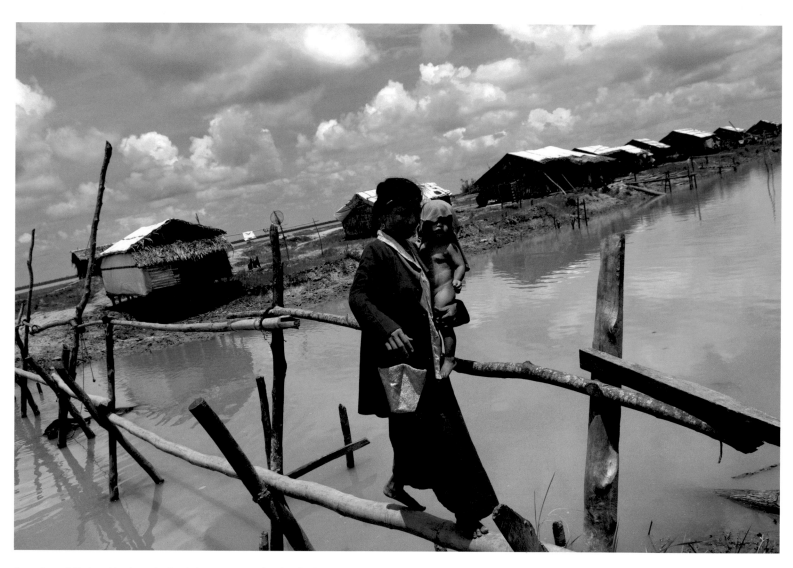

A survivor of Cyclone Nargis carries her baby across a tiny bamboo bridge near a temporary settlement.
Irrawaddy Division, 2008.

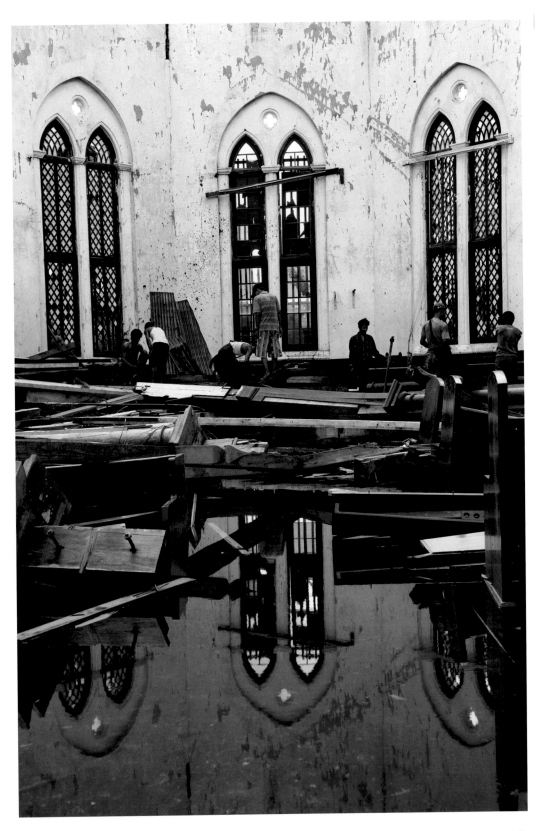

Workers remove debris from
a Christian church that was
devastated by Nargis.
Rangoon Division, 2008.

161

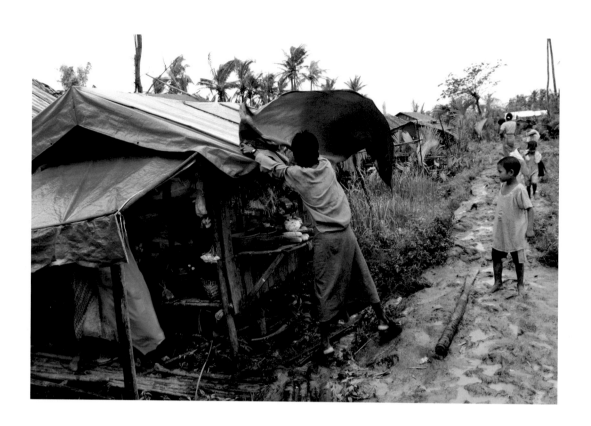

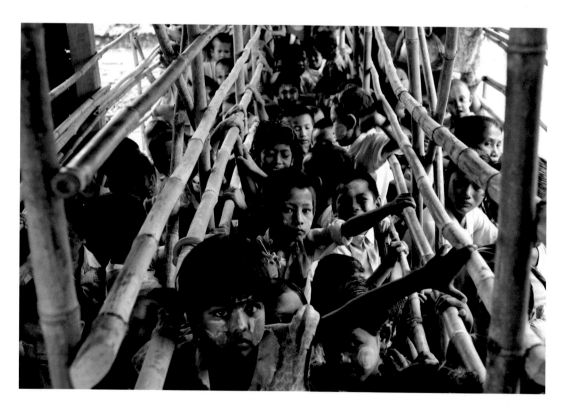

Top: The owner of a small shop in a village devastated by Nargis puts up a tarpaulin during heavy rain. Irrawaddy Division, 2008.

Bottom: Children who were victims of the cyclone gather for their afternoon meal in the Rangoon monastery where they are being sheltered. Rangoon Division, 2008.

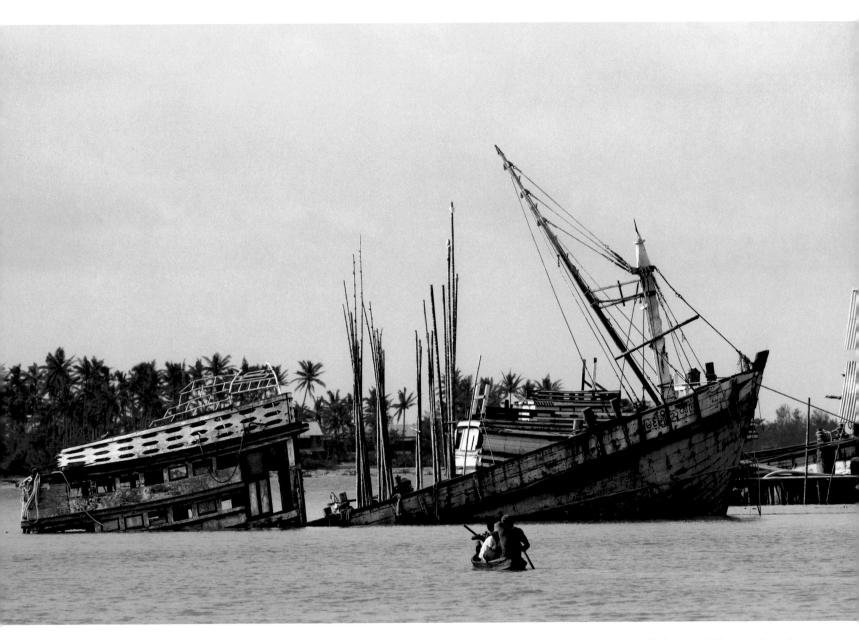

This boat moored in a tributary of the Irrawaddy River was half-sunk by the cyclone.
Irrawaddy Division, 2008.

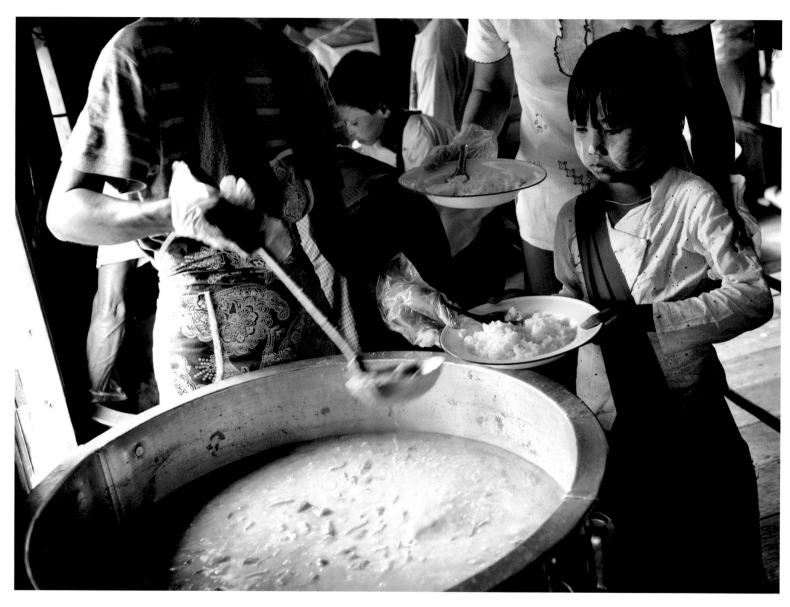

A local civilian organisation feeds children made homeless by the cyclone who are being sheltered in a Rangoon monastery.
Rangoon Division, 2008.

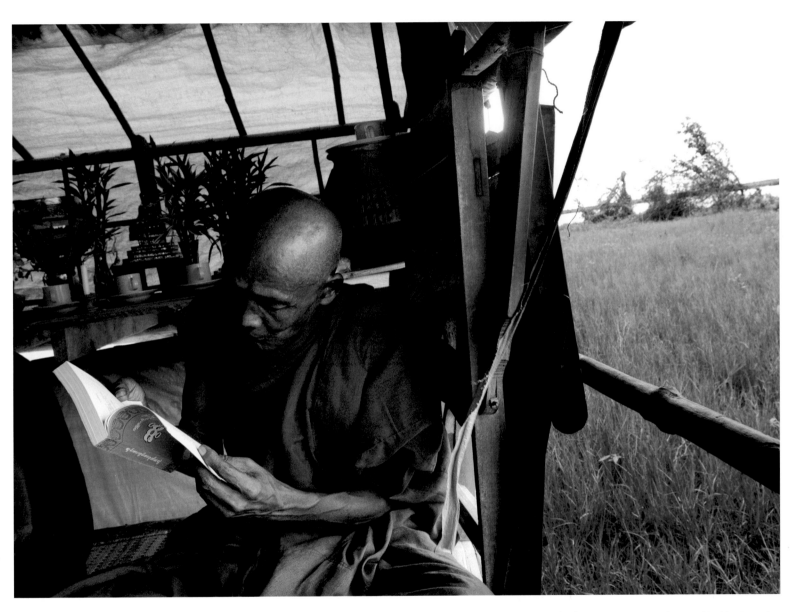

A Buddhist monk, whose monastery was destroyed by Nargis, reads a
book in a makeshift monastery built from scrap materials in a rice field.
Irrawaddy Division, 2008.

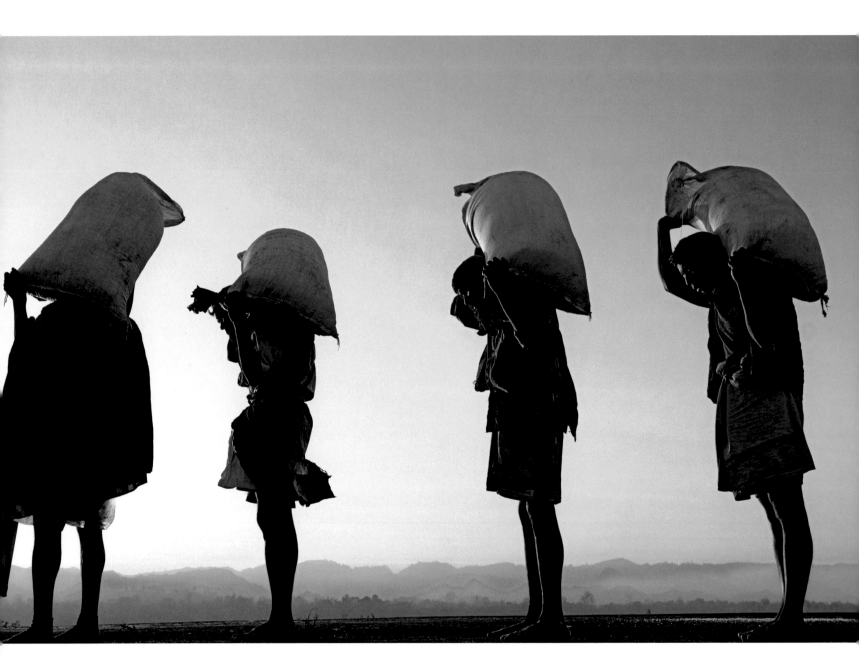

Rohingya migrants carry bags of raw salt produced at salt farms along Bangladesh's southern coastline.
Bangladesh, 2010.

166

Chapter Twelve

FOREIGN CLIMES
The Burmese diaspora

One rainy day in 2000 I photographed an intriguing sequence of events in Mae Sot, the main border town in western Thailand. At the foot of the bridge that crosses the Moei River that marks the border with Burma, Thai Border Patrol Police had gathered hundreds of Burmese illegal migrants and were holding them under a massive red tarpaulin bearing the Coca-Cola logo. The Burmese, who had been rounded up from local sweatshops, rice fields and construction sites, were waiting to be photographed and fingerprinted by Thai immigration officers. Some were brought in by police vans like criminals. Once registration had been completed, they were put in the back of trucks and driven a few kilometres down the river to where they were transferred into the long-tail boats that would take them on the quick journey back to Burma. As this was happening, a border officer who was watching the event smiled to me and said, "Don't worry, they will come back tomorrow, we need them."

Burma's devastated economy has caused millions to leave their homeland, permanently or temporarily, in the hope of forging a better life in foreign climes. In a 2009 report, the International Office for Migration stated that up to five million Burmese – about 10 percent of the country's population – lived overseas, legally or illegally. In another report, in 2012, Madhidol Migration Center found that two to four million of those migrants live in Thailand where they mostly work as low-skilled labourers in the manufacturing, agriculture and fishing sectors. Most of the rest live in Bangladesh, Malaysia and Singapore. A note from the New York-based risk consultancy Eurasia Group stated that the Burmese "typically work in industries considered as 3D by Thai workers: dangerous, dirty and difficult".

Besides these economic migrants, many other people had left their country because of ethnic wars and forced relocation policies. In Thailand, more than 150,000, mostly from ethnic minorities, live in refugee camps along the border although it's fair to say that the latest arrivals were mostly economic migrants rather than political refugees. But the worst off are surely the Rohingya, a Sunni Muslim minority considered to be the largest stateless population on Earth. About 800,000 Rohingya live in Burma's Western Rakhine State, hundreds of thousands of others are resigned to an itinerant life in southern Bangladesh where they work illegally or live in squalid refugee camps. More have moved to countries as far away as Pakistan and Saudi Arabia.

A major resettlement plan for Burmese refugees living in Thailand and Bangladesh was initiated by the United Nations a few years ago and tens of thousands of refugees have left the camps to start new lives in Western countries. In 2011, the beginning of dialogue and a new round of ceasefire agreements between the government and most of the remaining armed ethnic groups have raised new hopes about the future for refugees in Thailand. Still, for many, it will be very long time before they choose to return home.

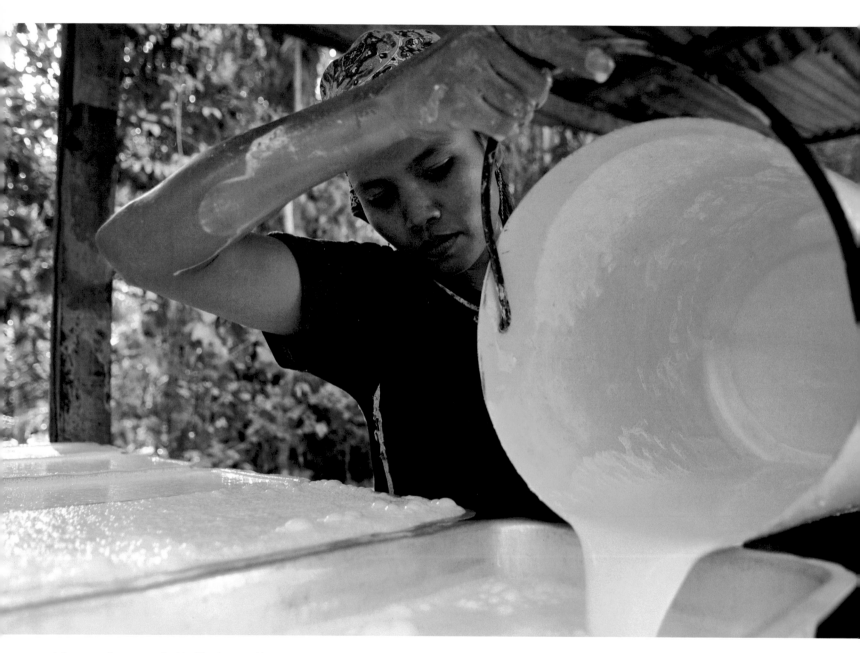

A Burmese migrant pours liquid rubber into moulds.
Thailand, 2006. (Credit Thierry Falise/IOM)

Top: A Burmese man works on a construction site while his baby sleeps in a makeshift hammock. Thailand, 2006. (Credit Thierry Falise/IOM)

Bottom: A Shan migrant picks oranges in a plantation along the Thai-Burma border. Thailand, 2007.

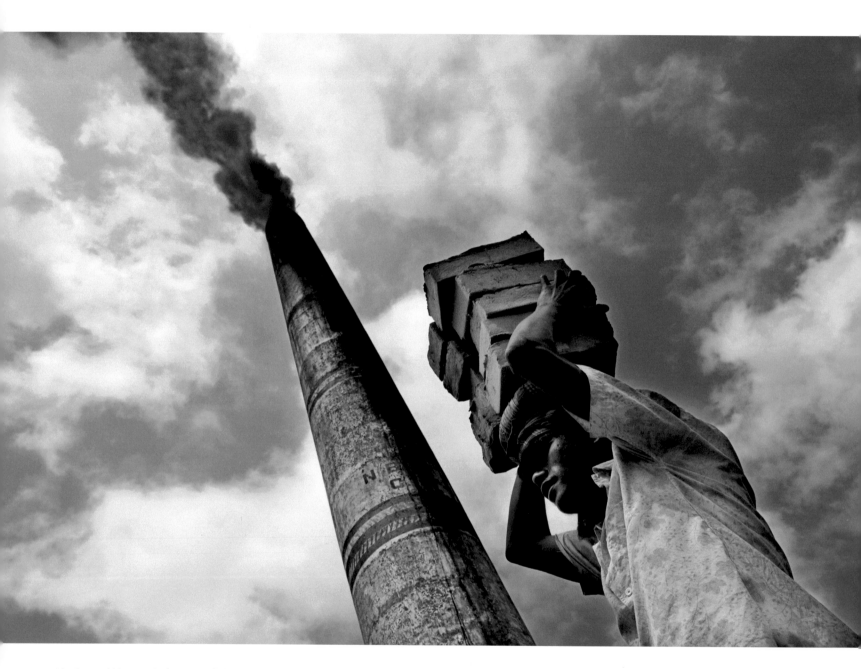

Hard manual labour is the best many Rohingya men, such as this migrant who carries a
stack of bricks on his head as he walks past a smokestack at a factory, can wish for.
Bangladesh, 2011.

170

Top: A Rohingya woman carrying her baby watches as other women beg for fish from a boat returning to Cox's Bazar port. Bangladesh, 2011.

Bottom: A man carries a giant rubber tyre used by Burmese migrants to cross the Moei River along the Thai-Burmese border. Thailand, 2011.

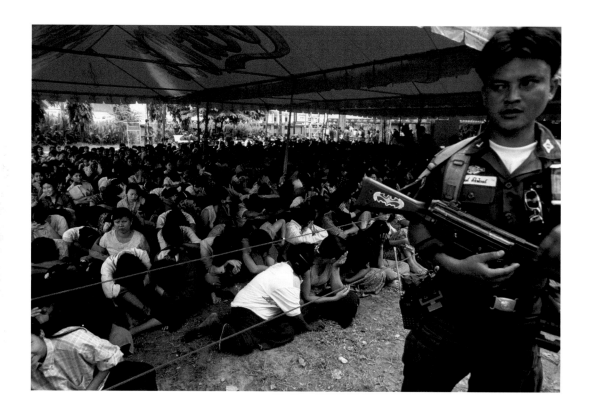

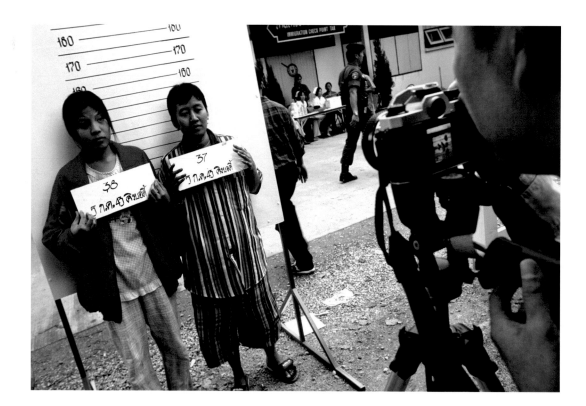

This and opposite page: Thai immigration police register Burmese illegal migrants in Mae Sot before sending them back to Burma by truck and boat. Most of the migrants will return the next day.
Thailand, 2000.

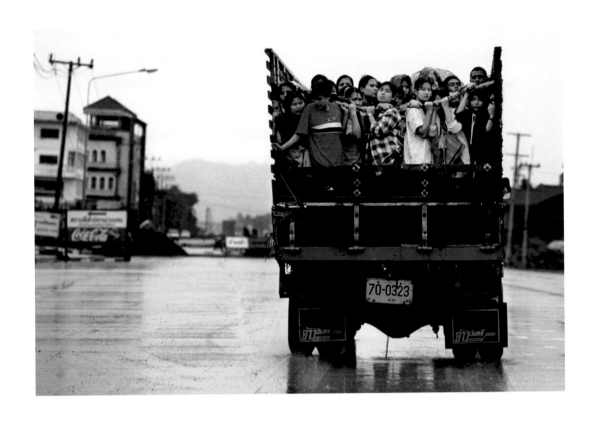

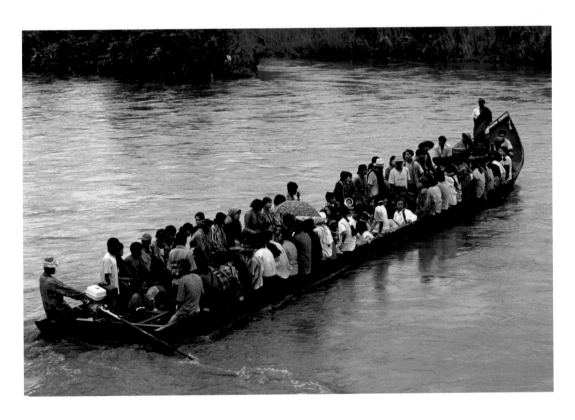

Umpiem refugee camp, home to more than 15,000 Burmese refugees, after a downpour.
Thailand, 2009.

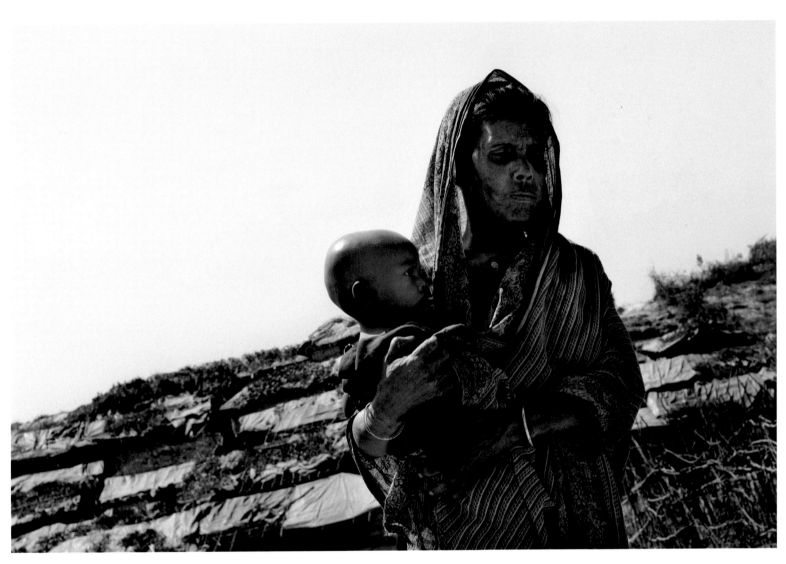

This woman and her baby live with some 30,000 to 40,000
other Rohingya refugees at the makeshift Kutupalong camp.
Bangladesh, 2010.

A Western tourist takes a picture of his two daughters with a "long neck" woman in Nai Soi village, Northern Thailand. The "long necks" are female ethnic Padaung (or Kayan), a sub-group of the Karen, who wear brass rings around their neck and lower legs. In Thailand, most "long neck" women, also known as "giraffe women", are refugees from Burma.
Thailand, 2007.

Two young Rohingya men work on a sewing machine at the Kutupalong refugee camp.
Bangladesh, 2010.

Top: A young refugee attends a baby care workshop in Mae La camp. Thailand, 2009.

Bottom: A woman reads information about being resettled in a foreign country from a bulletin board at Mae La camp. Thailand, 2009.

Opposite page: A young Burmese refugee is weighed during a medical screening at a Thai hospital. Thailand, 2007. (Credit Thierry Falise/IOM).

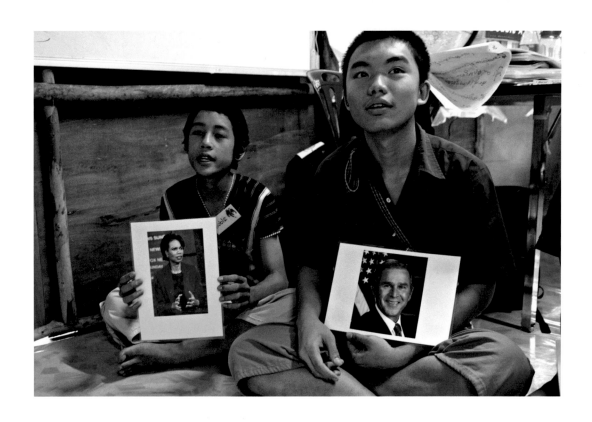

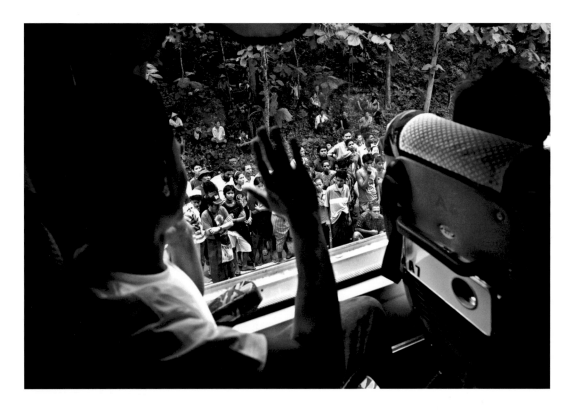

Top: Young Burmese refugees hold pictures of American politicians – President George W Bush and Secretary of State Condoleeza Rice – during a cultural orientation session about the United States.
Thailand, 2007. (Credit Thierry Falise/IOM)

Bottom: A Burmese refugee waves goodbye to relatives and friends as his bus departs Mae La camp for Bangkok airport after which the refugees will be flown to their new homes either in the US or Australia.
Thailand, 2007. (Credit Thierry Falise/IOM)